T·H·E BAUHAUS

T·H·E BAUHAUS

Uwe Westphal

GALLERY BOOKS
an imprint of W.H. Smith Publishers Inc.,
112 Madison Avenue
New York, New York 10016

The Bauhaus

This edition published in 1991 by Gallery Books,
an imprint of W.H. Smith Publishers Inc.,
112 Madison Avenue, New York, New York 10016

Copyright © Studio Editions Ltd., 1991

The right of Uwe Westphal to be identified as the
author of this work has been asserted by him in accordance
with the Copyright, Designs and Patents Act, 1988.

ISBN 0-8317-0701-1

Printed and bound in
Hong Kong

Designed by David Wire

Translated by John Harrison

A c k n o w l e d g e m e n t s

I would like to thank Joanna Newman, whose patience and good advice
enabled me to write this book, also John Harrison for his
invaluable suggestions for the translation.
Thanks to the painter Hugo Puck-Dachinger for his welcome inspiration,
and to Axel Westphal for his help in my research.

Uwe Westphal, London, 1990.

Contents

6 Introduction

1. The Art-Historical Background 13

14 Expressionism

18 Cubism, Surrealism and Suprematism

23 Da Da

25 Painting and the Bauhaus

28 Architecture

2. Pedagogy and Training at the Bauhaus: 37
 Preliminary Courses

40 Itten

46 Moholy-Nagy

50 Albers

53 Kandinsky

57 Klee

60 Schlemmer

3. The Workshops 71

73 The Furniture Workshop

83 The Metal Workshop

90 From the Graphic Press to the Printing
 and Advertising Workshop

97 Photography

115 The Bauhaus Stage

122 The Wall-Painting Workshop

126 The Ceramics Workshop

130 The Weaving Workshop

135 How a Whole Is Produced from Many Parts:
 Architecture at the Bauhaus

4. The Idea Lives on 157

167 Chronology

168 List of Illustrations

170 Picture Credits

171 Bibliography

173 Index

Introduction

The question of when a particular style, tendency, or approach in art first arose can never fully be answered unless we consider the circumstances in which it occurred. For no movement in the history of art has simply emerged out of a vacuum, or from the ideas of a few gifted geniuses. Rembrandt, Turner, Picasso – none of them created their pictures out of nothing; like other artists, they belonged to, and were expressions of, their time – or they saw tendencies developing which they reflected in their paintings. Though this may apply generally to all movements and ideas in the history of art, it is particularly true of the Bauhaus. The initial idea of a 'new form' in architecture and design in the period following the First World War was one very much rooted in the context of its time. And it is no less important to us today, since in our daily lives we are all faced with practical examples of the Bauhaus idea. Few other ideas and innovations in the history of art and architecture have had such a lasting impact on building, not only in Europe, but also world-wide.

When trying to find out what the essence of the Bauhaus movement was, we must first recognize that it did not consist of a homogenous group with co-ordinated ideas. Its ideas sprang from the Bauhaus teachers' various interpretations of generally acknowledged constants, though these were by no means accepted unquestioningly by the individuals studying and working at the Bauhaus. Perhaps it was the very fact that they did not follow a uniform style, with the constrictions this involves, that gave the Bauhaus such flexibility and facility for development. Its creative climate was born out of conflict and the struggle for a new understanding of art, rather than from the veneration of any artistic father-figure. But it was also the period itself that favoured these new developments. The *Bauhaus Manifesto*, written by Walter Gropius in 1919, remains to this day a living document of the idea, of its background, and of a movement which only years later finally came to be recognized and understood. It reads:

the complete building is the final aim of the visual arts. their noblest function was once the decoration of buildings. they were inseparable parts of the great art of building. today they exist in an isolation from which they can be rescued only through the concious, co-operative effort of all craftsmen. architects, painters and sculptors must recognize anew the composite character of a building as an entity: only then will their work be imbued with the architectonic spirit which it has lost as 'salon art'.

the old art schools were unable to create this unity. how could they, since art cannot be taught? they must once more become part of the workshop: the world of drawing and painting, of designers and handicraft-artists must at last become a building world again. if a young man who feels inclined towards creative activity begins his career by learning a trade, as in the past, then the unproductive 'artist' is no longer condemned to exercise his art incompletely, for his talents are now preserved for the trade in which he might achieve excellence.

architects, sculptors, painters, we must all turn to the crafts. art is not a 'profession'. there is no essential difference between the artist and the craftsman. the artist is an exalted craftsman. in rare moments of inspiration, moments beyond the control of his will, the grace of heaven may cause his work to blossom into art. but proficiency in his craft is essential to every artist. therein lies a source of creative imagination.

. . . let us create a new guild of craftsmen, without the class distinctions which raise an arrogant barrier between craftsman and artist. together let us conceive and create the new building of the future, which will embrace architecture and sculpture and painting in

1 Lyonel Feininger, woodcut, cover illustration (Cathedral) for the Bauhaus Manifesto, 1919.

a single unity, and which will rise one day towards heaven from the hands of a million workers like the crystal symbol of a new faith.

It is clear from these words how enthusiastic Gropius was about building a new world. (He had experienced the massacre of the First World War at first hand as a

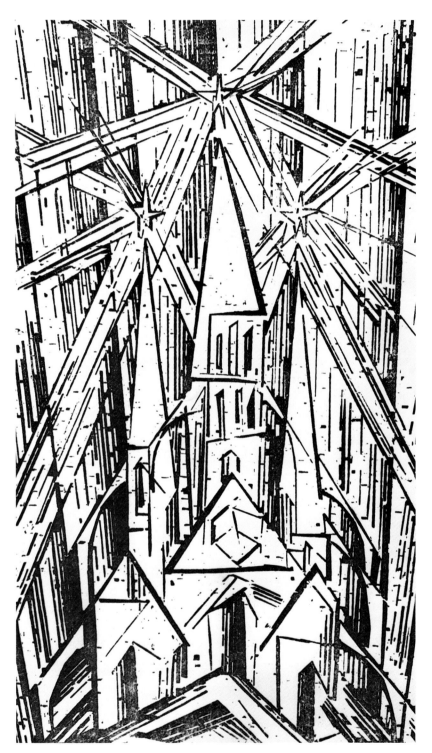

lieutenant in the hussars.) After the collapse of the German empire, the effect of the war and the time he spent as a trainee architect in Peter Behrens' studio in Berlin before the war led Gropius to pursue the ideal of a new kind of architecture: it was to be conscious of its responsibilities and responsive to human needs, but at the same time would seek to bridge the gap between advanced technology and craftsmanship. Gropius had already shown his leaning towards social themes and architecture with a social purpose in the Fagus Works in Alfeld (1911), and the office building for the 1914 Werkbund Exposition in Cologne. Both buildings were inspired by the idea of transparency in a dual sense: on the one hand the human workforce were to enjoy the daylight streaming through large glass façades; on the other, this would also introduce clarity into the work process. All in all, work was to be freed of its traditional dreary image.

Gropius himself saw the need, particularly after the war, for an intellectual re-orientation, and a complete change in approach. Architecture was to serve man and strengthen his social bonds; it was not to become a burden to him:

i saw that, first of all, a new scope for architecture had to be outlined, which i could not hope to realize, however, by my own architectural contributions alone, but which would have to be achieved by training and preparing a new generation of architects in close contact with modern means of production in a pilot school which must succeed in acquiring authoritative significance.

i saw also that to make this possible would require a whole staff of collaborators and assistants, men who would work, not as an orchestra obeying the conductor's baton, but independently, although in close co-operation to further a common cause.

consequently i tried to put the emphasis of my work on integration and co-ordination, on inclusiveness not

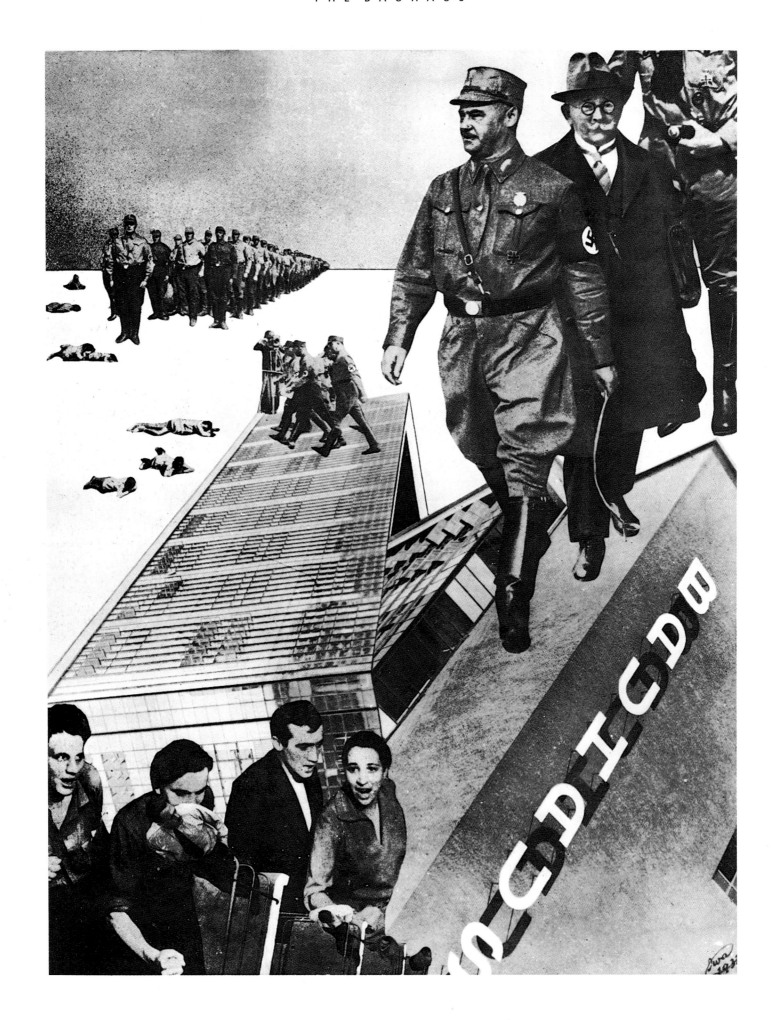

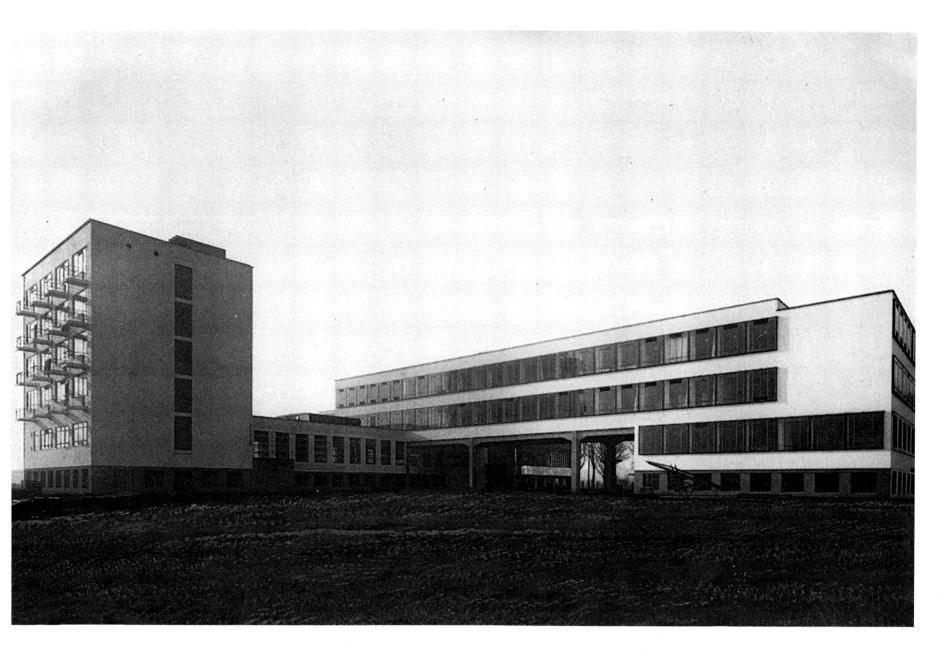

3 View of the Bauhaus building in Dessau, 1926.
Photo by Lucia Moholy.

exclusiveness, for i felt that the art of building is contingent upon the co-ordinated teamwork of a band of active collaborators whose co-operation symbolizes the co-operative organism of what we call society.

thus the bauhaus was inaugurated in 1919 with the specific object of realizing a modern architectonic art, which like human nature was meant to be all-

2 Iwao Yamawaki, Attack on the Bauhaus
(Der Schlag gegen das Bauhaus), photo collage, 1933.

embracing in its scope. it deliberately concentrated primarily on what has now become a work of imperative urgency – averting the machine's enslavement of mankind by saving the mass-product and the home from mechanical anarchy and by restoring purpose, sense and life to them. this means evolving goods and buildings specifically designed for industrial production. our object was to eliminate the drawbacks of the machine without sacrificing any of its real advantages. we aimed at realizing standards of

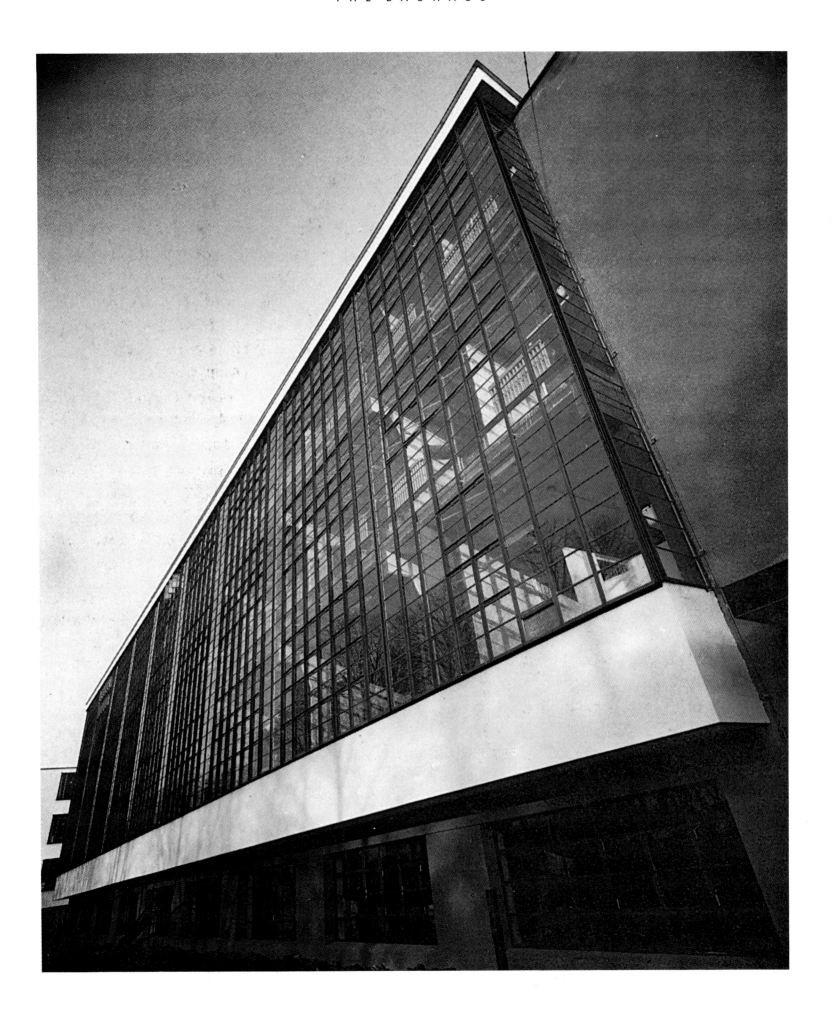

excellence, not creating transient novelties. experiment once more became the centre of architecture, and that demands a broad, co-ordinating mind, not the narrow specialist. (Walter Gropius, 'my conception of the bauhaus idea'.)

The co-operation between architects, painters and sculptors stressed by the *Bauhaus Manifesto* attacked the excesses of turn-of-the-century ornamentation as well as received ideas about the structure of buildings. Gropius thought the time was right to combine the technical possibilities of architecture with art, uniting the two in a human concept. The artist was to function not as a remote free spirit – the pure artist – but by learning and practising his skilled trade. This vocational approach also meant refraining from unnecessary ornamentation and regarding the form of an object as a reflection of its function. Gropius' words about the new building of the future and the 'crystal symbol of a new faith' may strike us as excessive today, but the *Bauhaus Manifesto* does provide an accurate picture of its time, and of the path then being taken by a younger generation of artists. Lyonel Feininger's woodcut of a cathedral, which he made for the manifesto, depicts in quasi-religious imagery this belief in another, better future. The cathedral symbolizes the trinity of the arts expressed by Gropius, and illustrated in the Cubist and Constructivist pictures of, amongst others, Robert Delaunay and Piet Mondrian.

Yet too strong a religious interpretation would be out of place here. The picture evokes, rather, the mood of departure felt by a new generation of artists, who were aiming to create values that could be applied universally, with man as the measure of everything. There can be no doubt that, despite frequent criticisms of later developments in Bauhaus practice, the Bauhäusler (as they called themselves) have to this day continued to make valuable statements and to produce successful works of art. It is no surprise that the National Socialists were responsible for closing Germany's Bauhaus schools. For the spirit these schools engendered, quite apart from any influence from socialist ideas, was fundamentally at odds with the authoritarian character of Hitler's dictatorship. Freedom of thought for the individual, coupled with a responsibility to society, did not square with Nazi ideas. The Bauhaus Institute in Dessau closed, under pressure from the Gestapo, on 20 July 1933. A period of personal persecution now began for the members of the Bauhaus, driving Walter Gropius to emigrate first to England in 1934, then later to the USA. Of the many other Bauhäusler who suffered under the Nazi regime twelve are thought to have died in Hitler's concentration camps, though the precise number is difficult to establish.

4 View of the Bauhaus building in Dessau, 1926.
Photo by Lucia Moholy.

1. The Art-Historical Background

Expressionism

'We threw ourselves into the artistic adventures of a difficult period,' remembers Lothar Schreyer, director of the theatre workshop at the Bauhaus in Weimar from 1921 to 1923. 'The Bauhaus became a "stronghold" for expressionism when the rest of the world saw it as a sign of world decline.' (Neumann,

Bauhaus und die Bauhäusler, p. 122.)

Schreyer uses the words 'threw', 'adventures', and 'world decline' to describe the Bauhäuslers' feelings towards an important, if not central influence on the stylistic precursors of the Bauhaus: Expressionism. Van Gogh's well-known words of 1880, used to describe his own work: 'instead of trying to record what I see. I use colour arbitrarily to express my feelings', reveal something of the ambience surrounding the early

5 *August Macke*, With a Yellow Jacket, *watercolour, 1913.*

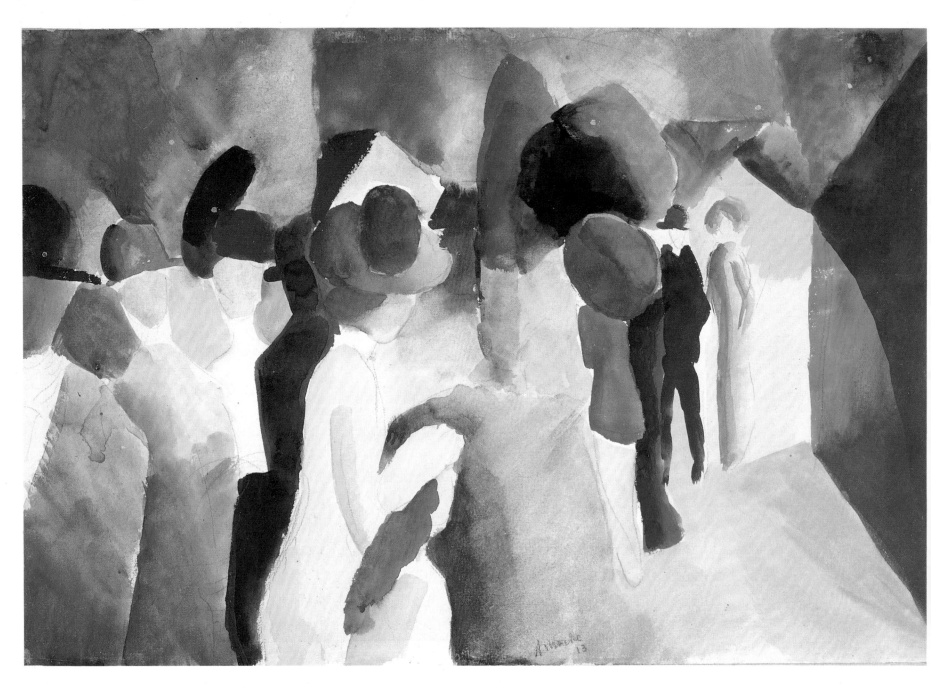

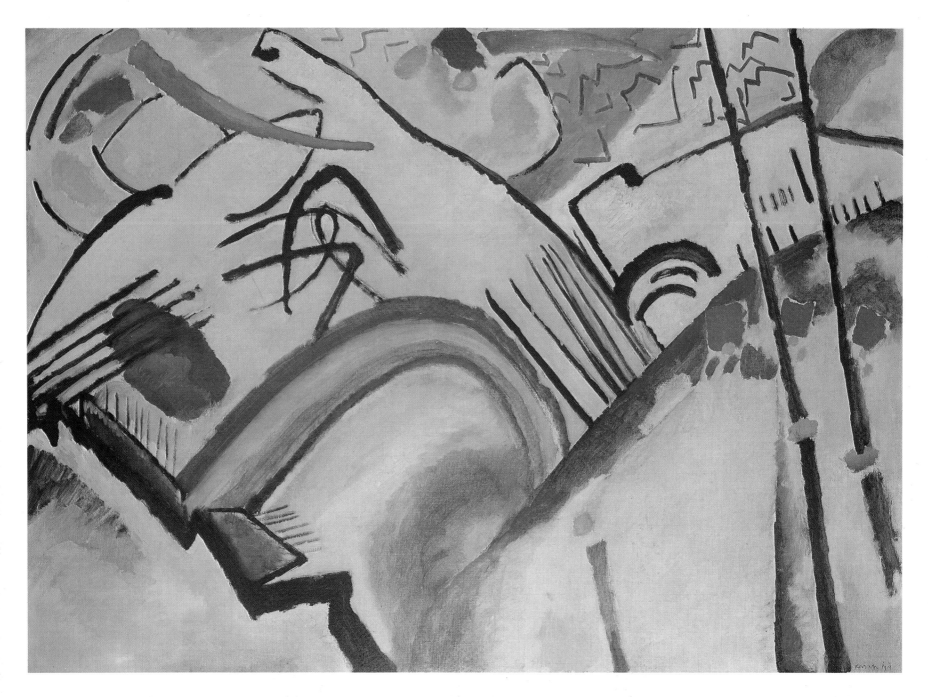

6 Wassily Kandinsky, Composition Study, *1910. Kandinsky
was one of the leading representatives of abstract painting
at the Bauhaus.*

Bauhaus teachers and pupils, who had grown up or
studied during the main period of German
Expressionism (c. 1910–20). Together with other artistic
currents, Expressionism was a major influence on the
Bauhaus, and although some of today's art critics view
this statement with scepticism, the painting that
emerged from the Bauhaus would have been
inconceivable without it. What, however, were the
distinguishing features of Expressionism? And what
was its link with Bauhaus art? Far more than an artistic
style which lasted over a particular period,
Expressionism reflected a way of thinking and of being,
at a time of considerable social and political upheaval.
The values that shaped intellectual life during the years

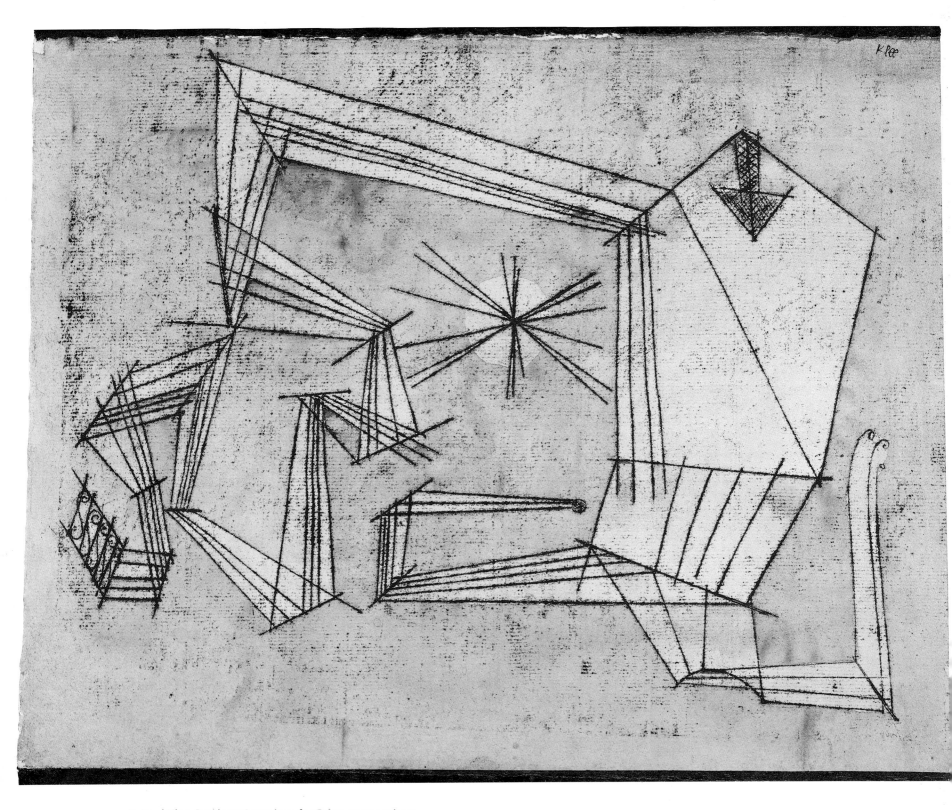

7 *Paul Klee*, Precious Container for Stars, *watercolour, ink and pen, 1922.*

shortly before and after the turn of the last century were shifting and in a state of collapse.

In their search for a new order, new models, and a new aesthetic no longer oriented towards the old traditions, the Expressionist painters saw themselves very much as part of a movement that sought to give

an authentic artistic expression to its feelings. They felt the need to convey, from a new perspective, the inner emptiness that resulted from a bewilderingly rapid change in the economic climate, which was itself a product of increasing industrialization in Germany before the First World War.

In France, it was above all the Fauvists influenced by Van Gogh, Cézanne and Matisse who gave Expressionism its distinctive quality, with their intense forms and vivid colours. They made a strong impression on painters in Germany, such as Franz Marc, August Macke, Wassily Kandinsky (later at the Bauhaus) and Jawlensky. Coming together under the name 'Der Blaue Reiter' ('The Blue Rider'), this group – and especially Kandinsky – also opened the door to analytic and futuristic painting. The Blaue Reiter group, which held its first exhibition in 1911, became the most powerful influence in Expressionist painting. The Munich artist Franz Marc had an almost religious attitude to painting. In contrast to Kandinsky, he was reluctant to abandon painting from objects, but he did stress the expressive importance of colour, which he applied in a strict, quasi-analytical way. His crystallized arrangement of colours and motifs – reminiscent of Feininger's wood-cut of 1919 – depicts a creation in harmony with itself. In its search for authentic values, following the catastrophe of war, the painting evokes a sense of primeval order. Marc, who was killed in 1916 at Verdun, was strongly influenced, along with August Macke, by Cubism and Constructivism, both of which were prominent at the time. Nothing is left to chance (if there is such a thing in painting): his pictures are thoroughly ordered, and powerful in their use of colour and form, the most famous example being his *Tower of the Blue Horses*. The central importance of the impact of colour combinations is also evident in the works of August Macke: *With a Yellow Jacket* of 1913, for example. The factors involved in colour choice were later to become a major preoccupation of the Bauhaus.

Wassily Kandinsky, who was born in 1866 in Moscow, first studied law and economics, before coming to Munich in 1896 and abandoning his legal ambitions. His initial involvement with painting – in 1909 he founded the 'Neue Münchner Künstlervereinigung' ('New Munich Artists' Group') – was primarily on an intellectual level. In 1910, after years of internal debate and development, he painted his first non-representational watercolour, *Abstract Watercolour*, about which he wrote, 'I feel ever more certain that the inner essence of the object constitutes its form. Art and nature became increasingly separated

8 Lyonel Feininger, Halle, Am Trödel, *oil on canvas, 1929.*

within me, until I was able to view each as independent and entirely distinct from the other.'

This remark is interesting in the context of the Bauhaus and its development in later years, for it is evidence that Kandinsky was developing an analytic method, which he advocated extensively at the Bauhaus, and which was to play a major role in the education of its students.

During his 'Blaue Reiter' phase Kandinsky met Paul Klee, who in 1922 was to exercise a great influence on colour theory at the Bauhaus in Weimar. By that time scientific interest in painting and the constructive method underlying its composition had been widely stimulated by Kandinsky, who also occupied himself with Johann Wolfgang von Goethe's *Theory of Colours* (1805–10). In this work Goethe provided an analytical study of the psychological effect of colours, and recorded detailed accounts of his findings. The near-mathematical precision of Kandinsky's method not only freed his painting from the mysticism and transfigured quality of the *Jugendstil* (the German equivalent of Art Nouveau), it also opened the door to a greater use of the imagination and the freedom to experiment with new forms of expression, both of which contributed significantly to the innovative force of the Bauhaus.

Cubism, Surrealism and Suprematism

Whilst Expressionism stressed colour, and its effect on the observer, there were also other currents at work in the world of painting that would later come to influence the Bauhaus. One such movement was Cubism, the creation of Picasso, Braque, Juan Gris and Léger, who, between 1907 and 1914, provided a new and revolutionary variation on the theme of art and our

reaction to it. As the name suggests, Cubist paintings represent their subject-matter using geometric shapes. Familiar objects and bodies, whose symmetry demands no kind of explanation, are removed from their usual context and rendered unfamiliar. A new way of seeing emerges. Nature is no longer to be imitated, the real experience should be one of colour and form. The Cubist painters often used musical instruments, animals, bottles, and so on, as motifs, though these all still bore some relation to the real world, and were not entirely abstracted from it as in Kandinsky's art. Although there is no direct proof, we may assume that the Cubists' use of other materials, such as cloth, sand, cardboard, wood and paper (particularly newsprint), exerted some influence on the Bauhaus and its future teachers. For in their case, too, we find the most diverse kinds of materials being used.

Another of the effects of Cubism was to stimulate the artists of the Dutch 'de Stijl' group. Unlike Expressionism, with its emphasis on feeling, de Stijl aimed to create pictures that were purely technical and geometric in composition. Having developed from a rejection of traditional Dutch figure painting, and a search for the inner structure of objects, de Stijl sought complete abstraction from the real world. Among the main representatives of the school were Theo van Doesburg and Piet Mondrian. It is not surprising that van Doesburg was later a frequent guest of the Bauhaus in Weimar and Dessau, for his ideas on paintings were also directly applicable to architecture and had a considerable influence on Kandinsky.

The 'technoide', as the fashionable jargon of the time put it, a distancing from the apparent claim of the world of objects, was also familiar to Giorgio de Chirico. Born in 1880 (his father came from Sicily), de Chirico spent the years from 1911 to 1915 in Paris. A railway engineer by profession, he was fascinated by the possibility of combining this technical knowledge with his own specific form of painting, metaphysical

pictures. He, too, abstracted concrete things and forms from their usual settings, and placed them in new contexts in the clearly partitioned picture. This use of a meta-level indicates that the individual elements of the picture have been removed from their original contexts.

In his *Grand Metaphysical Interior* of 1917, the real world appears only as a picture within a picture, which itself appears as part of an artificial arrangement involving other pictures. By means of this duplication, the picture within a picture, the painter attempts to

9 Pablo Picasso, Restaurant, Still Life, *oil on canvas, 1914.*

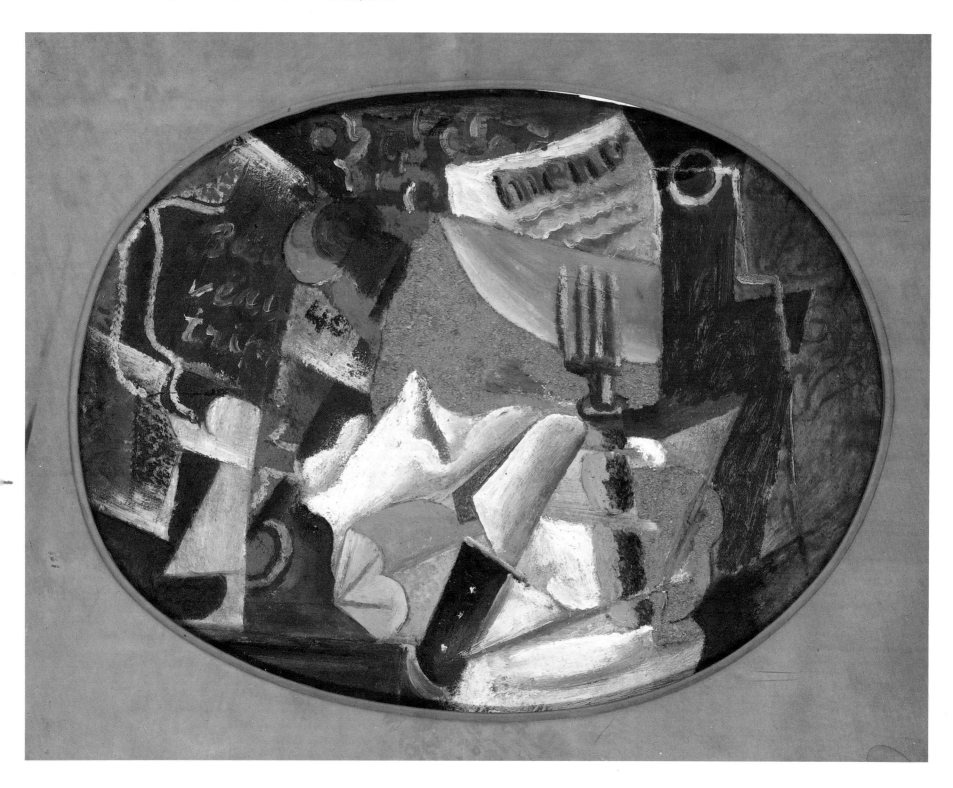

10 *Theo van Doesburg,* Composición en blanco y negro. *Van Doesburg condemned the romantic direction temporarily taken by Bauhaus teaching.*

Composed of intellectuals, it launched a critical, cynical attack on the existing post-war order in graphics, literature and painting.

Carlo Carrà, with whom de Chirico formed a friendship whilst in Italy, belonged to the 'Manifesto of Futurist Painters' group, and was moving in a similar direction. His painting, though, was more strongly influenced by Cubism, as the picture *Funeral of the Anarchist Galli* impressively shows. Although neither de Chirico nor Carrà had any direct contact with the Bauhaus, their work influenced Weimar, not least because of its expressive use of colour. The artistic affinity between them and the Bauhaus is also evident in their abstract compositions of familiar things and objects.

Italian influences took the shape, mostly between 1910 and 1917, of a stream of manifestos. Leaving barely any area of human relations and art untouched, they ranged from aggressive statements about the government and diverse political issues, to the analysis of sexual practices. Basically, they were Futurist in tendency. Gino Severini should also be mentioned.

After the October Revolution, Kandinsky returned to Moscow from Germany, where he took up important official posts and positions at the university. Along with Kandinsky, Kasimir Malevich was one of the most powerful and provocative figures on the Russian art scene to exert a European influence. Born in Kiev in 1878, he was strongly influenced by the Fauvists and inclined towards Léger's style of painting. In 1915 he turned towards the Cubist movement with a *Suprematist Manifesto* (the urge to communicate had reached the same proportions as in Italy). Malevich's

reveal the contradiction his work presents to traditional painting. De Chirico wishes to provoke the observer into an intellectual confrontation with the phenomena of the time in order to interpret the picture. Relying on surrealistic techniques, he consigns the modern world, as he sees it, to the grave, and hopes for another, better world. *The Duo*, of 1915, makes clear reference to the isolation of the individual in the world, reflecting the melancholy feelings which informed de Chirico's cultural critique. The atmosphere and ambience of the present dominate, as men and women are turned into ahistorical, asexual beings . The composition of his pictures, some of them appearing almost to have been created like collages, does suggest parallels with the DaDa group which had first formed in Switzerland.

11 *Carlo Carrà,* The Enchanted Room, *acrylic, 1917.*

minimalistic pictures explored the limits by reducing everything to form and colour. The paintings were arrangements of squares and circles, the rectangle being the suprematist foundation, and they bore no relation to the 'visible' nature of things. Malevich regarded his non-figurative pictures as being equivalent to, or as valid as, representational paintings. He later painted variations on *Black Rectangle on a White Background* of 1913, retaining the same arrangement, but using different colours. He saw this as another expression of realism in painting, which did not necessarily involve the faithful reproduction of what could be observed in nature. Fame came with his suprematist composition of a white rectangle on a white background (*White on White*) of 1918. Like Kandinsky, Malevich was searching for an underlying structure in his pictures, for a solution to the problem of 'what makes a picture a picture'. His achievement was to stimulate new ways of thinking about visual reactions, and these bore fruit a year later through Kandinsky at the Bauhaus.

DaDa

It is worth stressing at this point that like Expressionism, the artistic mainstream of the day, the Bauhaus was taking issue with an outmoded view of culture. Certainly, the First World War contributed decisively to the forcible dismantling of antiquated structures, as did those movements to the left of the political spectrum. However, the personal involvement in this process of those who later became Bauhaus teachers never led them to advocate artistic dogma. A similar absence of fixed doctrine was evident in the DaDa movement,

12 Kasimir Malevich, Scissors Grinder, *oil on canvas, 1912.*

which originated in the bitterness of the battles of the First World War and the disillusionment (after 1919, at least) of seeing any hopes for a better society frustrated. DaDa was also very much the product of an eccentric obstinacy.

Franz Marc and de Chirico were represented alongside Kandinsky, Lyonel Feininger and Paul Klee at the first DaDa exhibition in 1917. The most important cult figure, however, was Marcel Duchamp, who attracted attention in New York with his 'readymades', objects from everyday life in unfamiliar settings.

The DaDaists in Zurich, Hannover, and Berlin especially, saw themselves as intellectuals who opposed the prevailing business culture with cynicism, satire and wit (the name 'DaDa' was said to have been a random discovery in a dictionary). Attacks were aimed at German militarism, the bourgeois who still supported the deposed Kaiser, and the new war millionaires. For a short time, literature and painting pursued the same

13 Carlo Carrà, Funeral of the Anarchist Galli, *oil on canvas, 1911. Carra exercised a strong influence on the Bauhaus artists.*

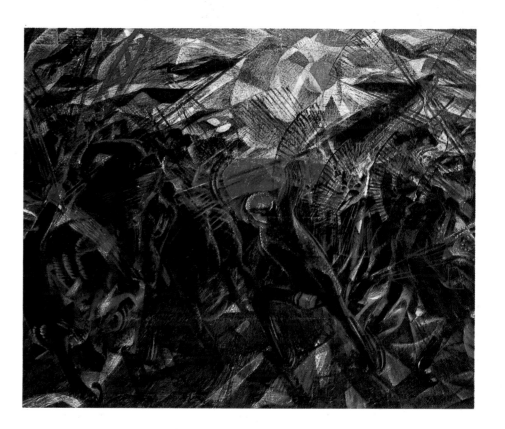

14 *Gino Severini,* Suburban Train, *oil on canvas, 1915.*

ends, as artists from different areas were united in common ideals and protestation. A year later, there was to be a similar convergence of a variety of artistic and creative tendencies at the Bauhaus.

The many influences affecting the Bauhaus and its founders through painting had one essential thing in common, even if they did appear under an almost bewildering variety of names. Expressionism, Fauvism, Futurism and Cubism: all channelled their energies into the clearly necessary work of breaking with artistic

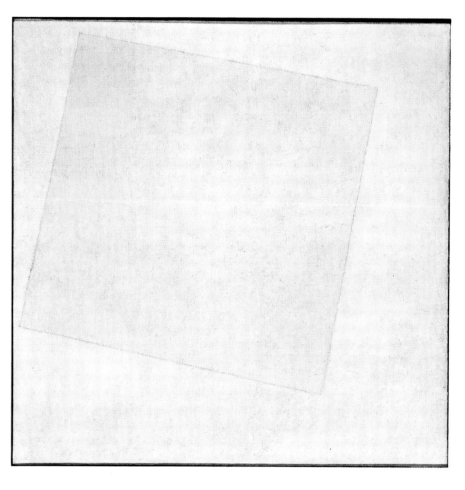

15 *Kasimir Malevich,* Suprematist Composition, White on White, *oil on canvas, 1918.*

traditions which were now proving to be an obstacle to progress. The creation of something original was called for, something that would bring a 'new' consciousness and make the coming age more humane and democratic, and hence free. This is very clear from Gropius's manifesto for the founding of the Bauhaus in 1919.

Painting and the Bauhaus

Fittingly, it was Gropius who created in the Bauhaus a focal point for all the positive and creative tendencies in painting. For Weimar, inspired by Gropius, now became the focus of hope for all those prepared for change – a

development, incidentally, which, from the viewpoint of art history, was to recur in Germany only in 1975. Although in the 1919 manifesto Walter Gropius advocated the primacy of architecture amongst the arts, under which heading painting and sculpture were also included, he nevertheless realized the crucial role painting had to play at the Bauhaus. Not only was it one of the most popular art forms of the day, but the painters themselves registered the vibrations of the age more quickly than other artists, mainly because they pursued their debates more vigorously than other groups. Of course literature and the theatre were also at the forefront of avant-garde Bauhaus thinking, and of its interpretation of contemporary events. Many in fact perceived themselves as DaDaists, as they polemicized in intelligent, sarcastic tirades against the government and the establishment. Gropius was well aware of the dominant influence and potential role of painting, as can be seen from the fact that he appointed numerous painters as teachers at the Bauhaus, and invited them there even when their ideas did not tally with his own.

Apart from those already mentioned, Georg Muche, Oskar Schlemmer, Lothar Schreyer, the sculptors Gerhard Marcks and Laszlo Moholy-Nagy, all taught at the Bauhaus. Some painters also involved themselves in the architectural field, drawing up their own plans and designs. This move was hardly surprising, since painting was pervaded by the analytical tendencies which had given birth to Constructivism as a variation on or a move away from Expressionism.

Cubism and Constructivism found expression, for the most part, in abstract geometric forms. Architecture then took the results of these analyses and applied them in its own field, as can be seen in the architectural aesthetic of the Dessau Meisterhäuser. Rectangles and squares made from a variety of materials were fitted together like boxes to form residential living spaces. The layout of Gropius's prefabricated houses of 1923

resembles in structure the pictures of Piet Mondrian or de Chirico. Kasimir Malevich had made arrangements of different cubes in his Constructivist pictures, thereby anticipating the ideas of Bauhaus architecture. The 'architectona' he developed, consisting of stone cut to various sizes and joined together to produce buildings and living units, was architecture in the Bauhaus spirit,

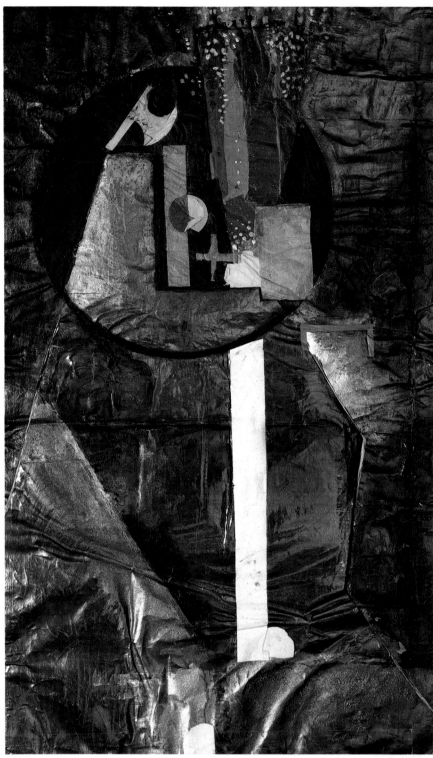

17 Johannes Itten, Coloured Composition, *paper collage, 1920.*

16 Lothar Schreyer, woodcut, Bauhaus Weimar, 1923.

though too futuristic perhaps even for Gropius.
 Similarly, the de Stijl group around Theo van Doesburg explored the interplay between the two disciplines. Van Doesburg, who was already making

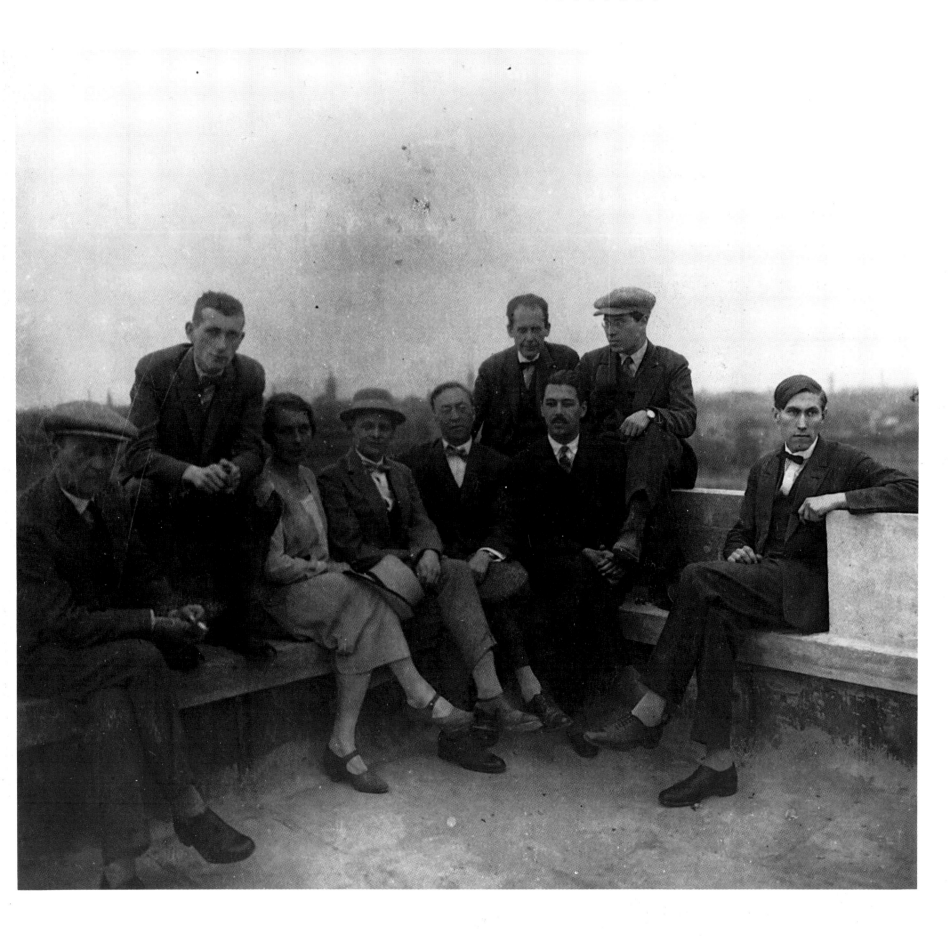

18 Members of the Bauhaus at Dessau on top of the roof, 1927;
Left to right: *Josef Albers, Marcel Breuer, Gunta Stölzl, Oskar* *Schlemmer, Wassily Kandinsky, Walter Gropius, Herbert Bayer,*
Laszlo Moholy-Nagy, Hinnerk Scheper. Photo by Lucia Moholy.

19 Piet Mondrian, Composition with Yellow and Blue, *oil on canvas 1929.*

theoretical statements in 1910 about the relationship of architecture to painting, painted a series of pictures between 1916 and 1918 and published writings which were to prove highly influential in Germany. His strictly geometrical, rectangular surfaces, mainly arranged at right angles in the picture, might easily be simplified bird's-eye-view photographs of a Bauhaus housing estate. *De Stijl* (*Style*), the journal started by van Doesburg in 1917, provided a vital stimulus for the Bauhaus, although Gropius did not always respond well to van Doesburg's brash style of self-advancement in Weimar. It could be said that the men shared something of a love-hate relationship.

Werner Graeff, a Bauhaus student at the time, remembers the Dutchman, who lived in Weimar from 1921–23, as someone who

fought it out certainly with at least half of his teaching colleagues and contemporaries at the Bauhaus. His only reason for staying in Weimar was to fight on as an outsider. He failed to understand how Gropius, who, in 1911 [with the Fagus Works building] and 1914 [with the building at the Werkbund Exposition in Cologne] had already provided such daring examples of his ideas on construction, and of his ability to create new forms, could at the start of his directorship of the Bauhaus cause or even allow, a return to expressionism and the excesses of romanticism . . . Doesburg argued the case for the machine and the modern mass production of well formed goods. He anticipated as early as 1921/22 part of the later Bauhaus programme. (Neumann, Bauhaus und die Bauhäusler, *p. 131.)*

On the subject of architecture, the feud between Gropius and van Doesburg was basically a confrontation between two contrasting views on aesthetics – involving the relationship between the meaning, purpose and form of a building – and had its roots in developments at the beginning of the century.

Architecture

In the period shortly before and after the year 1900 the world of architecture was shaken by the need to respond to new demands. After centuries of building cities along age-old lines, the growth of vast cities with populations of millions and with expanding industrial areas, now called for different measures. The people who came streaming in from the rural areas needed the kind of living space which could not be provided by the old ten-roomed city houses. The workers' estates which sprang up near the factories seldom allowed a standard of living compatible with human dignity. And so, in the congested conurbations of Berlin, the Ruhr and Leipzig,

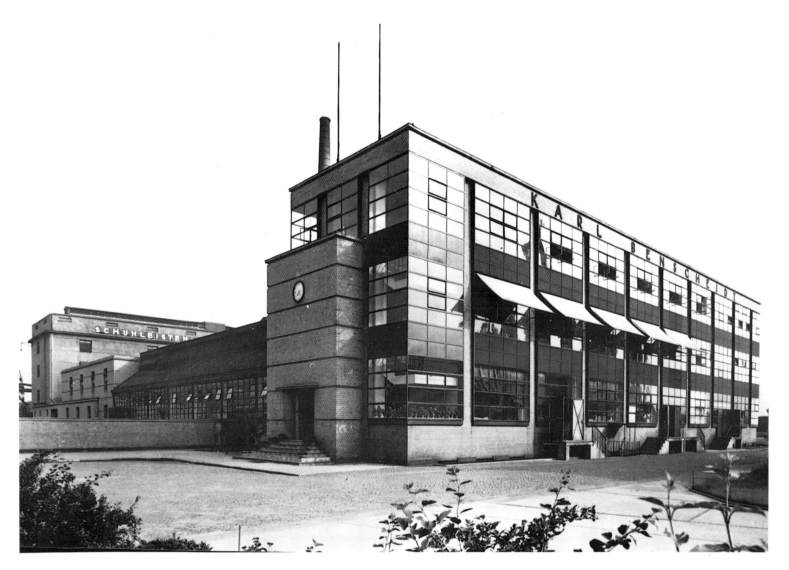

20 *Walter Gropius, Fagus building near Hannover, 1911.*

21 *Werner Graeff,* Rhythm-Study, *black on yellow paper, 1920.*

there were outbreaks of violent social unrest, due mainly to miserable living conditions.

By the turn of the century, the idea of building as a means of promoting social reform had spread only to isolated groups of architects. Joseph Maria Olbrich from Vienna, who with his Viennese Secession Building tried to establish new building standards, and Peter Behrens, for whom Gropius later worked, certainly belonged to such circles. But however much they tried, they were unable to rid themselves of a certain traditionalism, and deserved no prizes for social awareness in their building. Moreover, most architects were too isolated to be able to subscribe to any radical attempts at

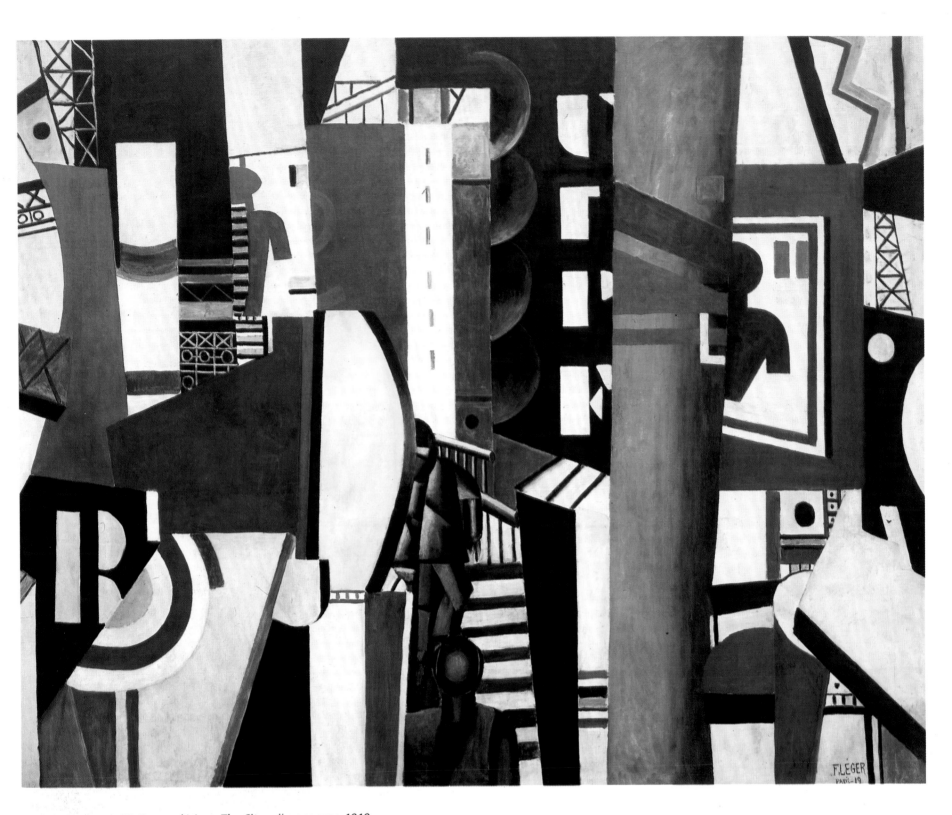

22 *Fernand Léger,* The City, *oil on canvas, 1919.*

innovation. This may have been partly because of the privileged standing their profession had long enjoyed at the royal courts, or perhaps because innovative ideas tended to spread more slowly in architecture: a building always requires an owner as well as a plot to stand on. Besides, what was required now was not prestige buildings but a form of architecture made necessary by rapid industrialization, which was bringing together

more and more people in a confined space. The painters, who were the first artists to take up the new ideas and trends, had, on the face of it, a simpler task.

Architects were still under the influence of the *Jugendstil*, which was in full flower around 1900, or, like Olbrich and Behrens, actively promoted it. The extent of their confusion in the early years of the century is only too apparent from obscure declarations of intent, which stemmed from muddled metaphysics rather than from any clear knowledge of the real world. The designing and construction of houses developed virtually into a sacred act, an aspiring, stylized, religious act of creation, which remained in the realms of the fanciful. Concepts such as the 'city of light', the 'cathedral of dreams', the 'house of heaven' or the 'golden glass pyramid' were bandied about in the circles of the architectural elite. (And when the architects themselves were not inspired to take up their pens, the writers who worked alongside them could be relied upon to produce vague, unrealistic descriptions.) These products of fantasy – the architect Bruno Taut designed the 'valley of blossoms' and 'crystal mountain' in alpine architecture, otherwise such ideas hardly ever passed the sketch stage – were for the most part inspired by the new building materials. By 1905/6, glass architecture had gained a position of paramount importance – since it was supposed to achieve in buildings a transparency which the architect was no longer able to find in his surroundings. Hence Taut's heady and emphatic tone when he wrote in 1914: 'glass architecture is bringing the European cultural revolution . . . it turns a vain, limited creature of habit into a bright, alert, refined and tender human being.'

Such ideas were not far removed from similar notions about building a supposedly brighter future for mankind: plans such as the so-called 'people's houses' and 'cathedrals of the future', which would place popular housing in a new perspective. Christian, socialist and futuristic ideas all combined into an amalgam, which if not realistic, still remained intriguing. Utopianism of this sort was also nurtured by the use of concrete and of steel constructions. Gropius himself admired the steel skeletons of American multi-storey buildings and Frank Lloyd Wright's designs, whilst Behrens, Taut and Olbrich were able to take advantage of the possibilities concrete provided for creating new building forms. At the same time these technical developments gave some architects a welcome chance to avoid an absolute break with traditional building styles. When we look at what inspired the ideas of turn-of-the-century architects, it is noticeable that in Germany, Holland, Austria, Czechoslovakia and Russia, there was a great desire to abandon architectural tradition, despite a certain harking back to the early nineteenth century. The English, on the other hand, and the Viennese architect Otto Wagner, campaigned doggedly for new views on building forms to be combined with traditional ones.

23 Walter Gropius, Wassily Kandinsky and Oud in Weimar, 1923.

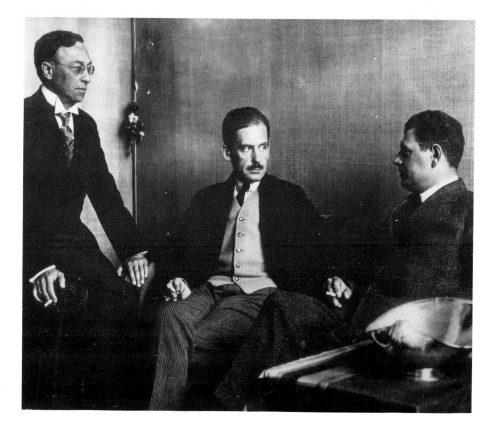

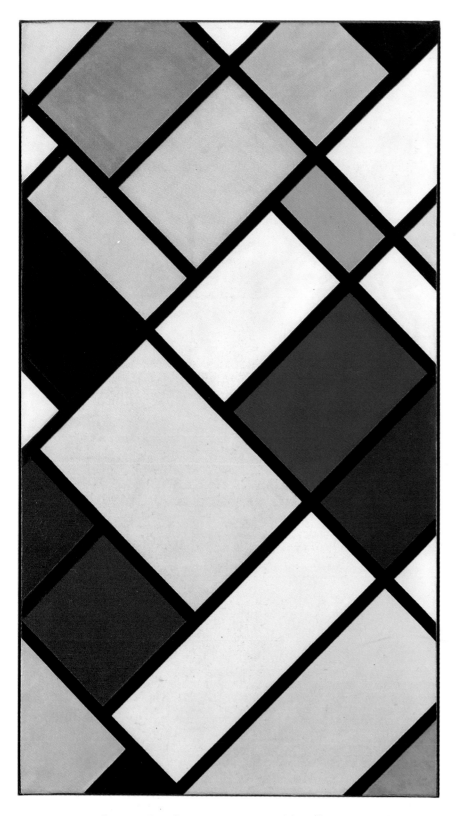

24 Theo van Doesburg, contra-compositie, *oil on canvas, 1925.*

and craftsmanship. In England, however, the traditions of art and design enabled such theories to be carried to their logical conclusion. In Germany the demand for a radical break with tradition was not so much inspired by theoreticians and artists, but more a response to the political situation, where social pressures and governmental crises kindled a revolutionary zeal, making it more easy to contemplate change without retaining the ballast of tradition.

To express their sense of a shared responsibility in matters of design and the proper use of materials, a group of entrepreneurs, writers and journalists in Munich joined with architects in 1907 to form the *Deutscher Werkbund* (an industrially subsidized association of artists and technicians). Its purpose was to promote German excellence in design both in theory and in practice. Walter Gropius was a member and executed a series of works on its behalf. His 1910 proposal, suggesting a standardized form of terraced house, can be traced back to the *Werkbund* and its architects. Yet the *Werkbund* itself was little more than a meeting place, where ideas could be discussed, and a source of stimuli.

Whatever the architectural pecursors of the Bauhaus may have been, there can be no doubt that painting was the strongest influence on the Bauhäusler. And however hard Expressionism tried to shake off all traces of romanticism, the early period of the Bauhaus had much idealism and fantasy to offer. And yet those years up to 1923 furnished an important part of the overall concept, for without them the Bauhaus would have been the poorer in creative terms. Indeed it might not even have existed.

Before the Bauhaus, the Englishmen John Ruskin and William Morris had anticipated — in a similar way to Gropius's manifesto of 1919 — a theoretical unity of art

Details from 23

Opposite
25 Walter Gropius.

Overleaf
26 Wassily Kandinsky. 27 Oud.

2. Pedagogy and Training at the Bauhaus:
Preliminary Courses

The word pedagogy may be translated from the Greek as the science or theory of education, and, in so far as Bauhaus pedagogy existed as a unified concept, it undoubtedly achieved great things. First in Weimar, and then in Dessau and Berlin, instruction was innovative in that it aimed to create an overall method for the teaching of art. To form a better understanding of art instruction at the Bauhaus, it is helpful if we return to Gropius's manifesto. In 1919, he wrote:

. . . architects, painters and sculptors must learn to know and to understand the many aspects of building both in its totality and in all its separate parts. only then will their work be imbued again with the architectonic spirit it has lost as 'salon art'.

the old art schools were unable to create this unity. how could they, since art cannot be taught? they must once more become part of the workshop. this world of drawing and painting, of designers and handicraft-artists must at last become a world of building again . . . for there is no such thing as 'art as a profession'.

This was an uncompromising position to adopt, and one which, not surprisingly, drew protests from the more traditionally minded. Like others before him, Gropius attacked the ideas of the conservatively biased art world of the post-war period, with its self-centred view of culture and its elitist claim that art was the preserve of a small, select minority. Nevertheless, behind all the modern, enlightened thinking was the light of a tradition which had survived every revolutionary break with the past: the almost medieval concept of craftsmanship embodied in the idea of the workshops. Not that this was a nostalgic yearning for an order of guilds in a conservative sense. Gropius felt that the acquisition of the craftsman's skills had an important part to play in the making of an artist by bringing him down from his ivory tower.

Gropius was still serving as a soldier in the First

28 Johannes Itten, Horizontal-Vertical, *oil on canvas, 1917.*

World War when Henry van de Velde, director until 1915 of the Arts and Crafts School of the Grand Duke of Saxony, proposed him as his successor. He accepted the position in 1918, whilst still a member of the 'Work Council for Art' that had formed during the days of revolution in Berlin. As a first step towards reforming the old system of education, and in order to find new formulations for his own ideas, he dissolved the existing school and founded the Staatliches Bauhaus Weimar.

Decades later he looked back at what his intentions had been.

When I founded the Bauhaus, I had come to realize that an autocratic, subjective teaching method frustrates the innate potential of students with

different gifts, for the teacher, even with the best intentions, imposes on them the results of his own thinking and work. In clear contrast to van de Velde's method I became convinced that the teacher must desist from passing on his own vocabulary of forms to the student, and that the student must instead find his own way, even if it involves him in detours. If the teacher encounters in the student the beginnings of a tendency to think and feel for himself, he should encourage it. Attempts at imitation, on the other hand,

he should vigorously oppose, or at least let the student know that he is harvesting on foreign soil. The student must proceed objectively and, as a basis for the creative process, build up his study of natural phenomena, which can then slowly be understood through properly directed observation of the biological and psychological facts. At the Bauhaus we tried, with the co-operation of many artists, to find a common denominator for design, to develop, so to speak, a design science . . . Because the teaching method is just

29 Paul Klee in his Dessau atelier, c. 1927.

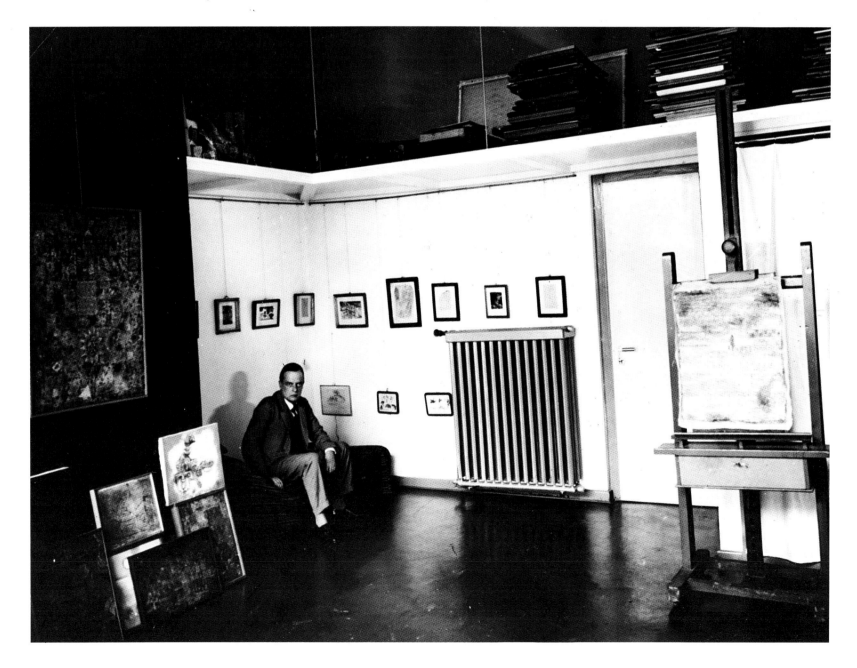

as important as the ability of the teacher – a fact which is still so often misunderstood today – I wanted to assess this problem in the area of teaching once more; for I am convinced that the objective teaching method, even if it follows a much longer and thornier path than the autocratic method, not only protects us from copying and imitation; it also preserves both the uniqueness in each creative personality and a common cultural link with the age. (Neumann, Bauhaus und die Bauhäusler, p. 17f.)

Viewed in their historical context, the theses and pedagogical ideas of Gropius have affinities with the English Arts and Crafts movement of Ruskin and Morris, as well as with reformist educationalists such as Rousseau, Pestalozzi and Froebel. The core of the whole theory and its practice was free, voluntary participation in a liberal, universal education which would produce confident, self-aware human beings. At the Bauhaus narrow specialization was out from the start. In a 1920 address to the Thuringian Parliament, where he was constantly subjected to strict control, Gropius referred to the fact that 'something is being accomplished at the Bauhaus that must develop continuously throughout the country, as it already is . . . The Bauhaus stands for a continuation, not the demolition, of tradition.' This was his response in particular to those politicians, often with right-wing, nationalist leanings, who looked on in suspicion and regarded the Bauhaus project as a sort of conspiracy. For the students' unconventional behaviour and approach to study contrasted conspicuously with the accepted image of the art school.

The entry procedure for students comprised interviews and the inspection of portfolios. To give them a solid grounding, they had first to attend a preliminary course, which was followed by workshop training leading to the Bauhaus diploma. The educational method pursued in the preliminary course was so successful that it is still widely imitated today.

Itten

Johannes Itten, who directed his own private art school in Vienna, had developed his particular teaching methods there, and, drawing on these experiences, was the first to introduce a preliminary course to the Bauhaus at Weimar. Itten, whose authority at the Bauhaus remained undisputed until 1923 – though there was no lack of controversy – described the method and aims of his preliminary course as follows:

1. To free the creative powers and thus the artistic gifts of the students. Their own experiences and knowledge were to lead to genuine work. The pupils were to free themselves gradually from all moribund convention and acquire an enthusiasm for original work.
2. Career choice was to be made easier for the students. Exercises with materials and textures were a valuable aid here. Each student soon established which material appealed to him, whether it was wood, metal, glass, stone, clay or woven textile inspired him to be creative. At the time, unfortunately, the preliminary course had no craft workshop in which basic tools, such as planes, files, saws, clamps, adhesives and solders, might have been made.
3. For their future professions as artists, the students were to be taught the basic laws of painting. The laws governing form and colour opened the students' eyes to the objective world. In the course of their work, the subjective and objective problems of form and colour could permeate each other in many different ways. (Peter Hahn, Experiment Bauhaus, p. 10.)

Itten's method in his preliminary course was to provide a comprehensive training in artistic form, handicrafts and technical skills, and in social and human concerns, so that every student, whether as pupil or potential artist, could become a responsible member of society.

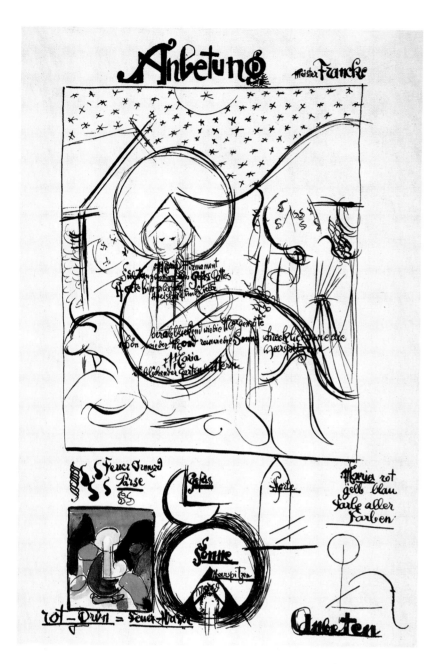

30 Johannes Itten, Worship Meister Francke, Weimar, 1921. Itten analysed pictures by Old Masters in his preliminary course from 1920 to 1923.

finger exercises. Already, in these initial sessions we sensed how rhythm arises; endless movements in a circle, starting as if from the finger tips, with movement flooding through the wrist, elbow and shoulder until it reached the heart – this is what one had to feel when forming each stroke and each line. – No more drawing without feeling or with half-understood rhythm. Drawing was not reproducing what is seen, but letting what one feels from external stimuli (and from inner ones too, of course) stream through the whole body. Then it would re-emerge as something absolutely one's own, as some artistic creation or other, or simply as

31a (b,c overleaf) Vincent Weber, Three Material Studies, wood and wire, 1920/21. Weber attended Itten's preliminary course.

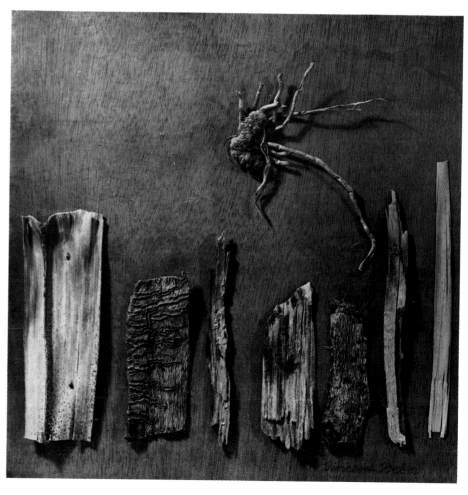

His teaching, which trained all the senses and intellectual abilities, therefore placed high demands on pupils and teachers alike.

Gunta Stölzl, who in autumn 1919 became a pupil at the mural-painting workshop in Weimar, later remembered the practical course of teaching in Itten's class.

His opening words were about rhythm. Firstly one had to train one's hand and make the fingers flexible. Just as a piano player does finger exercises, so we too did

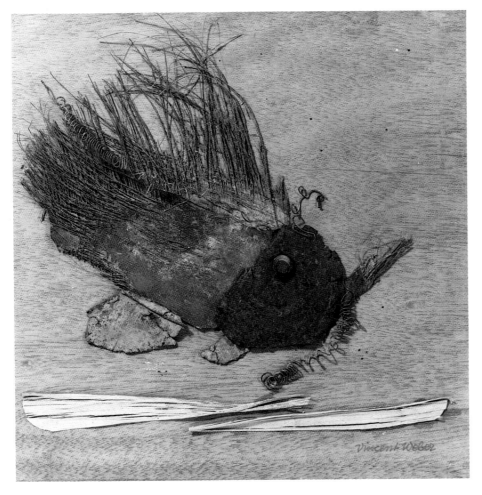

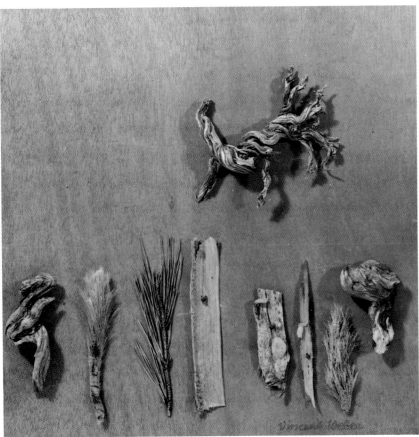

*pulsating life. (*Gunta Stölzl, diary entries, Bauhaus-Archiv Berlin, p. 36ff.)

We can clearly see from this description the method used to teach students how to abstract what is felt from what is seen. Itten's system involved instruction in how to reach this meta-level and utilize the transitive force in the draftsman's own rhythm. He himself and many of his pupils were attracted by meditation and the transcendental penetration of the 'object world'. Itten and his supporters followed a mystical doctrine with anthroposophical leanings, called Mazdaznan. This cult had its centre in Switzerland and the voluntary training included special diets and nutritional programmes, together with physical exercises and periods of resting.

Perhaps it was the fascination of Itten's personality that attracted so many of his pupils to a ritual which presented a bizarre spectacle to the external observer. With their simple, uniform clothing, heads shaved bald, and a constant smile playing about their lips, they provoked irritation among the people of Weimar and those who viewed the Bauhaus with scepticism. Yet for a long time Gropius gave Itten a free rein, and only Georg Muche, employed from 1920 as the second preliminary course teacher, worked with and deputized for him.

Gropius had a high appreciation of Itten's humanistic and artistic qualities. Between 1919 and 1923, when he and Gropius fell out, Itten, a former pupil of the Stuttgart painter Adolf Hoelzel, developed a theory of universal form at the Bauhaus. He later stressed the uniqueness of the 'method of representing and creating artistic form' being taught here systematically for the first time. Itten's basic preliminary course work was achieved during the first phase of the consolidation of the Bauhaus in Weimar. It therefore marks a decisive moment in the development and transformation of Bauhaus ideas during the early years. Idealism, enthusiasm and free creation untrammelled

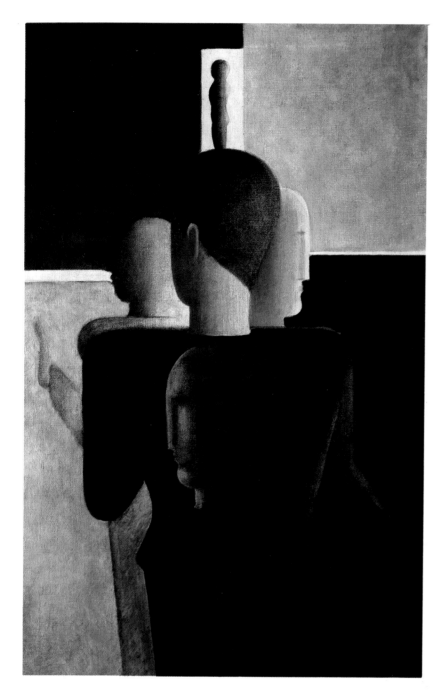

32 Oskar Schlemmer, Concentric Group, oil on canvas, 1925.

Parliament, were not the only source of pressure on the Bauhaus. Gropius was beginning to insist more emphatically than before on the acquisition of technical skills, as he sought to establish a connection with industrial production, in order to influence manufactured designs more effectively than before. This, however, clashed with Itten's freer views on art teaching and the structure of the preliminary course.

In 1923, therefore, Itten left Weimar in order to devote himself to his own work. By this time Kandinsky, Moholy-Nagy and Oskar Schlemmer had been given teaching posts, and Muche had come to regard the Bauhaus theory of form as outmoded. A new era was beginning in Bauhaus teaching. Although the works produced in Itten's preliminary course are today rightly viewed as works of art, we should not lose sight of the fact that they were for the most part workshop studies.

An impression of the simplicity of Itten's theory can be obtained from three quotations by the artist himself:

We speak of contrast when clear differences or intervals can be established between the comparative effects of two colours. When these differences become maximal, we speak of matching opposites or polar contrasts. Hence large–small, black–white, and cold–hot are, in their extremes, polar contrasts. Our sense organs can only provide the means of comparing perceptions. A line is perceived as short when a longer one is beside it for comparison, but as long if one beside it is shorter . . . Similarly, the effects of colours can be enhanced or weakened when they are contrasted. If we examine the characteristic ways in which colours take effect, we can establish seven different types of contrast . . . The seven colour contrasts are:

1. The contrast inherent in colours.
2. The light dark contrast.
3. The cold warm contrast.

by objective and material factors were all part of the foundations Itten laid for Bauhaus pedagogy.

The dispute and break with Gropius came at a point when discussions were being held on a new direction for the Bauhaus and efforts were consequently being made to tighten the teaching framework. External political factors, represented by the right-wing, nationalist, conservative majority in the Weimar

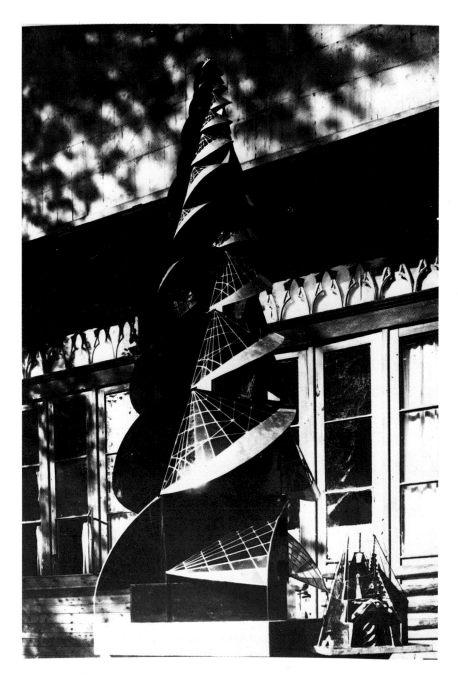

33 Johannes Itten, Tower of Fire, *wood and coloured glass, 1922.*

4. *Complementary contrast.*

5. *Simultaneous contrast.*

6. *Quality contrast.*

7. *Quantity contrast.*

All of these contrasts can be experienced by the senses, objectified by the understanding and created synthetically . . . The colours black and white are the strongest means of expressing light and dark. Between

black and white lies the realm of grey tones and of colours . . . A grey tone appears light or dark according to whether it is compared with a lighter or darker tone. Dark forms take effect against a light background, and light forms against a dark background. The contrast between light and dark is the medium for creating light, shadow and plastic forms; it finds useful employment in studies of nature . . .

For a genuine feeling to be expressed in a surface or a line, it must first of all resound within the creative individual himself. Externally fixed sight, fluctuating thought and wilful action must give way to inner vision. If, while a form is being created, the heart and hand work as a unity, then the form becomes the bearer of a spiritual content. If this content can be experienced again through its formal representation, one experiences the effect of a work of art.

It is particularly valuable for the senses to grasp the characteristic properties of all things. In order that various textures may be assessed, chromatic series [coloured and progressing in half-tones] are first of all made from real materials, then montages of contrasting materials are constructed. In order to deepen and develop control of the experience, objects made from wood, bark and hide should be looked at, handled and drawn, until these materials can be drawn by heart, from one's inner feel for them, without referring to the originals in nature . . . (Itten, 'Katalog der Wanderausstellung', in Johannes Itten – Der Unterricht, *1973.)*

Johannes Itten founded his own art school in Berlin in 1926, but it was closed in 1934. Four years later he emigrated to Amsterdam and in 1943 returned to Switzerland. He published two books on teaching in the 1960s. Itten died in 1967, in Zurich.

Itten's departure was not the only factor to stimulate discussion about a new concept of education

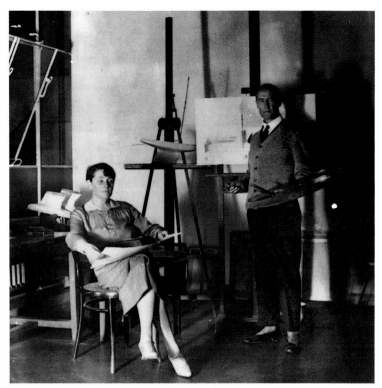

34 *Lyonel Feininger with his wife in the Dessau atelier.*
Feininger taught from 1919 to 1932 as a Bauhaus master.

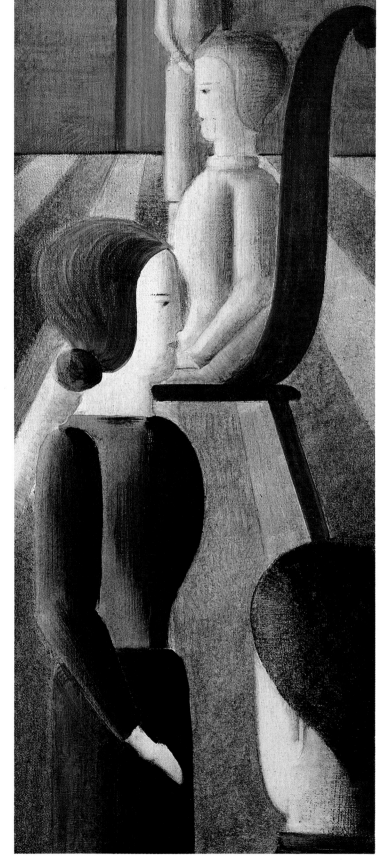

at the Bauhaus. The Weimar authorities were having to
introduce more severe financial cut-backs, not least
because of inflation, and in 1922 they asked the school
to produce some evidence of its work to justify its
existence. The resulting exhibition of works from the
Bauhaus in the summer of 1923, though a response
to pressure from the authorities, was highly successful,
and attracted new pupils to seek entry to the school.

Gropius's new direction, expressed in the motto 'art
and technology: a new unity', developed a dynamic of
its own, thanks to the succession of preliminary course
teachers who now followed. Georg Muche, Laszlo
Moholy-Nagy, Josef Albers, Wassily Kandinsky, Oskar
Schlemmer and Paul Klee did not always see eye to
eye with Gropius, but this was neither expected nor
considered necessary. After all, the Bauhaus principle
was to guarantee the individual the greatest possible

35 *Oskar Schlemmer,* Group with Seated Woman, *oil on canvas.*

scope to develop as an artist and to express his own views. Inevitably there were tensions and strong differences of opinion over teaching plans and the direction in which the Bauhaus should develop. Discussions oscillated between a stronger emphasis on artistic training and the pursuit of more practical work.

This dichotomy touched on the fundamental pedagogical principle of the Bauhaus teaching programme, whereby it was obligatory for students to be trained both on the artistic, formal level, and on the material, work-oriented level. In this now famous system of instruction with its two strands, formal aspects of teaching were left to the painters, who also directed certain workshops as 'Formmeister' [Masters of Form]. Though they did not strive for any formal or stylized unity, in many areas this nevertheless came of its accord. (Peter Hahn, Experiment Bauhaus, p. 350.)

The variety of preliminary courses that were now organized, extending to two or three semesters with an intermediate test, directly reflected the artistic personalities and educational theories of the teachers and demonstrated those aspects of their teaching they considered most important. Johannes Itten's immediate successor was Laszlo Moholy-Nagy, who directed the preliminary courses from 1923 to 1928.

Moholy-Nagy

Moholy, who was born in Hungary in 1895, began his painting career after being wounded as a soldier in the First World War. He became a doctor of law in 1918 in Budapest, and soon established contact with Gropius through an exhibition of his pictures in 1921, at the Berlin gallery 'Der Sturm'.

He organized his ideas on painting into scientific treatises many of which were later published in book form by the Bauhaus. Like Itten, he investigated the structure of objects and tried to identify their basic characteristics, in order to assist the students in their work. His teaching method was thus destined to have a major influence on design work at the Bauhaus.

In his book *From Material to Architecture*, Moholy set out the foundations of his theory of education.

Concerning a general course on elements.
A general course of elements is built on the relationships of:
1. *Existing forms:*
 mathematical-geometric forms
 biotechnical forms
2. *Newly produced forms and complexes of forms*
The creation of new forms can be based on:
1. *Ratios and measurements (medial sections and other proportions)*
 position (measurable in angles)
 Movement, speed, direction, displacement, penetration, crossing
2. *Material values*
 structure
 texture
 facture (accumulation)
3. *Light (colour, optical, illusion)*
The relationships of forms can become effective as:
1. *Contrasts*
2. *Deviations*
3. *Variations (a) shifting (friction) (b) rotation (c) reflection.*

There is clear evidence here of Moholy's primary concern with the ways in which things function. Following in the tradition of the Constructivists, he emphasized more than anyone at the Bauhaus had done before him the relationship between form and function, and rejected any suggestion that one should

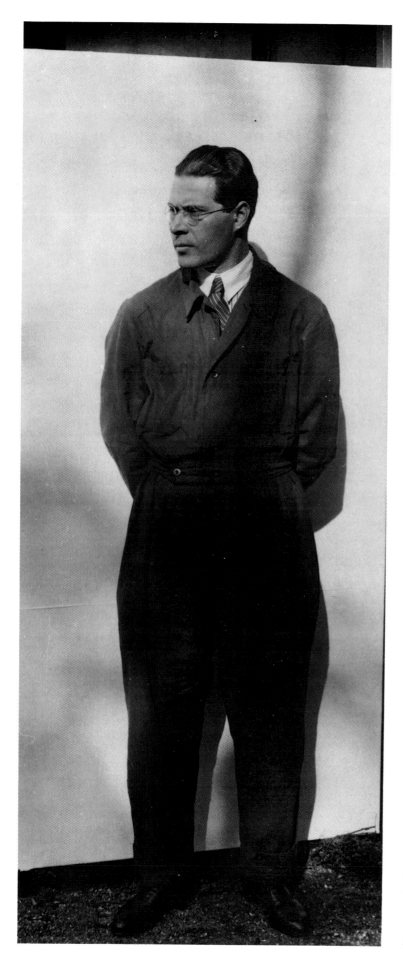

take precedence over the other. He conceived the preliminary course as a way of training the students' senses so that they would learn to distinguish clearly between objects by analysing their properties. Moholy differentiated between the structure, texture and make of objects, or, to put it more simply, he insisted that students were to acquaint themselves with the various qualities of the materials. Glass, for example, has characteristics and uses entirely different from those of wood. Many of the tasks set by Moholy for the students were to help them to grasp what these essential characteristics were, and then to use the materials accordingly. This resulted in three-dimensional figures of considerable aesthetic appeal.

The sense of touch could be trained by placing together various materials and asking students to feel the differences between them so that they might learn to identify the relation between a material and its possible use. Equipped with such knowledge, they could then set about the task of putting together figures, or small sculptures. Moholy was careful to draw a distinction between composition and construction:

. . . by composition one meant fully exploiting the elements and their relations. This could often be achieved even during the course of the work by introducing new elements and altering the overall composition. A construction, on the other hand, should have all aspects of its artistic and technical relations fixed from the beginning. Any change in its execution would bring to nothing the entire division of forces intended. Compared with composition, therefore, construction requires additional knowledge, though this does not mean that there can be any lack of intuitive momentum. (Peter Hahn, Experiment Bauhaus, p. 32.)

The balancing of three-dimensional figures, which for

36 Portrait of Laszlo Moholy-Nagy, 1926. Photo by Lucia Moholy.

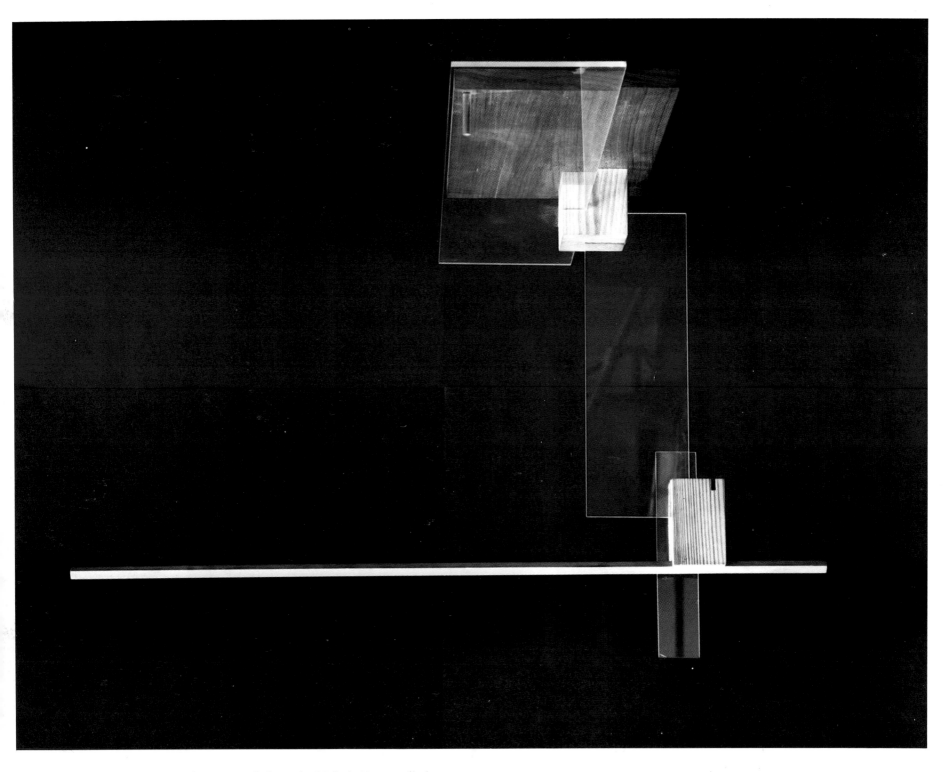

37 Artist unknown, study from the Moholy-Nagy preliminary
course, wood and glass, 1923.

the most part rested on a single, small point and owed
nothing to symmetry, involved exercises in experiencing
and dividing up space which tied in with the ideas of
Constructivism. The materials most often used were
wood, string and various metals, since they could be
found everywhere in their basic forms. New forms were
also created by deliberately reducing the amount of
material used. The impact these exercises had on

architectural ideas was welcomed by Moholy. But he went far beyond that, directing his artistic gifts towards an unceasing exploration of the technical materials of the age. The preliminary course teaching included the study and construction of designs, experimenting with light and its reflexes, blueprints for typography and stage-design, kinetic metal constructions, and experiments in film and photography. Thus, during his time at the Bauhaus Moholy made two short films: *Marseilles* (1926), and *Berliner Stadtleben* (Berlin City Life) (1927). Others followed over the next few years. His photographic work — he was one of the first to take photograms (film exposures without a camera) — influenced the Bauhaus students, as we can see from the numerous works of experimental art photography. Moholy-Nagy's keen and innovative approach to the use of all kinds of modern technical equipment reflected his own open-mindedness and youth. It is easy to see why the students under his direction were so enthusiastic about the preliminary courses. From these new potential areas for artistic activity, he also developed a new conceptual approach to modern art. 'In theory it does not matter whether a work of art is plastic, linear, painted, black and white, coloured, a photograph, or produced in some other way. In practice, though, it goes without saying today that a work of art produced by mechanical, technical means is preferable to one created by laborious, visual, manual means.' (Moholy-Nagy, *Vivos Voco*, Vol. V.) Such statements were quite fashionable, and also corresponded with scientific and critical discussion about the general possibilities of reproduction in art in the writings of Walter Benjamin and others.

The clear and continued development of these approaches at the Bauhaus, which moved to Dessau in 1925 after its funding had been completely cut, must have appealed greatly to the students. To incorporate his new ideas into the programme Moholy updated the teaching, whilst retaining the basic instruction in colour,

38 *Laszlo Moholy-Nagy,* The Girls' Boarding School, *photo collage, 1925.*

form, construction and composition.

As artistic director of the metal workshop, first in Weimar, then in Dessau, he had considerable influence on the nature and function of the works designed there. Under his leadership and the tutition of master craftsman Christian Dell, the metal workshop played a

central role for the first time, producing vessels, lamps and table services. In 1928, the critic Wilhelm Lotz noticed the link between the craftsmanship being practised in the workshops, the education of the students, and their inclination towards industrial design.

I think that Moholy-Nagy has a completely different concept of the craftsman: he is not the craftsman who creates with his hands, but the person controlling and overseeing the handicrafts production process, as in industry. Through being able to control and oversee, it is possible for him to influence the formation process. It makes no difference whether he happens to rely on the skill of his hands to produce the model for industry, or whether he can use a machine to do it. In either case he creates form logically and consistently in the sense of the mechanical process. In fact he is the creator of forms in industry . . . (Bauhaus-Archiv, kl. Katalog, Berlin, p. 46.)

So the metal workshop, which began by producing mainly jewellery, developed into a design workshop offering models for industrial mass production. Particularly well-known were the table lamps of Marianne Brandt, Wilhelm Wagenfeld, Christian Dell and Karl J. Junker, the prototypes of which were designed and created at the Bauhaus.

There can be no doubt that during the five years of Moholy-Nagy's directorship, the preliminary course and workshop work had undergone a complete change of direction. Gropius's demand for 'art and technology: a new unity' was now beginning to take shape. Moholy-Nagy emigrated in 1934 to Holland, and two years later to England, from where in 1937 he was invited to the 'New Bauhaus' being founded in Chicago. He continued, from 1939, to pursue a successful teaching career at the School of Design and died in Chicago in 1946.

Albers

Josef Albers was a Bauhaus master and teacher who became better known for the works he produced after the war in America than for what he created at the Bauhaus.

After coming to Weimar as a student in 1920, he directed part of the preliminary course with Moholy-Nagy from 1925, and took over all teaching of the preliminary course after Moholy had left. His speciality

39 Petra Kessinger-Petitpierre, study from the Albers preliminary course, pen and ink, 1929/30.

was a thorough examination and knowledge, for both artistic and educational purposes, of the basic materials to be used, and he set great store by this in his work with the preliminary course students. One of these, Hannes Beckmann, recalls his impressions of Albers:

I still have vivid memories of the first day's teaching: Josef Albers entered the room with a bundle of newspapers under his arm and had them distributed amongst the students. Then he turned to us and said: 'Ladies and Gentlemen, we are poor, not rich. We cannot afford to waste time and material. We must make the most of what we have. Each work of art starts from its own basic material, so first of all we must examine the nature of this material. To do this we must first – without actually producing anything – experiment with it. For the time being skill comes before beauty. The cost of the forms we create depends on the material with which we work. Remember that often you achieve more by doing less. Our studies are to encourage constructive thought. Do I make myself clear? I would like you to take the papers you have been given and to turn them into something more than they are at present. I would also like you to respect the material, and to give it meaningful shape, without losing sight of its basic qualities. If you can manage this without such aids as knives, scissors or glue, so much the better. Have fun!' Hours later he came back and had us spread out the results in front of him on the floor . . . This preliminary course opened up for us an entirely new world of seeing and thinking. Almost all the students had come to the Bauhaus with set ideas about art and design. For the most part they were romantic clichés . . . The preliminary course was like group therapy. By looking at and comparing all the solutions found by the other students, we quickly learned how to discover which solution to a task was most worth pursuing. And we learnt self-criticism, which was considered more important than criticizing others. There is no doubt that the sort of 'brain washing' we went through in the preliminary course led to clear thinking. (Neumann, Bauhaus und die Bauhäusler, p. 275ff.)

Practical exercises of this kind did indeed change received attitudes and approaches to art. Studies of materials, often in the form of positive–negative representations, assembled almost like collages, or depicting the different gradations between black and white, all trained the students to perceive the relations between material, colour, form and construction, as in Moholy's courses. Although it was seldom intentional, the courses in preliminary studies pursued by various teachers complemented each other.

Building on the foundations laid by Itten in the earlier classes, Albers placed greater emphasis in his teaching method on practical and technical exercises. One of the students' tasks was to try to create an impression of three-dimensionality in a two-dimensional drawing; another involved extensive studies for figurative drawings from nature. This type of drawing instruction was devoted less to creating an image that was true to nature (though this was not neglected), and more to grasping what was essential in the object being drawn. In this too, he was working along the same lines as Itten.

Under the directorship of Mies van de Rohe, who took over in 1930, the demands on the students grew, as the general emphasis on architecture called for a greater understanding of technical drawing. Overall, the preliminary courses in Albers' final years as director became more concrete in character, more geared to achieving results. His own artistic development only achieved public recognition after his Bauhaus experience, in the USA. In the 1950s Albers was rightly regarded as having paved the way for Op-Art. In America, too, the fundamentals of Bauhaus colour theory were evident in his painted compositions. He

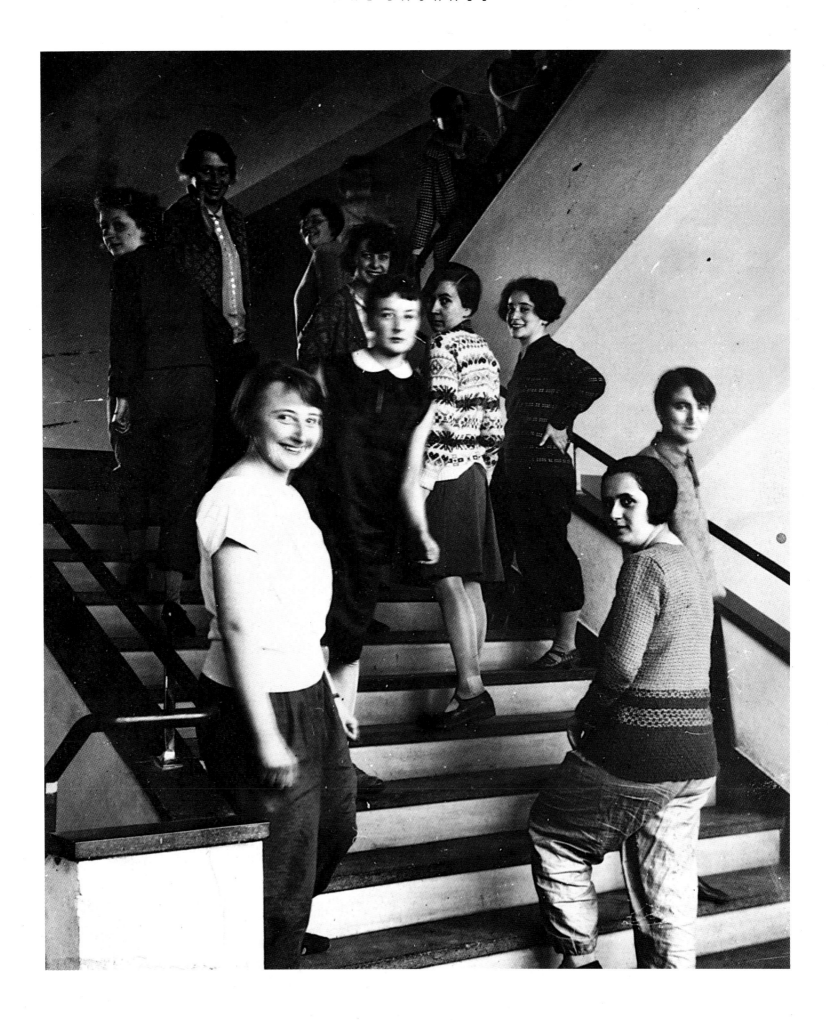

40 *Staircase in the Dessau building with students, 1927.*

was Professor at Black Mountain College from 1933 to 1949, and until 1959 director of the Department of Design at Yale University. Albers died in 1976 in New Haven, Connecticut.

Kandinsky

When the young Ursula Schuh came to the Bauhaus in 1931 and joined Kandinsky's class, she felt considerable respect and reverence for the great master, whose name was already familiar to her. For when Kandinsky left Moscow to work at the Bauhaus in 1922 at the invitation of Gropius, he was 56 and had achieved the sort of eminence in the art world that casts a long artistic shadow. It would, however, be quite wrong to assume that he was in any way behind the times. Ursula Schuh gives a moving description of the impression he made on her then:

His art and artistic experiments coincided exactly with the way we, as a generation, felt about life. We loved exploding old conventions just as we loved precision in fixing and formulating new knowledge, no matter what the area, and whatever the form of artistic manifestation. We loved abstraction and saw everything as 'abstract'. Significantly, it was never our aim to do 'modern' painting, nor did we think in terms of directions (we left both to the skilled observer). We were far more concerned with finding the one particular form which corresponded to our own personal way of experiencing things . . . 'Arranging' pictures was taboo. If a painting was 'arranged', this meant that it was a rectangle containing more or less pleasing forms, filled out with some skill but without any real experience. It was not composed, i.e. inner experience and formal dexterity did not become a unity.

The qualities that made Kandinsky a great artistic phenomenon were his relentlessness, his consistency, and his artistic love of the truth. He set the great example by which the young generation could measure itself, even if later it was to, or had to, break completely free. For the more consistent this generation was, the more it went its own way. (Neumann, Bauhaus und die Bauhäusler, p. 241f.)

The fascination evident in these words even today provides a vivid picture of the magnetism which Kandinsky possessed, and which he exercised over other pupils at the Bauhaus as well. Critics or admirers often claimed that there was a mystical aura surrounding him. The unerring aim Kandinsky showed in his work was even attributed to his half-Asian ancestry. But the man's work had no connection with magic or sorcery, nor did the Bauhaus contribute in any way to his mysteriousness. The structure of his teaching in the preliminary courses revealed, like his artistic work overall, an analytical thought process, which was to lead students to the basic concepts of design in painting. In his compulsory basic course, 'analytical drawing', which he ran from 1922 to 1925, students were first asked to produce a still life that was true to nature. This was just a transitional stage, though, on the path to recognizing basic forms, which he held to be far more important than studies from nature, or drawing objects. The next stage was to work out the existing tensions between the individual forms and objects, and how these interrelate. A further stage in the process led to abstracting from the objects perceived. In the journal *Bauhaus* published by the Bauhaus in 1928. Kandinsky explained his method of analytical drawing and the individual stages leading up to it.

First stage:

the students began with still-life compositions, and their first analytical problems were:

1. *the reduction of the whole composition to a simple major form which has to be precisely drawn within the limits determined by the student himself.*

2. *distinguishing the characteristic forms of individual parts of the still life seen separately and in relation to the rest.*

3. *the presentation of the whole composition in a simplified line drawing.*

Gradual transition to

Second stage:

1. *clarification of the stresses discovered in the composition which are represented by linear forms.*

2. *emphasis on the principal stresses through broader lines or, later, through colour.*

3. *indication of the constructional net with starting and focal points.*

Third stage:

1. *the objects are considered exclusively as energy*

41 *Lothar Lang,* Colour Scheme, *from Kandinsky preliminary course, tempera, 1926/27.*

42 *Fritz Tschaschnig, study from the Kandinsky colour seminar, tempera, 1931.*

tensions and the composition is confined to arrangements of lines.

2. *differences in structural possibilities: obvious and hidden construction.*

3. *exercises in the most far-reaching simplification of the overall complex and individual tensions – close, exact expression . . . Drawing instruction at the Bauhaus is a training in perception, exact observation and exact presentation not of the outward appearance of an object, but of its*

constructional elements, their logical forces or tensions, which are to be discovered in the objects themselves, and in the logical arrangement of them. The handling of plane surfaces is preliminary to the handling of space. (Kandinsky, Bauhaus (1928), 2–3, pp. 10–11.)

To the superficial observer, the diagonals, lines, squares and triangles at first seem to be arranged arbitrarily, and to lack any inner cohesion. This changes the moment one tries to trace the origins of the composition. An exercise taken from Kandinsky's preliminary course may serve as an example. A still life consisting of a stepladder, a chair, two baskets and a blanket loosely draped about the ladder, is sketched in outline. Unimportant details such as the wickerwork of the basket or the texture of the blanket are omitted. The outlines of the whole structure now come more strongly to the fore, and, as the drawing progresses, the triangle of the stepladder, the circle of the basket and the square of the chair clearly emerge. After it has been reduced to its geometric figuration, the whole construction of the picture consists only of a single connecting guideline, and of the draped blanket only the bold outline remains in the picture. This configuration is now the starting point for further work on the picture, using paint, for example. Kandinsky called this enciphering of objects, 'presenting the overall structure in the sparsest scheme possible'. As a teaching process, it aimed to lead students away from their attachment to the objects, and make them aware of the essential formal and structural elements in any picture or still life with an artificial or naturally occurring order.

In his statements on colour theory, Kandinsky tried to develop an independently ordered system involving the three basic colours, red, yellow and blue, along with the grey scale between white and black. In Lothar Lang's colour scale (1926–7), this functions as follows:

Work is dominated by a horizontal white, yellow, green, blue and black scale, amongst whose three middle bands the colours orange, red and violet occur: black and white are linked by a semicircular grey scale, the colours of which flow into one another. Kandinsky treated grey and green as corresponding to red, since he saw them as mediating between the light and dark poles on the scale of tonal values. Green was able to

43 Bauhaus balconies in Dessau.

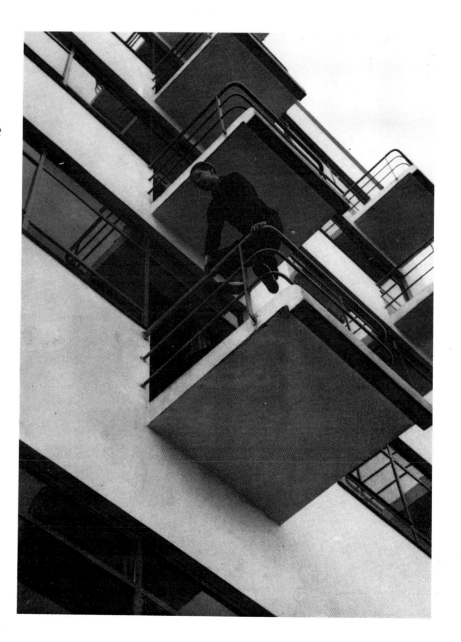

44 Karl Hermann Haupt, The Red Man, *gouache and watercolour on paper, 1925. Haupt attended the preliminary course with Albers and Moholy-Nagy, 1923/24.*

take the place of red in the diagrams, since it fitted in between yellow and blue, as the result of their mixing. (Christian Wolfsdorff, *Experiment Bauhaus*, p. 40.)

Best known of all, in this assigning of colours to geometric shapes, were the yellow pyramid, red cube, and blue sphere. This arrangement, which is still often used today, almost became a Bauhaus trademark. Of

course Kandinsky had already developed his theoretical observations on colour theory years before the Bauhaus. The attributing of colours to abstract geometric constructions effectively turned them into independent works of art, though few actually grasped the underlying process.

Starting from the allocation of colours to forms, Kandinsky worked on Goethe's *Theory of Colours* to

develop his own ideas on the psychological effect of colours. He often did this by using contrasting pairs such as order and chaos, or lightness and heaviness. Many of Kandinsky's conceptualizations in this context were borrowed from his understanding of music, in which he took a keen interest, as we can see from such picture titles as *Fugue, Crescendo* and *Allegro*.

As *Formmeister* (Master of Form) in the mural-painting workshop, he also applied his painting technique to the decoration of interior walls. Yet it was Oskar Schlemmer, despite the fact that he did not belong to this workshop, who established the practice of mural-painting at the Bauhaus in 1923. Kandinsky himself set no great store by it. Far more significant to him was the foundation at Dessau in 1927 of a free painting class under his direction. This supplied important stimuli not only for painting in general at the Bauhaus but also for Gropius's architecture. The essays Kandinsky wrote during his time at the Bauhaus (such as 'Point and Line to Plane' of 1926), his analytical teaching method, and his theoretical observations impressed scientists and artists, musicians and writers the world over. Thus he also served as a catalyst in creating numerous contacts abroad and stimulating keen international interest in the work of the institution, which became a major factor in attracting a larger number of foreign students to the Bauhaus in Dessau. However, the greater the recognition achieved by the Bauhaus abroad and the more widely its influence spread, the greater the opposition it encountered at home in Germany. In an interview Kandinsky's wife, Nina, looked back at this period. Asked whether there was still any hope of political life stabilizing, once the National Socialist majority on the Dessau city council had illegally cut their funds, she replied:

No, but there was always the hope that we would be able to continue on our own, alone, but able to work in peace. Unfortunately, though, the school was suddenly closed early in 1933 . . . in March. Not for good, that is, but provisionally. Investigations were carried out, with all the usual phrases attacking communists and Jews. Nothing was found, but then they told Mies van de Rohe that the school could only continue on two conditions: Kandinsky was not to be allowed to stay – he was too dangerous a presence – and the architect Hilbersheimer could not stay either, since he was in the Social Democratic Party. Of course Mies van de Rohe refused to accept these two conditions, and the school was closed for good. (Neumann, Bauhaus und die Bauhäusler, p. 238.)

After this Kandinsky turned down all further offers of teaching posts. Josef Albers tried to continue working with him, but Kandinsky refused. Following the closure of the Bauhaus, and the confiscation and labelling of his pictures as 'degenerate art' by the Nazis, he wanted only to work on his own.

Kandinsky's theories and teaching practice, which, amongst other achievements, turned the Bauhaus into the 'Hochschule für Gestaltung' (School of Design), remain extremely topical and significant to this day. He died in France in 1944.

Klee

We turn now to the role played at the Bauhaus by Paul Klee. That Klee should have been there was no mere accident for he and Kandinsky had been close friends since 1912. 'I could have been his pupil', confessed Klee on Kandinsky's sixtieth birthday, 'and in a certain sense I was, for some of his words managed to encourage, confirm and clarify my striving.' (Klee, *The Thinking Eye. Notebooks of Paul Klee*, p. 521f.)

45 Lena Meyer-Bergner, Radiating Displaced Centre,
water-colour from the Klee course, 1927.

Like Kandinsky and Feininger, Klee was a figure of major artistic importance at the Bauhaus. From 1928 to 1931 he taught the compulsory course 'Elementary Theory of Surface Forms', in which second-semester students were allowed to participate – 'allowed' because the painter and his pictures were venerated to an almost extraordinary degree at the Bauhaus. Even though, as we have seen, painting instruction was never formally organized at the Bauhaus, or included in the syllabus, painting still played a major role. Free painting classes were established in 1927 and although they formed only a marginal part of the overall teaching framework, they were nevertheless a central influence on the design work of the students. Klee, who taught at the Bauhaus from 1920 to 1931, developed a complex framework for his teaching method, which explored the

analysis of sensory perception, picture construction, and colour theory on a more profound level. It would, however, be a gross oversimplification to try to reduce Klee's teaching notes, which fill several thousand pages, to a uniform scheme. Indeed, his programme scarcely invites this: it is all-embracing in its vision, which transcends the object world in its interpretation of feelings and painting technique. 'Art', wrote Klee, 'goes beyond the object, whether real or imaginary. It plays an innocent game with things. Just as a child imitates us in its play, so in our play we imitate the forces that created, and go on creating, the world.' (*Knaur's Lexikon moderner Kunst*, p. 149.) Some years later he expanded on his insights and intentions: 'Previous, artists depicted things which could be seen on the earth, which people liked, or would have liked, to see. Now the reality of visible things is revealed, and at the same time the belief is expressed that, in relation to the whole, the visible world is only an isolated example, that there is a latent majority of other truths. Things appear in an extended, manifold sense, seemingly contradicting the rational experience of yesterday. We strive to transform the incidental into the essential . . . Art is like an allegory of the creation. It is always an example, in much the same way as the earthly is a cosmic example.' (Ibid.)

This statement shows the clear impact of two fundamental influences on Klee: firstly, that of Expressionism, since his search for the essence of things and his attempt to discover their inner truth was Expressionist in spirit; secondly, the influence of the sciences, for in his search for information that would help answer the questions he posed, he took an interest in the state and development of the sciences, and especially of the natural sciences. Indeed, his knowledge of mathematics, physics, politics, in fact of world events generally, formed an integral part of his approach to art. It is evident, too, from his Bauhaus lectures, in which he put over to students his own ideas

about art's context, that he kept in touch with reality.

In art, too, there is room enough for precise research, and for some time now the gates have been wide open. The field of painting shows the beginnings, at least, of what had already been achieved in music by the end of the eighteenth century. Mathematics and physics offer the means in the form of rules which may be observed or broken. Salutary here is the fact that one is compelled to deal first with functions and not with the finished form. Algebraic and geometric tasks are factors that train one to think in terms of the essential and functional, as opposed to the impressive. One learns to see behind the façade, to get to the root of things . . . one learns to substantiate and to analyse. One learns to have scant regard for the formalistic, and to avoid taking on what has already been finished . . . (Paul Klee, *quoted by* Hans Wingler, *Bauhaus Archiv Berlin*, p. 63.)

Klee published his fundamental ideas on painting and construction in his *Pedagogical Sketchbook*, which the Bauhaus published in 1925. Starting, like Kandinsky, from the line and its variations, he moved on to its arrangement in space, 'to the complicated artistic phenomena of creating structure, dimension and movement, and the problems involved in drawing them. Klee's teaching was from beginning to end a dialogue with nature.' (Ibid.) He practised his method of analytical drawing and painting with his students, among them Gertrud Arndt and Lena Meyer-Bergner. Set tasks included drawing geometric figurations from mathematical calculations, and assigning colours to them, as well as the study of his theory and method of artistic perceptions. His schematic representation of the synthesis formed by the eye of the externally observed world and his path of inner reflection led to an abstraction from the optical, physical phenomenon to a dynamic process, and this led, in turn, through the

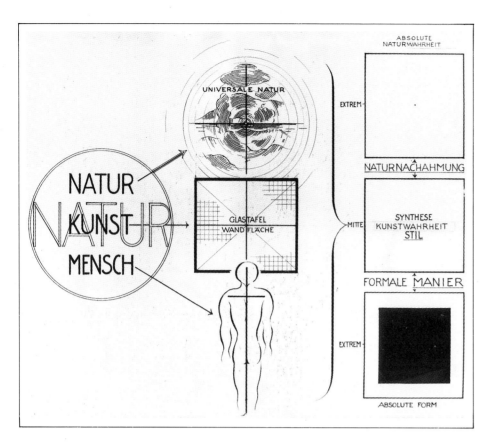

46 Oskar Schlemmer, Nature, Art, Man, *ink on paper, c. 1928. This is a schematic representation of Schlemmer's complex theory.*

in well there. Indeed they represented a synthesis of the ideas that prevailed during Itten's period of teaching at the Bauhaus and developments after 1925. The important influence of Klee, who had contacts with such leading artists as Picasso, Marc, Apollinaire, and Robert Delaunay, points again to the role Expressionism played at the Bauhaus: at the centre of everything stood man and nature. Although, as the years passed, debate persisted about the applicability of this maxim to the Bauhaus, Klee's contribution remained undisputed. After his voluntary departure from the Bauhaus in 1931, he became Professor at the Düsseldorf Academy of Art. Two years later he returned to Bern in Switzerland, where he died in 1940, aged 61.

Schlemmer

Oskar Schlemmer was born in Stuttgart in 1888, and in the context of the Bauhaus his name is always associated with the theatre. Although it is impossible to quantify, the impact of his work remains undiminished to this day, and evidence of his influence on modern stage design and costume is still very much with us. The figures from his *Triadic Ballet*, first performed in 1922, have lost none of their fascination, and Schlemmer's reputation as a great optimist and a highly gifted artist is amply supported by numerous photographs both of the man himself and of his productions. At the age of 15 he began a two-year apprenticeship in mosaics, after which he studied until 1909 at the Stuttgart Academy of Art. Two years before the war, and from 1918 to 1920, Schlemmer studied with Adolf Hoelzel, who also taught Johannes Itten. Though a painter, Schlemmer was also a man of many other talents, as can be seen most clearly from the dance experiments which he began in 1912, and resumed during the second part

stage of a non-optical 'cosmic identity' and the 'non-optical path of a common earthly root'. (Both factors worked reciprocally on the process of perception.) Put more simply, this schematic, theoretical statement meant that the artist's perception of the world must become a conscious process, during which he should be aware that he is 'transforming' the pictures, enciphering or deciphering them. The extremely complicated system of calculations Klee used in his pictures also meant that, particularly in his later phase, the process was impossible for others to copy. His erudition and personal charisma contributed decisively to the success of his practical classes (which were more like lectures), and played a major part in creating a positive atmosphere at the Bauhaus. Even if Klee did regard with scepticism the strong technical orientation that later prevailed at the Bauhaus, his theories, which rested partly on findings of the natural sciences, fitted

of his studies with Hoelzel. Of course this developing talent also meant that Schlemmer became deeply involved with music and movement. He himself directed, appeared as a dancer and designed both costumes and scenery. Perhaps it was because of his theatrical activities that Schlemmer devoted himself increasingly to an all-round study of the body, and the ways in which human movement depicts certain forms

47 and 48 Oskar Schlemmer, Simple Head Construction, *pencil on paper, c. 1928.*

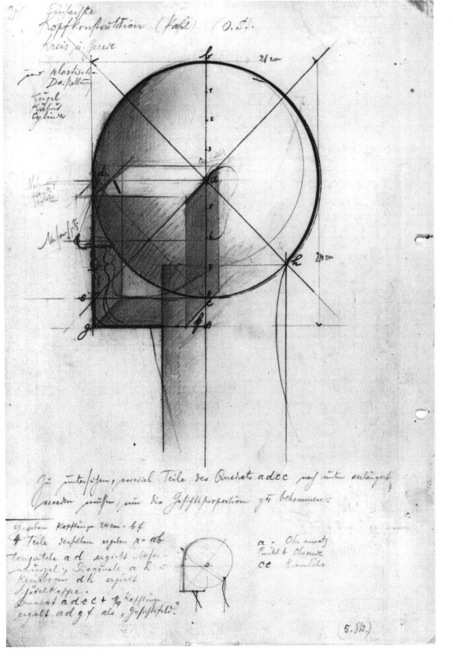

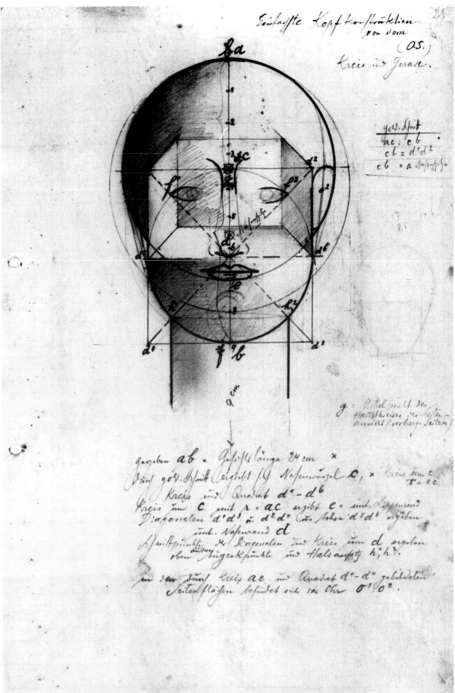

of expression, character and action. For theatre does not merely require individual actors — it aspires to appeal comprehensively to all the senses, and can move from being fantastic to being serious, or sad. It is both life and play. And at the centre there is always man, with his wishes, hopes and fears.

Schlemmer's all-encompassing view of the theatre was clearly reflected on the Bauhaus stage, which he

directed from 1923 to 1929, making it the principal focus of his artistic activities. As a result the theatre workshop now began to attract the attention of the Bauhaus teachers and students and of the general public, although it had been in existence since 1921. Groupius's concept of the unity of the arts under architecture did not, after all, exclude theatrical work and the first director of the theatre workshop was Lothar Schreyer, whom Schlemmer replaced. Indeed Gropius (who brought Schlemmer to the Bauhaus in 1921) himself stressed the importance of the connection between the theatre and architecture. 'Stage work, as an orchestral unity, has an inner relationship to architecture. Each receives from, and gives to, the other.' (*Experiment Bauhaus*, p. 250.) While this statement is hardly a concrete expression of Gropius's attitude to stage work, he never missed an opportunity to support the Bauhaus theatre. In the Dessau Bauhaus building, the theatre itself was situated between the workshop wing and the studio building. As a result the stage was centrally placed between the great hall and the canteen, and the auditorium could be opened on both sides.

An article for the *Bauhauskompendium* of 1927 reveals how novel Schlemmer's theatrical theories and their practical application were. In a clear departure from traditional notions of theatre decor, he aims to create impressions that will appeal to the imagination, thereby showing a marked artistic proximity to Bauhaus ideas and teachings in general:

Moreover since we are not intent on creating a naturalistic illusion, and therefore do not paint scenery in order to transplant a sort of second nature onto the stage; since it is not our wish to create an illusion of wood, rooms, mountains and water – we make wooden screens covered with white linen, line them up so that they can be drawn along on parallel rails, and project our light onto them. Or we create transparent walls and with them an illusion in the higher sense, produced by our own direct method. We do not want to use our lighting to create sun and moonlight, morning, midday, evening and night. We want the light to achieve its own effect, as yellow, blue, green, red, violet etc. – Let us not burden these simple phenomena with concepts such as red = demonic, blue-violet = mystical, orange = evening etc., let us rather open our eyes and react to the pure force of light and colour. (Bauhaus 3/1927, p. 3, in Experiment Bauhaus, p. 270.)

The abstraction from the object world already being taught in other areas by Bauhaus teachers was absorbed by Schlemmer into his own framework of ideas for the theatre. Significant and, for many, contradictory was the fact that whereas Schlemmer's theory of art was essentially focused on human beings, in his productions the human body disappeared behind the costumes and geometric forms. Similarly, many of his pictures show very simplified human forms in outline – the naturalistic details are unimportant to him. This is only an apparent contradiction, however, since through his painting and stage work Schlemmer sought to unite all the arts in a synthesis, with man as the measure of everything. His understanding of human beings, like that of Klee, Kandinsky or Itten, was not derived from externals. He sought truth via the transcendent penetration of appearances by artistic means. From 1922 his life-drawing classes were intended to enable his students to achieve this for themselves. In the course unit 'Man', which started in 1928, Schlemmer analysed the human body almost as Leonardo da Vinci or Albrecht Dürer had done. In his own words:

The 'Man' class is preceded the previous evening by

49 Oskar Schlemmer, copper, brass and nickel, figure in nickel-plated zinc, 1930/31.

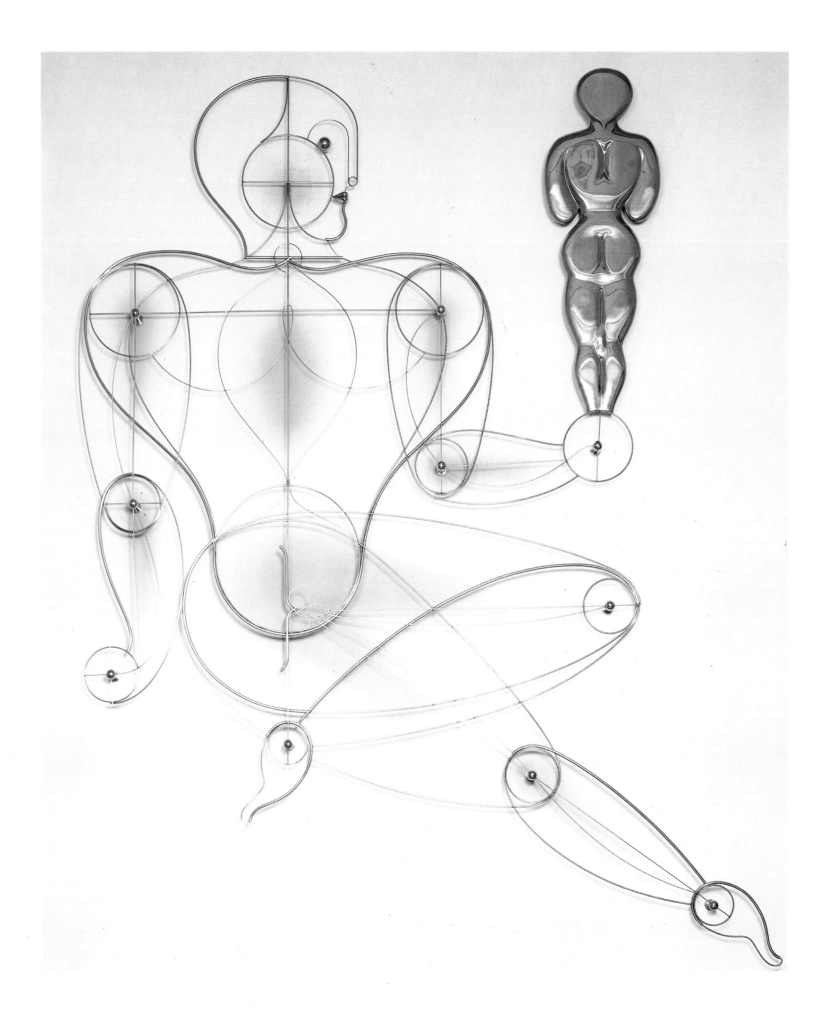

drawing a live model. In the absence of good models the students resort to self-help, taking it in turns to model. This guarantees much variety in the bodies being drawn. The drawing of nudes is then transferred to the stage or great hall, where, in contrast to the sober classroom, with its monotonous, constant light, stimulation and diversity are created by the sets, equipment, spotlights and, from time to time, by gramophone music also. When the nude pose is held for between one and two hours, with no quick

50 *Sculpture workshop with works by Schlemmer, Weimar, 1923.*

sequences of movement, we do a blackboard analysis during the break, highlighting the essentials: the basic forms, the axes of movements, bone structure and musculature, light and shadow. (Schlemmer 'Aktzeichen', from Zeitschrift Bauhaus, No.2/3, 1928, p. 23, in Experiment Bauhaus, p. 54.)

Schlemmer's drawing course and teaching method were based on the assumption that the student must first of all understand the underlying concepts of drawing and proportion, and recognize the body's relationship to space. Schlemmer, however, went a step further: 'The standard measure, theories of proportion, Dürer's measurement, and the Golden Section deal with the schemes and systems governing line, surface and the plasticity of bodies. From these develop the laws of motion, the mechanics and kinetics of a body, both in itself and in space, natural space as well as cultural space (the building). The last mentioned carries particular weight, of course: man's relation to his dwelling and to its furnishings, or objects.' (Ibid.)

So on the one hand Schlemmer's teaching employed traditional drawing techniques and analyses, and on the other he developed them further by refusing to include in his programme anything that he considered to originate in barren theories devoid of experience or feeling.

Drawing, in his opinion, should create surprises and unexpected results, as in fact it did. In this way the synthesis that was so typical of Schlemmer's work could be achieved, leading, as it developed further, to abstraction. His studies of movement sequences have had an impact on the training of stage and costume designers which has lasted to the present day. Apart from his extensive teaching and stage activities, Schlemmer also produced important work as a painter. Here, too, his theme was the human figure in space. By reducing it to essential details, he created a sculptural impression, as in the 1928 picture *Group*

with a Seated Woman (Five Figures in Space). The perspective of the converging floorboards gives this strictly composed picture its impression of space. The near facelessness of the women, together with the barely suggested hands and simplified proportions, reveal in the context of the whole picture, with its raised, rectangular surface, a central theme of Schlemmer: the relationship of the human figure to space. In addition to the many pictures he left behind at his death in 1943 near Stuttgart, there were also some extraordinary three-dimensional works. He had taken his first steps towards sculpture in 1919 with some wall reliefs. At the Bauhaus he extended his activity to wall-painting and attempted to achieve a more plastic effect from the painted wall surfaces in rooms. The cast-iron reliefs he began making from 1923 give a further insight into the construction method described above in the context of the drawing class. Figures are depicted in simplified form, in proportional cubes, with the introduction of an additional factor in the shape of the prevailing light in the rooms to be decorated. Like his stage costumes, they are all geometrically divided and segmented. This is still more evident in his free-standing sculptures. In 1921–23 he sculpted his *Abstract Figure*, about which he wrote, 'The plastic is three-dimensional (height, breadth, depth) . . . It can be grasped not in one moment but in a time sequence, as the observer changes position. Because the plastic cannot be known exhaustively from one viewpoint, the observer is compelled to move, for only by walking around it can he come to grasp it and the sum of its impressions.' (Diary, 8.1.1924, in Schlemmer, *Briefe und Tagebeucher*, in *Experiment Bauhaus*, p. 398.) This multifaceted demand on the observer leads to the core of abstract sculpture, for it is not the external character of things which must be grasped, but their inner nature. Once again, Schlemmer insists here on his conception of the ideal human image. When he borrows from the sculpture of Ancient Greece, in this case from the

Apollo of the Temple of Zeus at Olympia, he does so consciously. He was constantly moved and fascinated by classical art.

Shortly after the departure of Walter Gropius in 1929, Schlemmer also left the Bauhaus to take up a professorship at the Breslau Academy. However, the strength of radically right-wing political influences there forced the Academy to close in 1932, and he went to Berlin, to the State Art School. The political oppression of Schlemmer was to continue unabated. An exhibition of his works in March 1933, in Stuttgart, was closed by storm troopers and he was dismissed from his teaching job in Berlin. To make matters worse, shortly after his move to Seheringen, near Stuttgart, his work was banned by the Nazis in their exhibition of 'Degenerate Art'. Faced with such opposition, Schlemmer increasingly withdrew. No longer able to pursue his own work in Germany, he earned his living as a painter's assistant. In 1940 he took a job in the colour laboratory of a chemicals factory in Wuppertal, where he worked alongside Willi Baumeister, Georg Muche and Gerhard Marcks, all of whom he knew from his time at the Bauhaus. By now it was simply a question of survival, and eventually Schlemmer gave up the struggle. He died on 13 April 1943 in Baden-Baden. His inexhaustible optimism as an artist had made him a figure of central importance at the Bauhaus and the major stimulus he provided has lasted to this day. He also had a taste for simplicity to match his predilection for the fantastic. Visionary-like, he wrote:

When one considers the entire phalanx of human figuration, from the naked human being to the costumed, to the figure in art and the marionette, to

52 Oskar Schlemmer, abstract figure, plaster and metal, 1921/23.

the larger-than-life fantasy figure: when one considers the whole spread from the comic-grotesque to the heroic and pathetic.

. . . when one considers the music of the spheres, the organized waves of the ether, or the music that can be created by mechanical-dynamic means which has an unprecedented intensity of sound, and of which a Busoni dreamed:

when one considers that the poets – stirred by the new possibilities – will arrive at completely new ideas and subjects, that they will then think less in terms of pictures, and more in terms of spatial, plastic architecture:

when one considers the progress made in the area of optics and mechanics, and above all, that these means can be an end in themselves, so that they do not serve to produce the illusion of a second nature on the stage, but can affect one directly through the elementary force of what they are: then indeed one can say that creative fantasy has possibilities that are virtually endless. (Neumann, *Bauhaus und die Bauhäusler*, p. 232.)

At this point it is worth mentioning an unusual aspect of the Bauhaus: its position as a centre for the arts. The artists discussed so far were brought there by Gropius, and were for the most part directly involved on the teaching side. In keeping, however, with the spirit of the place, a number of other figures were drawn to the institution, who did not come to teach, or only in a peripheral way. Many were attracted by the opportunity to associate freely with artists whom they venerated, or for political reasons, to guarantee protection for their work, or simply to find artistic inspiration. Albert Einstein was a guest at some events. The painter Alexei von Jawlensky, whom Kandinsky knew from his earlier years, admired the work of the

53 Karl-Hermann Haupt, Composition, watercolour, 1925.

Bauhaus, just as Kandinsky himself was influenced by the music of Arnold Schoenberg and Stravinsky. Then there were the recurrent links with the 'Blaue Reiter' group: Franz Marc, Klee, Macke and Campendonk. Lyonel Feininger, too, belonged to the circle of teachers who stamped their personality on the Bauhaus, even if, after designing the 'Cathedral of the Future' for the *Bauhaus Manifesto* in April 1919, he was only peripherally involved in Weimar, and later took no part in the teaching at Dessau. Hans Wingler, the great chronicler of the Bauhaus, wrote of Feininger: 'His mature culture and humanity were what made his presence at the Bauhaus so significant. Although he hardly ever appeared, we were constantly aware of his proximity; we sought his advice . . . So Feininger was indirectly more influential than many others actively engaged in teaching. The regenerative power of his early humour should not be underestimated, nor should the fine musical sense with which he liked to surprise friends, as he improvised on the harmonium or the organ.' (Hans Wingler, Bauhaus–Archiv Berlin, p. 60.)

Walter Gropius must take the credit for having brought together so many prominent figures at the Bauhaus, for he was well aware of the influence that even the mere presence of such artists would have on the students. As a result, the school's sphere of activity was extended; Gropius's circle developed increasingly into an international centre for creative potential. Foreign students came to Dessau, eager to absorb the new teaching, and they then passed it on. A fundamental factor behind this success was the structure of teaching in the preliminary courses, where the workshops played a leading role. Although they were later reorganised to meet the need for a more technical orientation, they provided an important link between theoretical knowledge and its practical application. It is therefore crucial to trace the role of the workshops. Here, as in architecture, Gropius saw the creative idea turn first into a design and then into material shape.

3. The Workshops

The path leading from educational ideas to practical reality was a long and often thorny one. The workshops Gropius found at Weimar in 1919–20 looked more like an empty house than rooms which might function as studios or lecture halls. Yet the overall concept was clear: students were to acquire solid craft skills, so that they would have some activity to fall back on when times were hard. Moreover, the fact remained that only through familiarizing themselves with their preferred material and acquiring a basic know-ledge of its particular qualities, could they really learn to work with it.

So, as time passed, a total of eight workshops were opened, all of which achieved extraordinary results in their respective areas, each a reflection of the interests of the various directors. They comprised:

the furniture workshop
the metal workshop
the print and advertising workshop

54 *Albert Henning,* Bauhaus students before an excursion, *1932.*

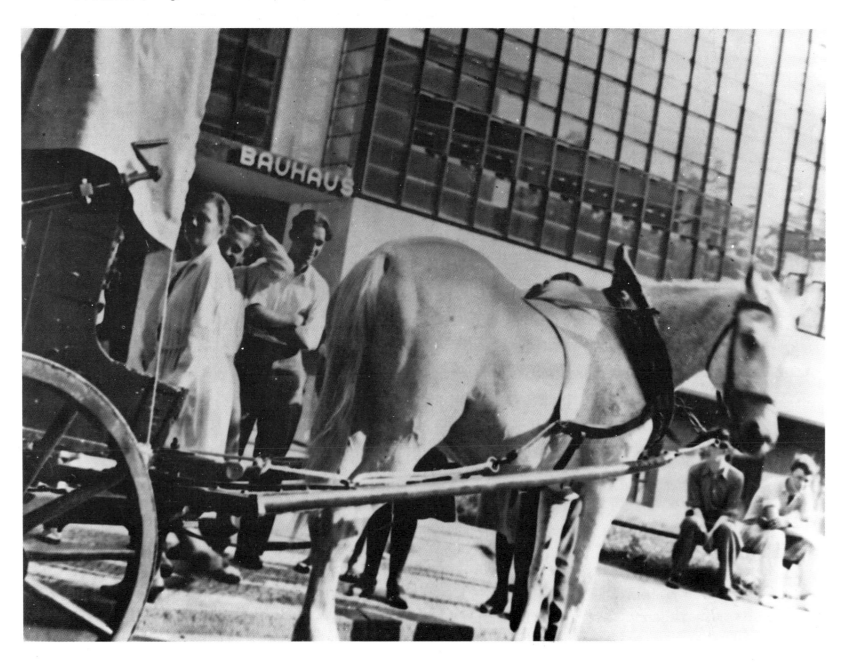

55 *Laszlo Moholy-Nagy, letterhead and cover for Bauhaus Verlag, printed on paper, 1923.*

the photography workshop
the theatre workshop
the wall-painting workshop
the ceramics workshop
and the weaving workshop.

Basically, the history of the development of the workshops falls into two phases. The Weimar period, until 1925, was devoted to experimental work, although it was not without its successes. The Bauhaus began to test the connection between theoretical instruction and practical application. The motto initially adopted by Gropius and expounded in the 1919 Manifesto, 'art and craftsmanship: a new unity', set the tone for the workshops and the approach to work in them. The ability to produce designs that would be acceptable to industry did not emerge until the original motto had been adapted to read 'art and technology: a new unity'. The effects of this reformulation varied and can best be assessed by looking at the individual workshops. The roles of their respective teachers and master craftsmen will then become more apparent.

The Furniture Workshop

One of the predictable outcomes of the far-reaching ideas behind the Bauhaus was its involvement in furniture-making. In our daily lives we are surrounded by pieces of furniture – we live and work with them. It is possible to regard a traditional piece of furniture, a chair for example, simply as something to sit on. But since sitting is not restricted to one particular type of chair, throughout history a variety of chair forms have developed as styles of art have changed. The ancient world, the rococo period, and the nineteenth century all produced their own distinctive forms of furniture. Apart from its function, furniture can also make a statement (as does a king's throne, for example) and, like architecture, acts as a source of information about the culture in which it was made, and with which it remains inextricably linked. (The same applies to clothes and fashions.) The Bauhaus involvement in furniture design therefore comes as no surprise. Just as changes were becoming noticeable in art in 1918 after the war, in furniture design too there was a reform, if not an upheaval, of traditional ideas about how people should live. Pretentious ornament and unnecessary decoration were to be shelved, and the appearance of furniture was to be determined by a new emphasis on the rational and the functional. Johannes Itten, the first director of the furniture workshop, opposed any notions of adaptation to suit the demands of industry as disruptive to teaching, and was prepared to fight the matter out with Gropius. When Itten left the Bauhaus in 1923 because of this and other differences of opinion, Gropius himself became *Formmeister*, or Master, of a newly structured course. The main discussion now centred on basic approaches to furniture design, and revealed an analytical tendency that was also the hallmark of Kandinsky, who arrived at the Bauhaus in the middle of 1922. Before choosing the material,

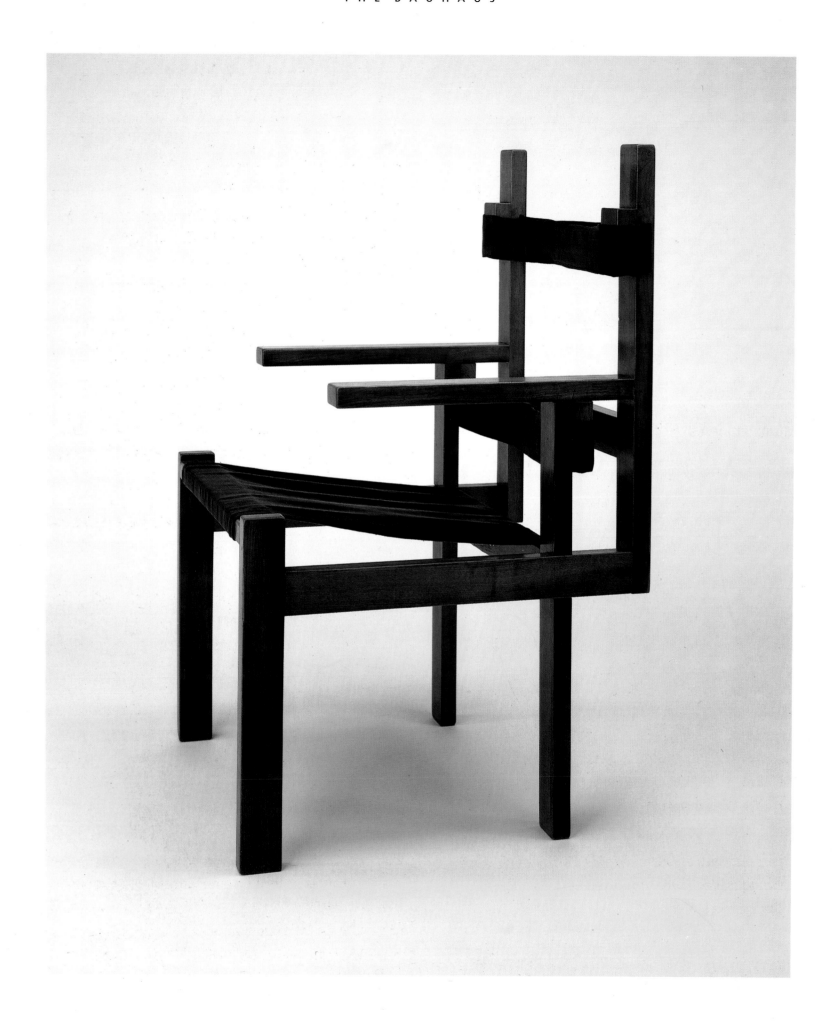

developing a new idea and starting construction work, students had to conduct an analysis of the proposed item of furniture and its function. Such a procedure was typical of the Bauhaus, and showed the clear influence of the Constructivists – particularly those close to Theo van Doesburg. (Van Doesburg was staying in Weimar at the time and campaigning – with some success – against Expressionism at the Bauhaus.)

There can be few better examples of the connection between functional analysis and the finished article than the chair designed and made at the Bauhaus by Marcel Breuer in 1922. Born in Hungary in 1902, Breuer came to the Bauhaus in 1920. In his first four years he completed an apprenticeship as a cabinet-maker, and in the years that followed went on to become a *Bauhausmeister* and a central figure in modern furniture design.

He himself describes his 'armchair with fabric seat, fabric back and cross support' as having developed out of the following considerations:

The starting point for the chair was the problem of how to combine comfortable seating with the simplest construction. Hence the following requirements were established:

a) An elastic seat and back support, but no upholstery, since it is heavy, expensive, and attracts dust.

b) A slanting seat, so that the whole extent of the thigh is supported without the pressure that occurs with a level seat.

c) The upper body in a reclining position.

d) The spine left free, since any pressure on it is uncomfortable, besides being unhealthy.

This was achieved by the introduction of an elastic cross support. Thus only the small of the back and the shoulder blades are supported by the skeleton, elastically in fact, and the sensitive backbone is left

entirely free. Everything else emerged as an economic solution to these requirements. Another factor determining construction was the static principle: positioning the broader dimensions of the wood against the pull of the fabric and pressure from the sitting body. (Experiment Bauhaus, p. 102.)

Although anyone reading these lines may wonder whether it is remotely possible to sit on such a construction, and anyone seeing the result may be reminded of anything but a chair, the practical test of sitting on it is convincing enough.

Breuer's description and his work clearly illustrate the unusual development process that was so important to the Bauhaus. The complete rejection of decorative elements, and the prominence given to the basic material in the construction method were both new and have provoked sharp comments from critics past and present. Although this chair was among Breuer's earliest works it remains his most significant, since it provides the most obvious example in furniture-making of Gropius's new approach.

As in painting and architecture, the search for solutions and for the essence of things was evident in the furniture workshops. A rejection of traditional forms was also strongly marked here, with Gropius himself repeatedly directing operations towards industry. At the same time it was important to identify absolute statements concerning design, for the aim was to arrive at a type which would answer all further questions of form (at least for the foreseeable future). In his 'Principles of Bauhaus Production' of 1926, Gropius wrote: 'There can only be one firm solution to the creation of a quality article: the type.' (*Experiment Bauhaus*, p. 98.) Though one may question this assertion, it nevertheless demonstrates that Gropius was very much in harmony with industry, even if industry was not always quick to realize this. Industrial production generally had reached the point where it

56 *Marcel Breuer, lattice chair, wood and black fabric, 1922.*

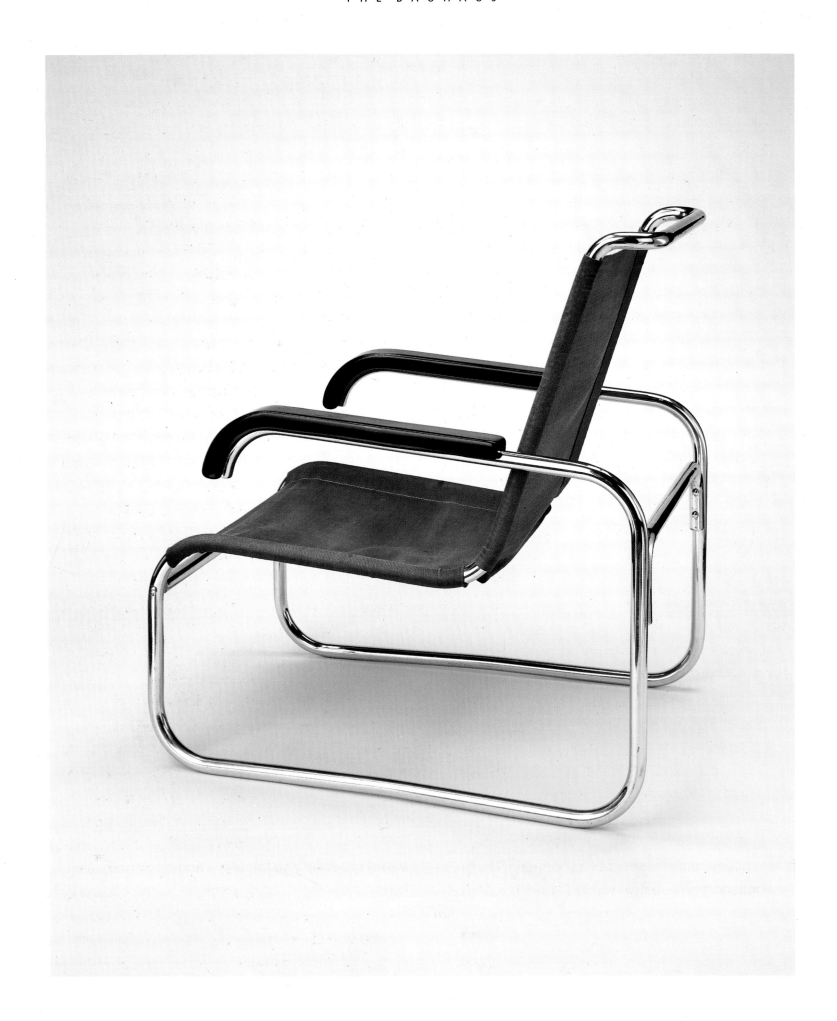

could repeat a series, that is, a standardized form, almost indefinitely. At the same time there was a growing demand for new furniture, which went hand in hand with manufacturers' desire for cheaper raw materials than wood. These developments coincided with the aim of the Bauhaus to create a new architecture, which in its turn was to produce a new concept of living. Ideas also came from other cities and other furniture-makers. The Dutch designer Rietveld, under the influence of van Doesburg's de Stijl group constructed a wooden chair, named the Red-Blue Chair; and in Frankfurt, Ferdinand Kramer designed and produced a series of furniture types. In Stuttgart, Adolf Schneck was working on similar plans and designs.

Part and parcel of the reforms in furniture and life-style – which affected Bauhaus architecture as well as the furniture workshop – were the newly developed ground-plans for houses. Boxed into a narrow space were kitchen, bedroom, living room and nursery. Hallways and staircases were dispensed with. An analysis was made beforehand of the function and purpose of each of the rooms. The kitchen – previously almost sacred to German architects – was equipped with the necessary fittings economically and in such a way as to conserve space. On the same basis, new furniture was accommodated in the home, with smaller pieces being pushed under tables or sideboards. Some Bauhaus designers must have had inscribed on their drawing boards Le Corbusier's remark that a house should be a 'machine for living'. There was, however, another aspect to the furniture being built. Apart from being an integral part of the total architectural conception, which was much more convenient to live in than many older buildings, it also represented a much freer attitude to the whole subject of interior design.

For a short time, between 1924 and 1925. Marcel Breuer left the Bauhaus. When Gropius summoned him

57 *Marcel Breuer, chair, tubular steel and black fabric, 1928/29.*

from Paris to be director of the furniture workshop in Dessau, he was quick to respond. There now followed a time of heightened creativity. In the months that followed, after noting that steel tubes could be bent, Breuer designed and constructed an innovative and influential series of pieces of furniture based on tubular steel. Tables, stools, chairs and armchairs of all kinds were now produced in collaboration with industry, and the newly built houses of the *Meistersiedlung* in Dessau (1926) were furnished with them. The bending of steel tubes into curves drew directly on six years of practice and experience at the Bauhaus. A recognizable form was created which had a transparency already familiar from the designs of Laszlo Moholy-Nagy and Oskar Schlemmer. Breuer's analytical approach to the task was also in the same spirit. The state-commissioned Weissenhof scheme, built in Stuttgart in 1927 under the direction of Mies van der Rohe (other collaborating architects included Le Corbusier, Mart Stam and Oud from the Netherlands, Walter Gropius, the Taut brothers and Peter Behrens from Germany) was the ideal setting for the new furniture. Conceived as a 'workers' settlement', the need for workers' accommodation being acute, it was intended to give people an impression of the new architecture and furniture. But it was a project that involved many contradictions. The occupants, who were deprived of any traditional decoration and ornamentation, described the houses as too cold and heartless. And so they were rejected by the very people for whom they had been built – the workers. The conflict this created made the designers aware of their limitations: an analytical building with similarly analytical internal furnishings might seem perfectly rational, but it by no means necessarily guarantees a homely atmosphere. Practical evidence of such a realization only came years later, after March 1928, when Hannes Meyer took over the direction of the Bauhaus.

Breuer's tubular steel furniture was immediately

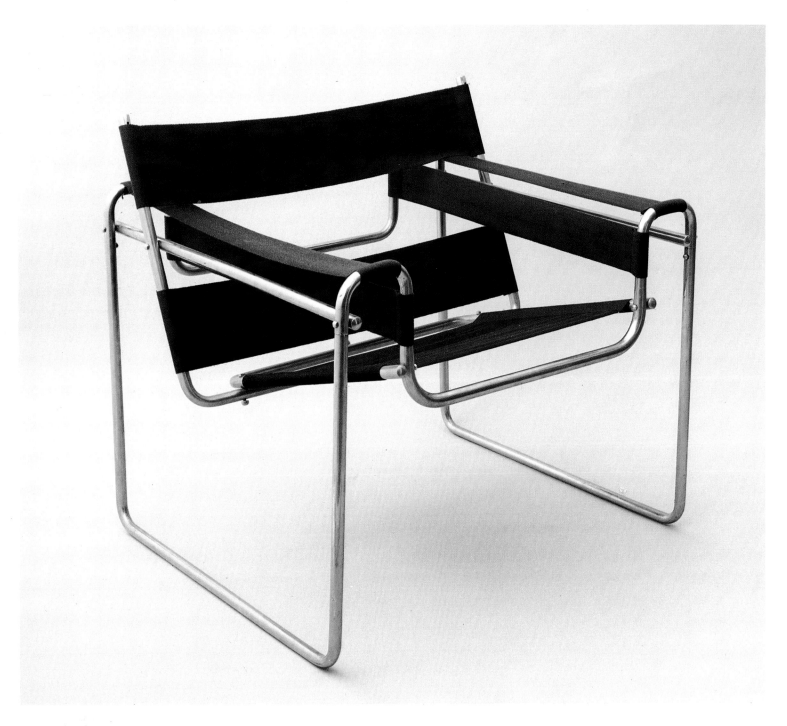

58 Marcel Breuer, chair, tubular steel and black fabric, 1925/26.

produced in relatively large quantities by various other firms, though admittedly examples of it were more likely to be found in the studios and residences of architects and intellectuals than in the houses of ordinary working people. Apart from numerous pieces of furniture for everyday use, during his Bauhaus years Marcel Breuer also constructed a basic tubular steel chair which broke new ground in design and which other designers have continued to copy to this day.

In March 1928, Breuer left Dessau to work on interior furnishings. Between 1935 and 1937 he

59 Mies van der Rohe, Weissenhof chair,
tubular steel and cane, 1927.

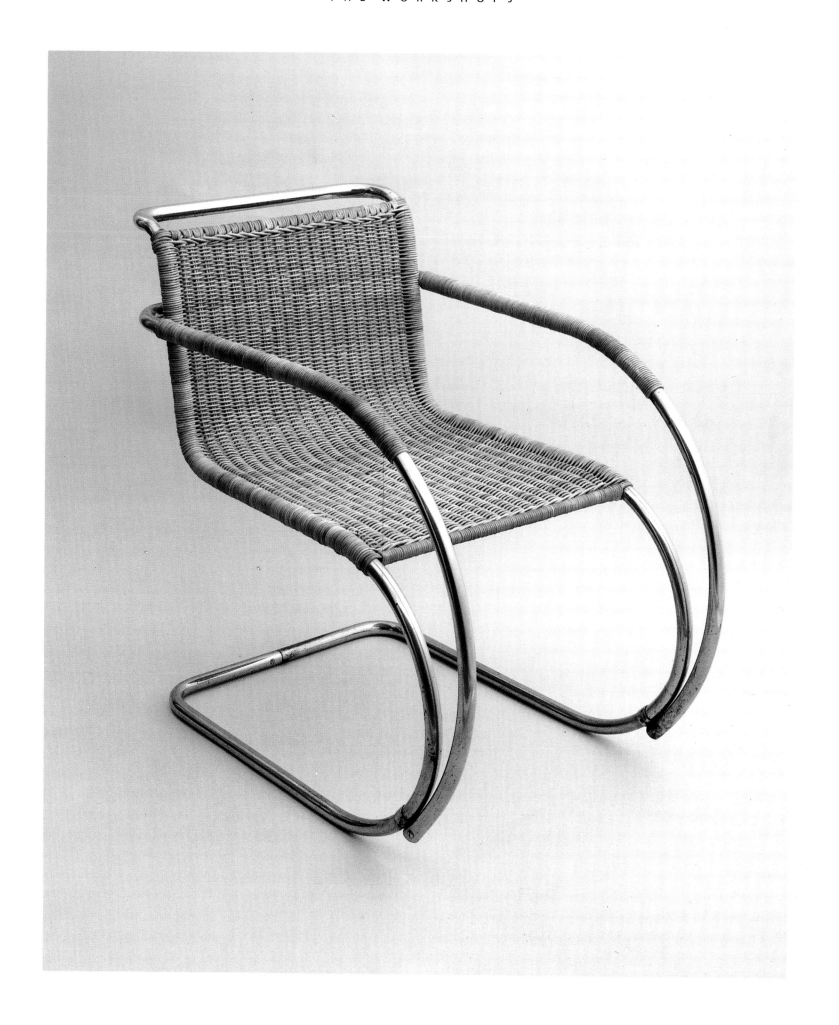

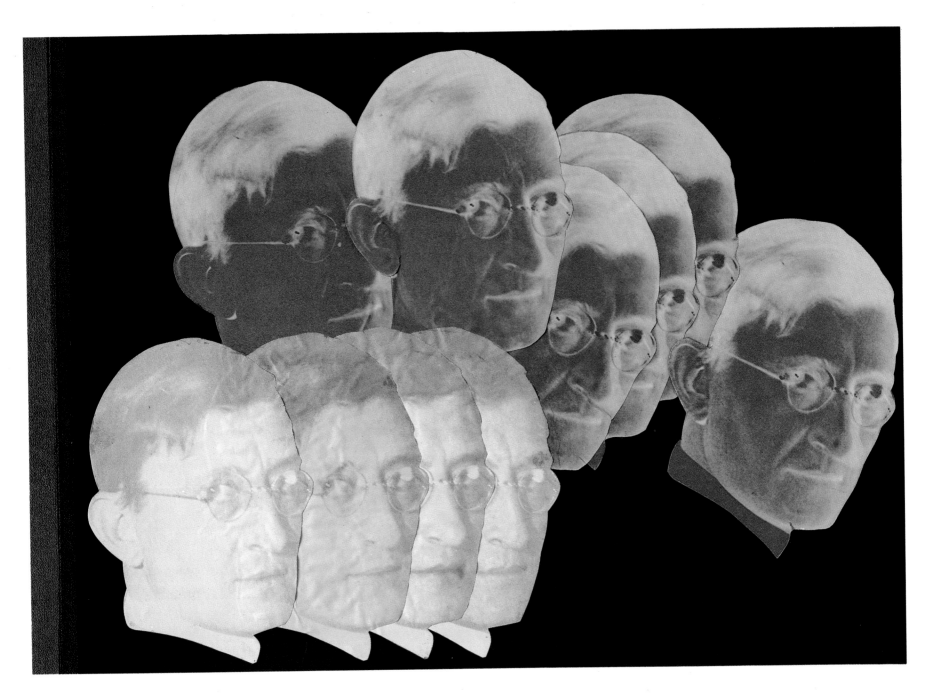

60 *Photographer unknown,* portrait collage of
Josef Albers, c. 1928.

worked as an architect in London, from where he was invited to become Professor of Architecture at Harvard University. He died in New York, after a successful career as an architect and furniture-designer, in 1981.

Josef Albers, who was in charge of the workshop between 1928 and 1929, designed and built, together with the students, a series of simple pieces of furniture including writing tables, chairs and armchairs, which

were worlds away from Breuer's ambitious projects, even if they too resulted from an initial process of functional analysis. Overall, Meyer's directorship was characterized by a trend towards simple furniture. Whilst teaching at the Bauhaus from 1927 to 1928, he had already criticized a tendency to overstylize, and held Gropius responsible for divorcing design from social needs. Meyer's affiliation to the political left then

gave rise to some impressive practical achievements in furniture design: for example, the entire furnishings and fitting of the Bundesschule des Allgemeinen Deutschen Gewerkschaftsbundes (ADGB) in Bernau, and a doctor's house in Mayen in der Eifel.

After Hannes Meyer had been dismissed following political and artistic differences of opinion, Mies van der Rohe took over the directorship of the workshop. He rejected social themes just as strongly as Meyer had embraced them, and he gradually reduced the role played by the furniture workshop, since he was mainly interested in architecture. The few, but very famous,

furniture designs Mies created also show a different emphasis from those of Meyer. His 'chair without back legs', which came to be known as the *Freischwinger* or 'free swinger', was in fact designed for the Weissenhof Settlement. With long curves of steel tubing supporting the wickerwork seat and back as well as the arm rests, it displayed all the qualities associated with interior design on a grand scale, and required a good deal of space, although one of the major problems of the Weissenhof Settlement was precisely its lack of space. Mies gave little thought to such problems, a fact which doubtless contributed to the exclusion of the Bauhaus from

61 Heinrich Bormann, interior architecture, 1932.

62 *Walter Gropius's office, Weimar, 1923.*

international discussion about the 'home as a minimum of existence'. On the other hand, he supported another tendency, evident all over Europe, towards towering, visionary high-rise buildings and futuristic details. As far as the furniture workshop was concerned, though, it was Marcel Breuer who developed through his chairs a new way of relating ideas to material conditions, and it was under his direction that the workshop truly blossomed.

The Metal Workshop

Because the two areas overlapped in many ways, there was a close link between the furniture and metal departments. However, as with the furniture workshop, in 1919 Gropius found the building vacated by van der

63 *Metal workshop in Dessau, Marianne Brandt and Hin Bredendieck.*

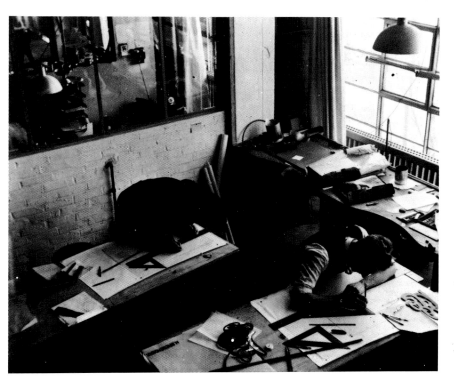

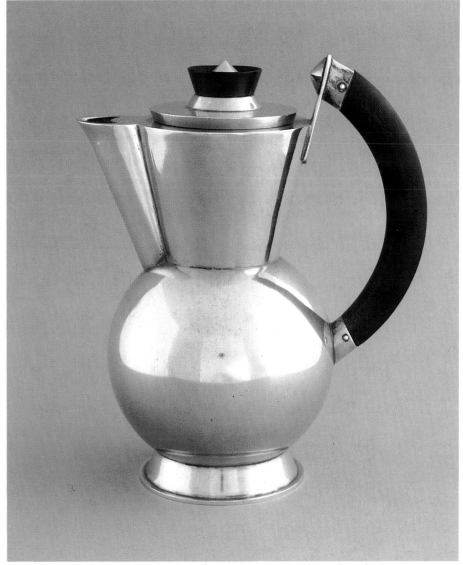

64 *Christian Dell, wine jug, plain silver and ebony, c. 1925.*

Velde almost completely empty. So the initial months were taken up with acquiring the neccessary tools and machines. The aim of the establishment was to provide a comprehensive education in metals and their uses, and the timetable consequently included the following: beating, embossing, and mounting, alloys, tin-plating, etching, dyeing, gilding and silver-plating. Skills and basic knowledge were also to be taught in welding and rolling. According to Gropius, all these activities were to concentrate on domestic fittings, for architecture, as ever, was his prime concern, and the workshop was intended to serve it. The beginnings, however, were

modest indeed. Instead of resembling a gold- or silversmith's studio, or an experimental laboratory for testing Itten's theories, the workshop contained teachers and students working away on their own schemes, unnoticed by the rest of the world. This was due more to the initial emphasis on uniting art and craftsmanship than to Itten himself (who made no secret of his dislike of industrial production). Changes were brought about as a result of Itten's departure; the appointment of Christian Dell in 1922 as Master Craftsman, and particularly the appointment of Moholy-Nagy as director until 1928. The workshop was commissioned to develop the lighting for the model house 'Musterhaus am Horn' in Weimar. Part of the Bauhaus exhibition of 1923, it was designed and built by Georg Muche as the only one of a proposed series.

Moholy had the following memories of the period: 'When Gropius transferred the directorship of the metal workshop to me, he asked me to build it up again from scratch, bearing in mind the industrial design aspect . . . Changing the way the workshop worked amounted to a revolution as professional pride forbade the gold- and silversmith's from using iron, nickel and chrome. They were quite repelled by the idea of producing models for electrical household equipment.' (*Experiment Bauhaus*, p. 125.) Nevertheless the new emphasis began to bear fruit: the glass table lamp by Jucker and Wagenfeld, as well as Marianne Brandt's tea service, were produced in small series. A few examples of work from the metal workshop were on display at the 'Werkbund' exhibition in Stuttgart in 1924 under the heading 'Form'. At the same time the Bauhaus in Weimar was plunging further and further into a financial crisis, and this naturally influenced what was happening in the workshops. A 'circle of friends' was formed to give the Bauhaus, now under pressure from local government, intellectual and moral support. Albert Einstein, Peter Behrens and Arnold Schoenberg were all members of this circle. The permanent state of financial crisis may have been a major hindrance to work in the workshop, but it was not the only problem.

It was during this difficult period that Marianne Brandt joined the metal workshop at the recommendation of Moholy Nagy:

At first I was not exactly welcomed with open arms: a woman's place, they felt, was not in a metal workshop. They admitted as much later on, and expressed their opinion by giving me work which was for the most part boring and laborious . . . We subsequently adjusted splendidly to each other.

Gradually, by visiting industrial concerns, inspecting them and having on the spot discussions, we approached our main goal, of industrial design, with Moholy Nagy's tireless energy supplying the impetus. Two lighting companies were particularly open to our proposals . . . We strove for a sensible assembly plan, one which would not compromise the appearance of the lamps, whilst also minimizing the risk of dust building up etc., etc. – considerations which in my experience are no longer regarded as prerequisites in the production of a first-class lamp. . . . It was far more difficult to persuade industry to accept our table accessories and other appliances than our electric lights, and not very many reached production. So we acquired the reputation of being something of a lighting department. We furnished entire buildings with our industrially produced lights, and only rarely did we plan and produce special items in our workshop for rooms that were unusual or on a grand scale. At the time I held the conviction that a thing should function as efficiently as possible, whilst expressing the quality of the material from which it was made. Later, however, I came to realize that what counts in the end is artistic personality. My error was due to the fact that we were living in a community made up for the most

65 Wilhelm Wagenfeld, gravy boat, silver and ebony, 1924.

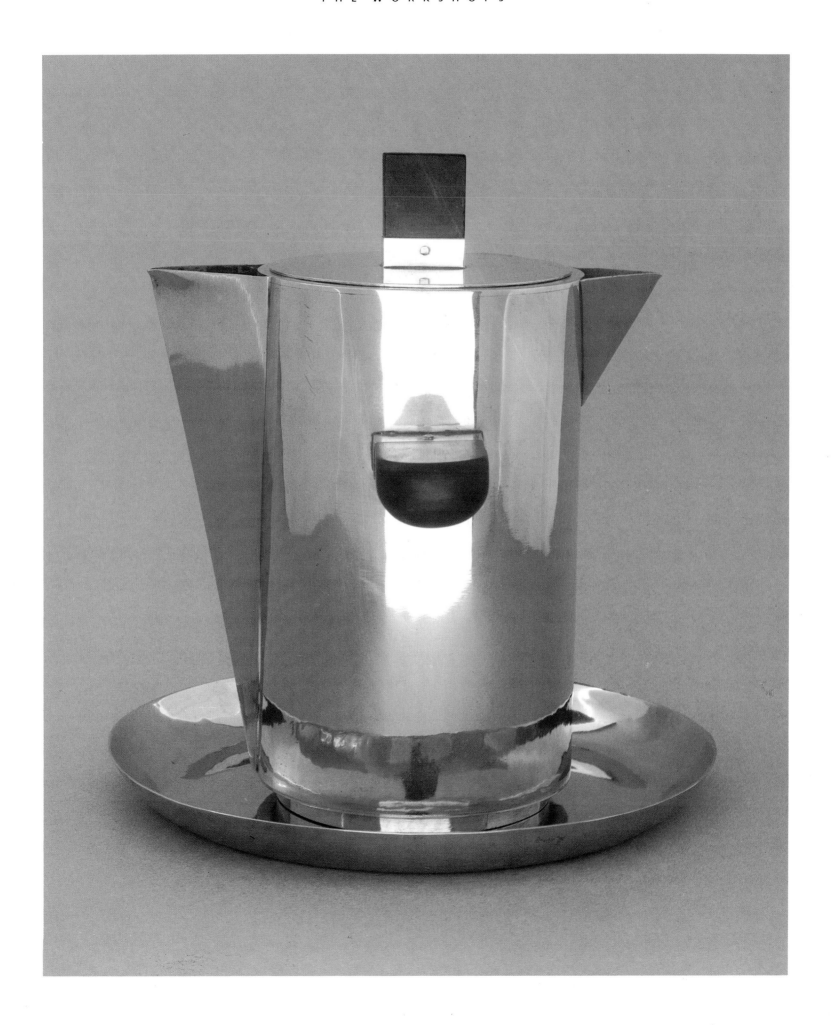

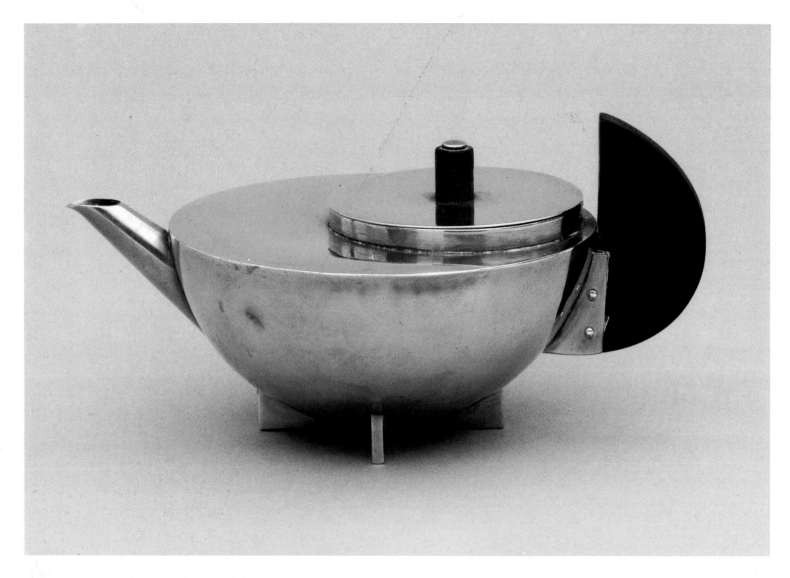

66 *Marianne Brandt, teapot, brass and ebony, 1924.*

part of such personalities, the high quality of whose work was taken for granted. (Neumann, Bauhaus und die Bauhäusler, p. 159.)

The work of Marianne Brandt, who took the preliminary course with Albers and Moholy, but also attended the courses of Klee and Kandinsky, clearly had an analytical, or, as she puts it, functional character. One of the most gifted of the workshop members – she temporarily took over its direction from 1928–29. Her work contributed greatly to Bauhaus metal work becoming more widely known.

The move to Dessau on 1 April 1925 was an

important step, but Gropius still criticized the progress of work in the metal workshop for being too slow. 'In the metal workshop it is still as necessary as ever that the production of receptacles be restricted and a preference shown for objects with a potential for industrial production. That means, above all, lamps. We are failing to take advantage of the start already made in this area in Weimar. Here, too, systematic preparatory work is necessary . . . so that the business

67 *Metal workshop in Weimar, 1922: back, left to right: Hans Przyrembel, Wolf Rossger, Marianne Brandt, Werkmeister Schwarz; front, left to right: Otto Rittweger, Joseph Knau.*

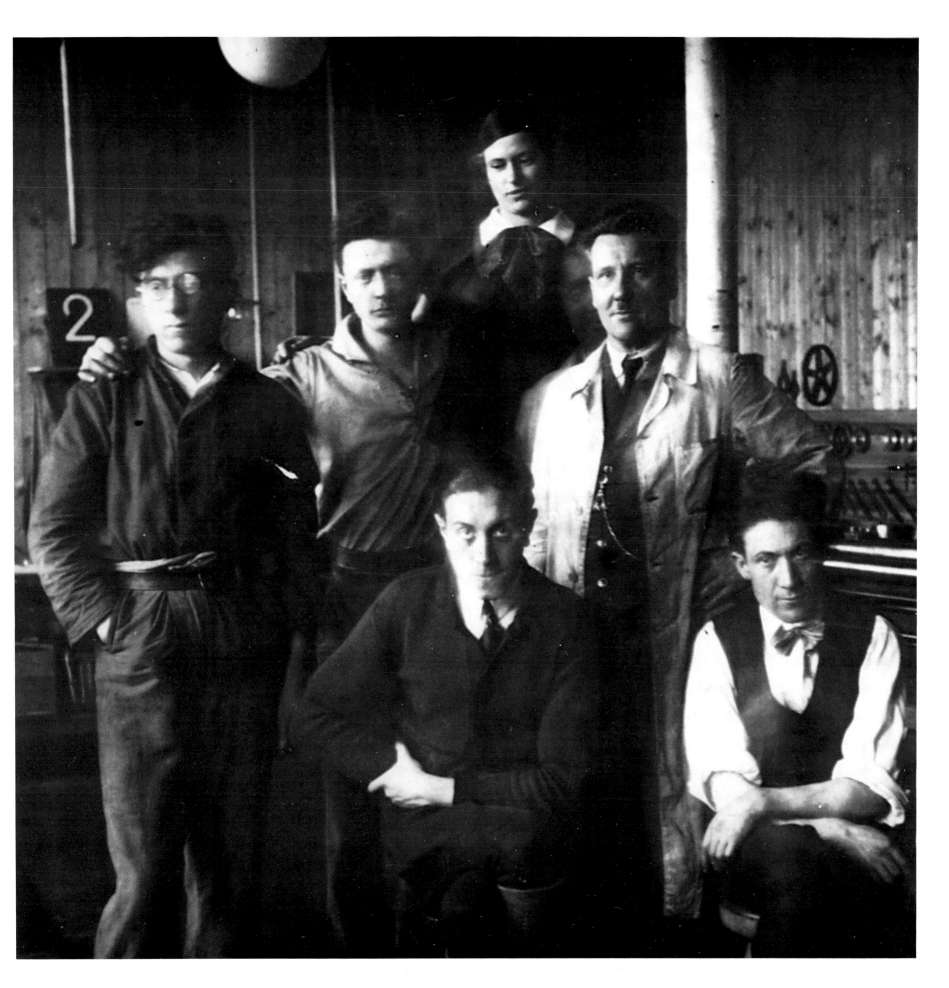

department has a basis for attracting orders'. (*Experiment Bauhaus*, p. 126.) The breakthrough on the business side at the Bauhaus only came once Hannes Meyer was director. Two contracts for co-operation with outside firms brought long-awaited and deserved success. Jucker and Wagenfeld's table lamp went into industrial production, along with the bedside-table lamp by Marianne Brandt and Hin Bredendieck. By 1931, over 50,000 lamps and lights from Bauhaus designs had been produced and sold.

Now that their designs were being put to more effective use, in July 1929 Meyer set about reorganizing the workshops. The most important step was to amalgamate the metal workshop with those for wall-painting and furniture, in order to create an enlarged workshop complex for architecture and interior design. This also marked a temporary departure from highly ambitious developments, since the emphasis was now on designing articles for mass production. There was, however, no question of a reduction in quality. With this move towards creating practical furniture, the

68 *Josef Albers, teacup, porcelain, glass and steel, 1926.*

69 *Marianne Brandt, bedside Kandem lamp, metal, c. 1928.*

students' work on the applications of steel tubing began to yield impressive results in the form of stools, folding seats and work chairs. Of the Bauhaus orientation towards standardized products, Hannes Meyer wrote: 'Not every commission offered to the Bauhaus from outside was typical enough to be standardized . . . and the individual workshops ran the risk of resembling the branch of some producing firm or other. In selecting from offers, preference had to be shown for those which set a task posing the most

70 *Wilhelm Wagenfeld, desklamp, metal and white glass, 1923/24.*

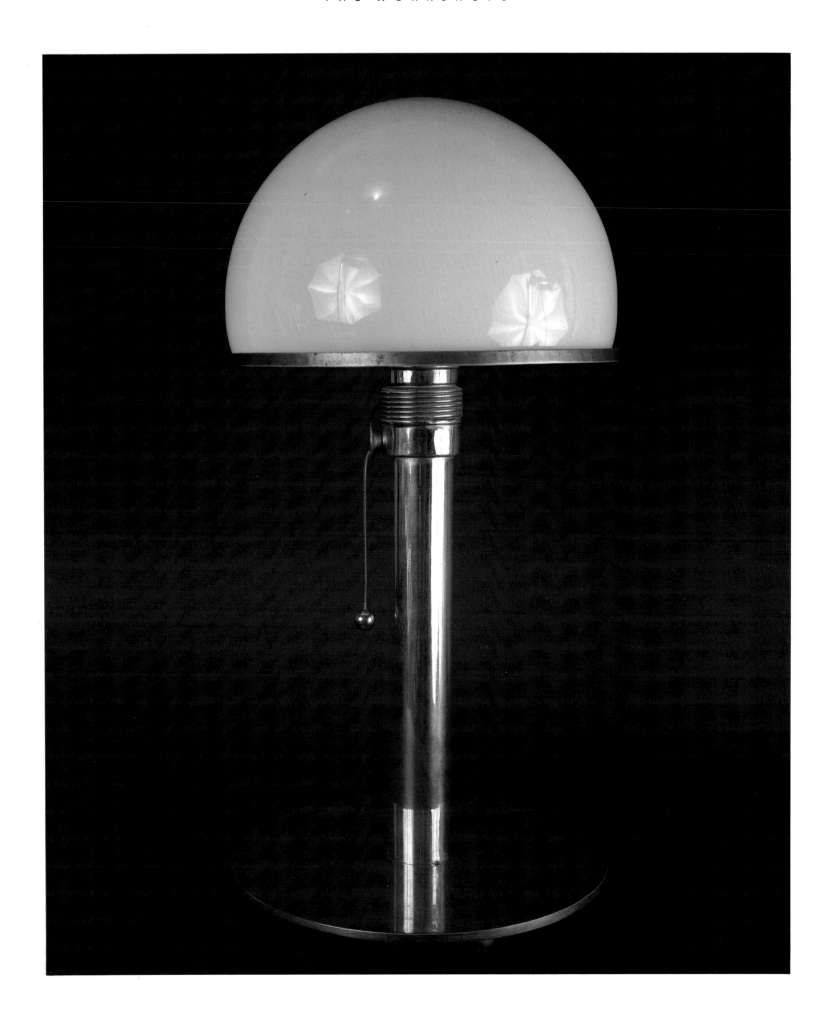

general demands, since this would contribute most to the continuing development of the traditional types of lamp, work chair, and furniture fabric etc.' (*Experiment Bauhaus*, p. 127.)

The new enlarged workshop was under the direction of *Bauhausmeister* Alfred Arndt. In May 1929 the Bauhaus mounted an exhibition of its work at the Industrial Museum in Basel and took part in the International Exhibition in Barcelona. Political developments led to Meyer's dismissal in 1930 as a precondition set by the city of Dessau for the institution's continued funding. Meyer, with his leftist political ideas, was thus sacrificed, and Mies, with the

help of Gropius, took over as director. As a consequence, the Bauhaus lost interest to some extent in industrial designs for utility furniture and in the lamps it had previously produced. The new workshop was now redirected by Mies towards architectural tasks. There was more teaching, with the range of subjects expanded to include structural engineering, iron and building construction, heating, air-conditioning, installation, and lighting. And so the metal workshop ceased finally to exist as a separate entity.

71 Christian Dell, wine jug, plain silver with ebony handle and finial, stamped CD, 1924.

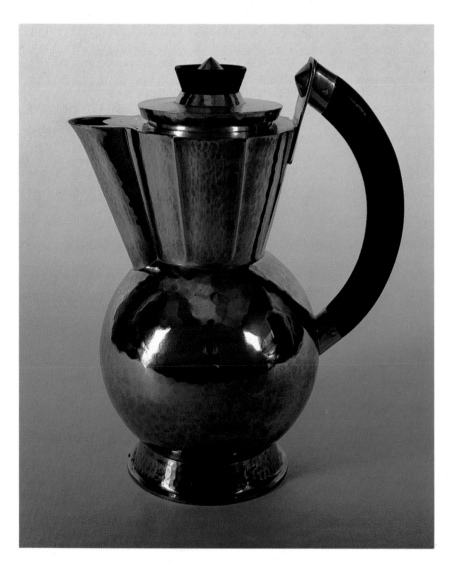

From the Graphic Press to the Printing and Advertising Workshop

Today anyone who examines the numerous prints that have been reproduced of pictures by Bauhaus masters will find that some of them bear the small stamp 'Kunstdruckerei des Staatlichen Bauhauses-Weimar' ('Art Press of the State Bauhaus-Weimar'). This means that they are not prints advertising or cataloguing Bauhaus products, but valuable prints of pictures by Klee, Kandinsky, Kokoschka or Feininger.

The first graphic press at Weimar was established shortly after the establishment of the Bauhaus in 1919. As the workshops of van de Velde's earlier art school were still in reasonable condition, it was possible for work to begin straight away. In contrast to the other workshops, where connections with industrial production took years to develop, the graphic press immediately accepted and completed a small number of commissions from outside. Carl Zaubitzer, the printer, was director of the workshop until 1926. However, its work bore the stigma of non-creativity, since the press by its very nature reproduced rather than

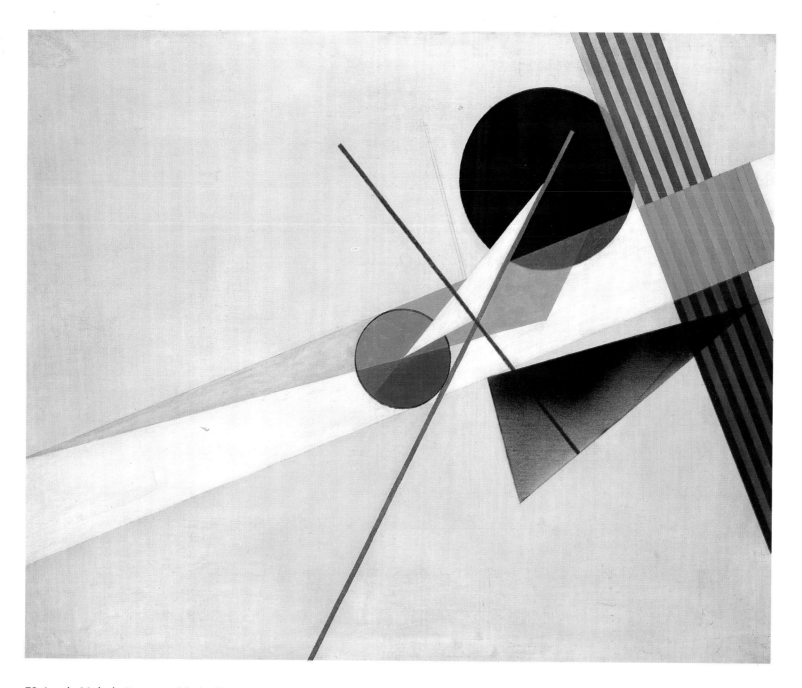

72 *Laszlo Moholy-Nagy, untitled, oil on canvas, 1925.*

produced its own creations. Although traditional fine art printing had long been valued as a craft in its own right, the workshop remained somewhat peripheral to the advances in new techniques and to the general mood of change at the Bauhaus. This was noted by the students, who were soon protesting about it. Gropius intervened in 1920, recommending that the students should have individual portfolios of their own graphic prints, and that a fresh start be made in book illustration.

Lyonel Feininger, who directed the press as *Form-meister* (Master of Form) from 1919 to 1923, produced an impressive series of prints. Various techniques were employed including woodcut, lithography and etching:

Some of the most important achievements of the graphic press were the graphic cycles and portfolio works it produced in rapid succession after 1921, beginning with Feininger's 'Twelve Woodcuts' and

Georg Muche's cycle 'Y'. In 1922 Kandinsky's portfolio *'Little Worlds'* appeared, and 1923 saw a series of polychromatic lithographs by Lothar Schreyer, the 'Wielandlied' sequence of woodcuts by Gerhard Marcks, Schlemmer's cycle 'Game with Heads', and the 'Master Portfolio of the State Bauhaus', which brought together eight examples of prints by Bauhaus masters. (*Experiment Bauhaus*, p. 146.)

73 Joost Schmidt, printed poster for the Bauhaus Exhibition, 1923.

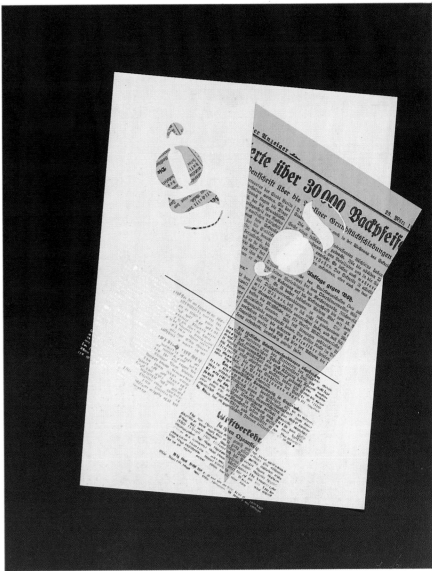

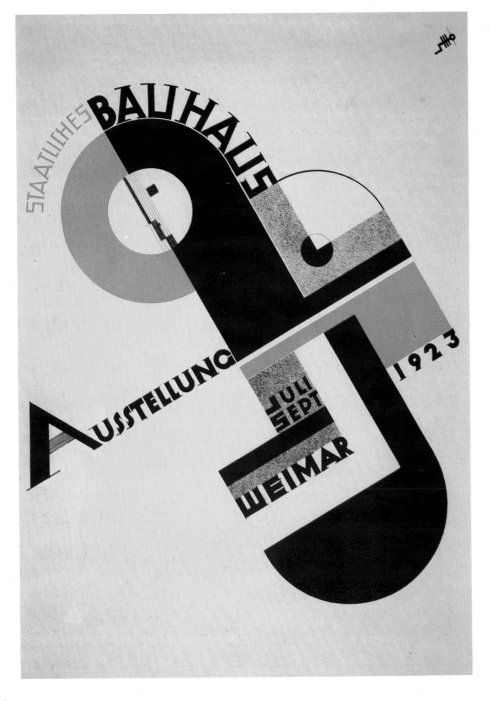

74 Eugen Batz, typographic study from Albers preliminary course, collage with newspaper and posterpaint, 1929/30.

The workshop maintained its links with contemporary and avant-garde artists through a series of prints of works by international artists, including Beckmann, Grosz, Schwitters, Baumeister, Kirchner, and Heckel from Germany; Chagall, Larionov, and Goncharova from Russia; Carrà, de Chirico, Boccioni and Severini from Italy, and the French artists Léger and Marcoussis. Although the project was unfortunately never completed, it clearly shows the links with the

international artists of Expressionism, the painters of 'Die Brücke', and the Futurists and Constructivists, who all played an important part in the artistic development of the Bauhaus. The work – one could almost call it the concerted action – of the graphic press under Feininger set standards, albeit for the last time, by which this type of work might be assessed. Until the move to Dessau, where the graphic workshop in its original form was not re-established, all invitations, posters and prospectuses advertising the Bauhaus, including those for the 1923 exhibition, were printed in Weimar, with Moholy-Nagy relying on his own ingenuity to produce the typography for the exhibition catalogue.

Gropius and Moholy in fact deliberately steered the new course towards advertising, and the inauguration of the new printing and advertising workshop in Dessau ushered in a highly innovative phase in graphic design and typography. This development from fine art to technical achievement is characteristic of the whole of Bauhaus history and of the general changes that had occurred at intervals since the *Bauhaus Manifesto* of 1919.

It came as no surprise when an advertising department was added to the press in Dessau, since many advertising commissions had already been accepted at Weimar. Apart from the desire to have an impact on advertising forms, which had rapidly become established since the turn of the century, the Bauhaus showed a particular fascination for commercial art, not least because it hoped to attract greater attention to itself through better advertising. Whilst in England and America there had, by about 1918, been huge developments in the area of commercial art and science, German advertising specialists and graphic artists were linked only by a few professional associations, and the Bauhaus was relatively late in devoting itself systematically to advertising. Outstanding graphic artists such as Lucian Bernhard and Fritz Rosen from Berlin, as well as others who might

well have contributed much to the Bauhaus in the area of style and graphics, did not feature in Dessau. Instead the major influences included the work of van Doesburg and the script developed by El Lissitzky. Most probably this was because members of the Bauhäusler circle were initially limited very much to their own ideas; in other words, they were slow to build on existing contacts. Moreover, the starting point for many new developments was non-commercial. Moholy developed

75 Herbert Bayer, printed poster, 1930.

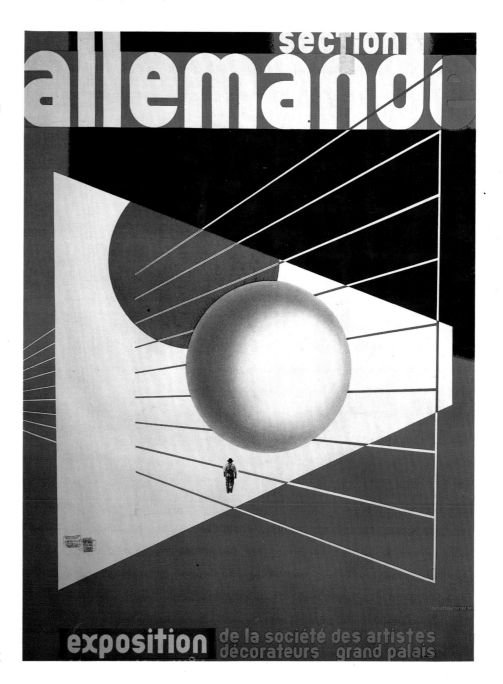

76 Erich Mrozek, printed poster for matches, 1932.

his 'new typography' and its layout from his experience and knowledge of the arrangement of space and surfaces in painting composition. His statement that one should convey 'a clear message in the most penetrating form' suggests that he was thinking along aesthetic lines, whilst also reproducing the truisms of 1920s' advertising. These were voiced in a variety of

77 and 78 Joost Schmidt, Bauhaus wallpaper for the Bauhaus catalogue. 1930/31. Text: 'The future belongs to Bauhaus wallpaper'.

ways, particularly by American sociologists, at the World Advertising Congress in Berlin, in 1929. Together with the metal industry, advertising was among the fastest growing areas of German industrial expansion during this period, and a sign of the times was the effect it had on graphic and fine artists.

The difference between commercial art in general and the way it developed at the Bauhaus first became apparent under Herbert Bayer, who had attended Itten's preliminary course and been taught by Paul Klee. He took over direction of the print and advertising workshop in 1925, and devoted himself to the study of typography. Picking up where other theoreticians had left off, in 1927 he developed his reflections on the 'universal alphabet', that is, a universally applicable typeface based on geometric building blocks. Joost Schmidt, who had been at the Bauhaus since 1919, taught the students typography as part of the preliminary course, and developed his own typeface, which was then put into use. Albers, too, developed new possibilities for artistic representation with the typefaces and letters he introduced in his preliminary course.

It was Herbert Bayer, however, who finally liberated typography from the ornamental excesses of the

79 Herbert Bayer, Xanti Schawinsky and Walter Gropius
in Ascona, 1933.

previous century. In the process of working out his designs he clearly demonstrated the mathematical and analytical nature of his procedure. His 'Plan for a Newspaper Kiosk' of 1924 has all the individual elements of the typical Bauhaus composition. Looking almost as if it has been constructed from a variety of square boxes, it displays extremely large advertising surfaces, which are painted yellow, blue and red (to emphasize the visual effect) and bear inscriptions indicating the purpose for which it has been made. Basically then, the kiosk is a purpose-built construction, and its collage-like character points to a relationship with the DaDaists. The design belongs to a seven-part

series by Bayer, in which he breaks radically with traditional ideas and follows the functionalism of Gropius. Along with other typographical works, it must have been shown at the convention of the Association of German Advertisers, when they met in Dessau in 1927, for a 'week of instruction'. Interest in the new ideas had plainly banished the mutual reserve amongst professional advertisers. The appointment of Hannes Meyer as director had the same effect on the printing workshop as on the metal workshop. Between 1928 and 1930, the advertising workshop received a variety of commissions, and worked in the closest co-operation with the printing workshop, which used its designs. The

commercial art class, which started in 1929 (shortly after Bayer's departure from the Bauhaus) was a logical offshoot of this collaboration. Almost two years later, the advertising classes organized by Joost Schmidt were extended to include basic concepts of the psychology of perception, and of the ways in which advertising takes effect. The connection between photography and typography elaborated at the Bauhaus proved to be the most telling and progressive development in advertising at the time. The arrangement of image and type was somewhat reminiscent of Surrealism, and proved extremely successful in practice, since the break with convention made advertisements more eye-catching. The desire for reform also extended to orthography, with the proposal that German spelling should discard the use of capital letters at the beginnings of words and sentences. But these ideas were not successful – or at any rate they did not catch on.

After leaving the Bauhaus, Herbert Bayer became an independent commercial artist and worked in Hitler's Berlin until 1938. Numerous commissions, including the designing of exhibitions, enhanced his reputation as a graphic artist. In 1938 he moved to New York, where in the same year he designed the exhibition 'Bauhaus 1919–1928'. After 1946 he worked in Aspen, Colorado, for private and public clients.

The advertising department at the Bauhaus never developed into a smoothly running financial concern, and was consequently never in danger of acquiring the limited outlook of an advertising agency. Commercial exploitation was not regarded as a principal aim, and the changes the department achieved were, rather, long-term, as can be seen from the frequent use of its typography in the years that followed. To this day graphic artists still copy Bayer's 'universal alphabet'. He died in 1985 in Santa Barbara, California.

Joost Schmidt replaced Bayer as director of the advertising department until the time of the Bauhaus ban, after which he was employed as a teacher at the Reimannsschule in Berlin between 1935 and 1936. In 1946 he became Professor at the Hochschule für Bildende Künste, also in Berlin, where he ran the preliminary courses for the architecture students. He died in 1948, in Nuremberg.

Photography

The inclusion of photography among the other crafts to be taught may require some explanation today. Unlike activities in many of the other workshops, which had been in operation since 1919, or were founded shortly

80 Laszlo Moholy-Nagy, photogram with Eiffel Tower, *c. 1929.*

of stylistic devices, is already very evident. Muche is making a break with traditional pictorial photography, that is, with the most authentic possible presentation of what is seen. Such a departure from conventional approaches was typical of the Bauhaus.

As we have already seen, Moholy-Nagy also conducted early experiments with his photograms, or film exposure without a camera. The pictures he created in this way between 1922 and 1925 reflect the compositional method of the Russian Constructivists. Moholy-Nagy was amongst the first of those engaged in photography at the Bauhaus to advocate a turning away from traditional exposure by means of a camera: 'Where photography is used without a camera – as in a photogram, or light imprint – the contrasts between deepest black and lightest white, with all the fine

shadings of grey in between, suffice to create a language of light, which, although it has no object-related meaning, is capable of producing a direct visual experience.' (Moholy-Nagy, *Experiment Bauhaus*, p. 199.)

In an almost visionary way, Moholy takes up a strand of thought, the 'language of light', which suggests a universal concept of communication. By reducing photography to structures, or distinctions between light and dark, he comes closer and closer to authentic representation. For at the time, photography (particularly journalistic photography) had already shown itself to be a manipulative medium that leaves a great deal of scope for interpretation on the part of the observer. So any aim to reproduce reality, whatever one takes this to be, can only be partly achieved. We all know that when a group of people are looking at a photograph, very different opinions may emerge about what it represents. Often a photograph in a paper will acquire its full meaning only from the caption. Changing the caption can produce a completely new interpretation. Such subjects were discussed in the 1920s by, amongst others, the photographer Renger-Patsch, and Moholy, in his quest for 'pure photography' and clarity of statement, will have taken notice. So in the photography workshop, too, we find the general Bauhaus desire to arrive at statements that would be universally valid and comprehensible to all. And, as Johannes Itten stressed, this was only possible by revealing the true nature of things. It is all the more astonishing that for a long time photography had no significance at the Bauhaus and no role to play as an artistic medium or area for experimental and analytical work. Gropius saw photography almost exclusively as a documentary medium, and in his time as director until

85 *Photographer unknown, double portrait of Holde Rantzsch and Miriam Manuckiam, c. 1927.*

86 *Ilse Fehling and Nicol Wassilieff, 1926. Photo by Umbo (Otto Umbehr). Umbehr studied from 1921 to 1923 at the Bauhaus, Weimar, where he attended the Itten preliminary course.*

88 *Irene Hoffmann*, detail from an ashtray, *c. 1928.*
Peterhans course.

1929, there were no plans for its integration in a workshop.

In some ways it must have been seen as a challenge to the Bauhaus, given its Expressionist history, when, in 1925, Moholy published his book *Painting, Photography and Film*. In it he expressed his respect for new technical devices, including photography, almost setting them up in opposition to painting, which was held in such esteem at the Bauhaus. Would the machine now replace the hand of the artist? As Moholy wrote: 'In the mechanically exact processes of film and photography we possess a means of representation which functions incomparably better than the manual process already familiar to us in representational painting.' (*Experiment Bauhaus*, p. 200.) It would be quite wrong to assume from this that Moholy wished to abolish painting: his aim was to extend the possibilities of art by using new methods.

At this point mention must also be made of his wife, Lucia. On a practical and theoretical level, Lucia Moholy was an expert photographer who developed her own style through the Bauhaus. She soon came to be regarded as the documentary photographer of the Bauhaus Catalogue and exhibitions – almost all the photographs of work from the workshops are by her, though she also took portraits and general pictures of

87 *Laszlo Moholy-Nagy*, Tactile Exercises, *photo montage, 1938.*

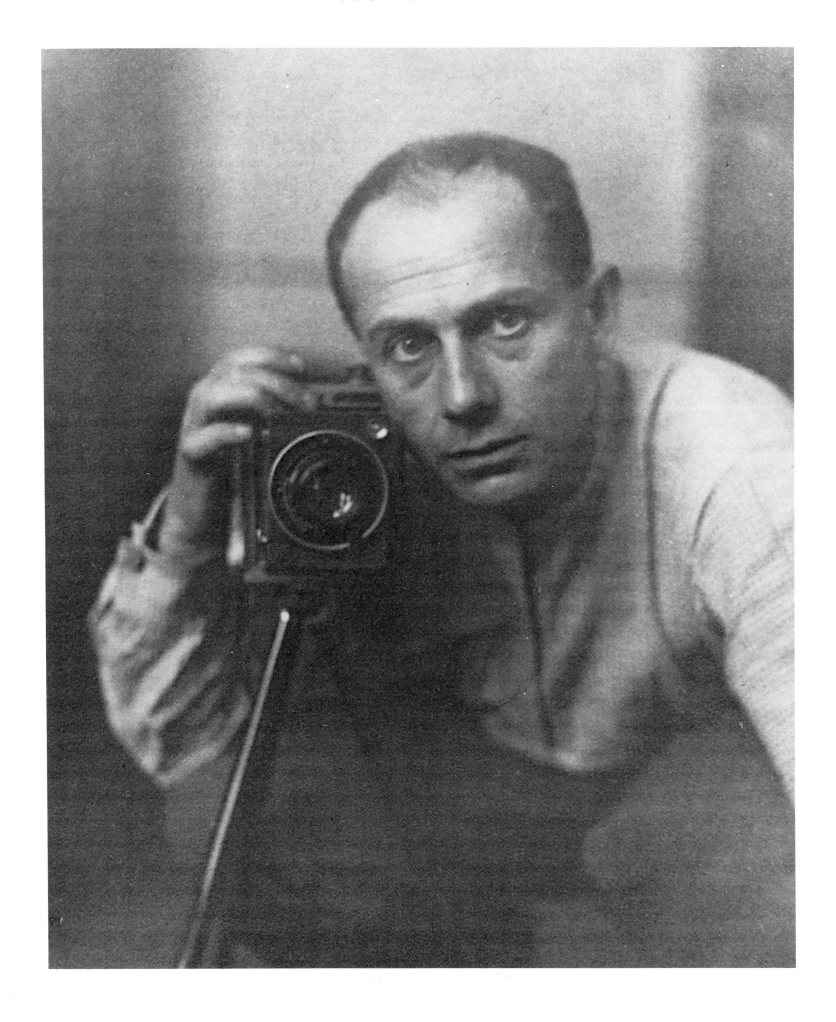

89 Paul Citroen, Self-Portrait, *1932.*

human subjects. The innumerable photographs of students and teachers provide us today with a unique insight into the life of the Bauhaus and its personalities. The continuity in her photography and the intensive work she put into the Bauhaus publications show her to have been much more than the wife at Laszlo Moholy's side in his avid quest for glory. Her role as an important representative of the Bauhaus to the outside world was certainly underestimated at the male-dominated institution, revealing a particularly unenlightened side of Gropius and the other staff. Through her position as an editor at the Rowohlt-Verlag in Berlin she had been able to gather a wealth of experience from the

publishing world, and possessed an expertise few others at the Bauhaus could equal. After her separation from Laszlo Moholy in 1929, she emigrated in 1934 to London, where she taught at the London School of Printing and Graphic Art, and at the Central School of Arts and Crafts. In 1948 she was made a member of the Royal Photographic Society. After further photographic work, she devoted her old age to publishing her Bauhaus photographs, and died in 1989 at the age of 94, in Switzerland.

In addition to Lucia Moholy's photographs documenting everyday life, many others were also taken which give an impression of the lively atmosphere at the school. They also show that the students regarded themselves as 'special' – it is possible to detect

90 Marianne Brandt on her balcony at the Bauhaus atelier. *Dessau, c. 1928. Photo by Werner Zimmerman.*

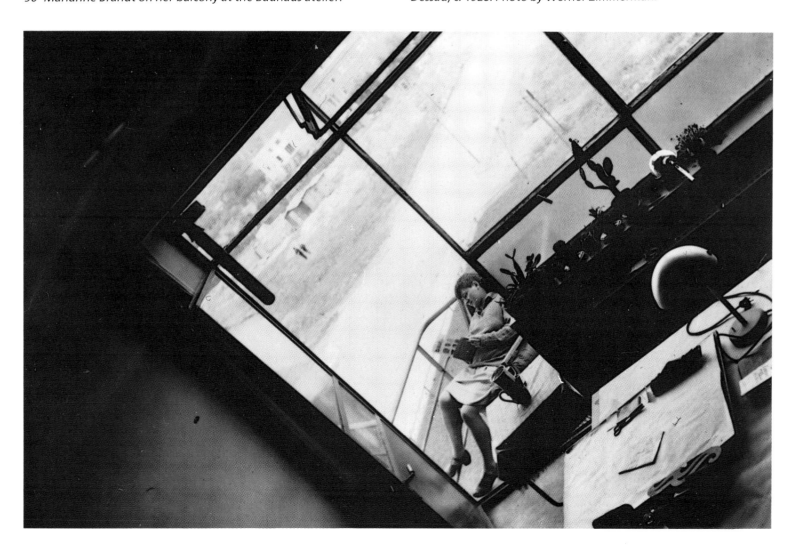

91 *T. Lux Feininger*, Collage of Weaving Workshop, *1928.*

a certain pose even in their pranks and light-hearted games.

A further important development and the opportunity to measure themselves by the standards of others came when the Bauhaus experimental photographers took part in various photographic exhibitions. At the 1926 'German Photography Exhibition' in Frankfurt, Moholy-Nagy may still have been in the amateur section, but two years later his work was gaining increased recognition at the Jena exhibition 'New Paths in Photography', alongside photos by Lucia Moholy, Renger-Patsch, Peterhans and Umbo. The 'Film and Photo' exhibition (FiFo) of 1929 in Stuttgart brought the first breakthrough for Bauhaus work. Almost without realizing it, the students and teachers achieved a new resonance

which attracted international attention:

It was possible to gauge how widespread photography had become in the Bauhaus at the time from the number of Bauhaus students and teachers taking part at the FiFo in 1929. The students included Marianne Brandt, Edmund Collein, Max Enderlin, Lux Feininger, Werner Feist, Walter Funkat, Lotte Gerson, Fritz Heinze, Willy Jungmittag, Fritz Kuhr, Keinz Loew, Naf Rubinstein and Hinnerk Scheper. Then there were the former Bauhäusler, Bauhaus teachers and members of the Bauhaus circle: Irene and Herbert Bayer, Andreas Feininger, Werner Graeff, Florence Henri, Lucia and Laszlo Maholy-Nagy and Otto Umbehr ('Umbo'). This attendance is all the more astonishing when one

considers that photography had not been introduced as a teaching subject at the Bauhaus until 1928/29. The change was only to come once Walter Gropius had been replaced as director by Hannes Meyer, who was keen to apply the arts and recognized the importance of photography for advertising and reportage. Thus, as part of a substantial reorganization of the workshops and change of timetables, he established photography as an official teaching subject. The photography class was not granted the status of an independent workshop. Instead it became amalgamated as a special department within the advertising workshop and press, which at this time were being directed by Joost Schmitdt. (Jeannine Fiedler, Experiment Bauhaus, p. 202.)

Walter Peterhans, a trained photographer by profession, had studied philosophy, mathematics and art history before taking up photography. From the beginning of his time as Bauhaus director of photography, he made clear his opposition to Moholy-Nagy's stance. Experimenting with photography and its

92 *Lou Scheper,* Collage, *1928.*

93 *Photographer unknown, picture from the Peterhans course, 1929.*

constructive use had no appeal for him: he was concerned that the photographed image should be technically perfect and as optically correct as possible – perhaps because he was the son of one of the largest manufacturers of optical instruments in Germany. Much greater, however, was the influence of Hannes Meyer, who pressed for a more factual approach to work. The whole of the restructured teaching programme clearly bore his stamp. A broad range

of scientific instruction was introduced, to give the students a sound basis for their future professions. Kurt Kranz, who joined Peterhans's class as a young student in April 1930, remembers it clearly: 'To most students, the Peterhans course seemed very technical and mathematical. He devoted a good deal of theoretical interest to chemical processes. We were only able to follow the lens-calculations imperfectly, since most of us had large gaps in our mathematical

knowledge. So Peterhans also gave us coaching in algebra.' (Neumann, *Bauhaus und die Bauhäusler*, p. 347.)

Thus experimental photography gave birth to applied photographic technology. The photography department offered a comprehensive programme of courses which gave the students every opportunity to learn their profession as photographers. There was no lack of demand for them, since photography had now become part of all the printed media, and illustrated magazines were a regular feature of the journalistic world. Moreover, advertising was calling for more and more new photographers with fresh ideas. Amongst those who graduated from the Bauhaus were Ellen Auerbach, Grete Stern, Eugen Batz, Charlotte Kuhnert, Herbert Schuermann and, last but not least, Kurt Kranz. Not long after leaving the Bauhaus, Lux Feininger and Willy Jungmittag started up picture archives and photographic agencies.

Amongst many others, it is possible to single out Lux Feininger (Theodore Lucas Feininger), who took the preliminary course with Albers and was the son of Lyonel. He has left us with splendid documents of life at the Bauhaus, many of his snapshot-like pictures recording Schlemmer's stage work. Then there is Otto Umbehr, whose photography was the complete opposite of Moholy's technical, experimental work. Umbehr (better known by his nickname 'Umbo') had attended Itten's preliminary course and belonged to that generation which, after experiencing the disaster of the war, reacted against the hypocrisy of glorified murder. His photography was direct and unpretentious, although he also remained open to experiment and did not pursue a particular theory, at least not systematically. His mastery of the medium is revealed in practically every photograph he took. One particular example is his 1927 photograph of Ilse Fehling and Nicol Wassilieff, which reflects, in this case literally, a bohemian scene from the artists' lives at the Bauhaus.

'Here Umbo has combined the doubly alienating effect of mirrors and perspective to produce a picture which distorts all natural relations. Wine, coffee and cigarettes are all sustainers of life in an artist's world that has thrown off all restraint, in which the mirror image of things is experienced more truly and intensively than the things themselves, in which, viewed from a "normal" standpoint, everything seems to stand on its proverbial "head". In 1927 there was not another photograph like it, at least not in Germany.' (Herbert Molderings, *Fotographie am Bauhaus*, p. 36.) After turning his back on photography for a short time, Umbo took it up again in 1933 as a commercial artist

94 Herbert Bayer, Portrait of Ilse Gropius, *1928.*

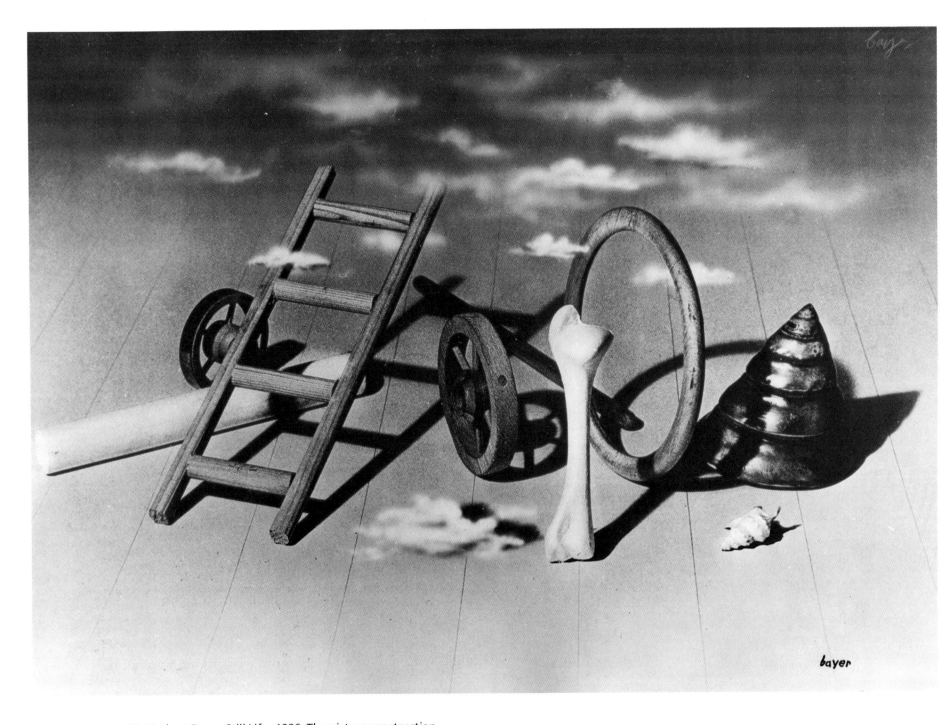

*95 Herbert Bayer, Still Life, 1936. The picture construction
is reminiscent of Salvador Dali's surrealist paintings.*

and local reporter. Between 1957 and 1974 he taught photography, and died in 1980 in Hannover.

Florence Henri, who spent part of 1927 at the Bauhaus, where she made remarkable photographic portraits of the teachers and others, is a figure whose work would virtually have been forgotten, had it not been preserved by Anne and Jürgen Wilde at a Cologne gallery. Originally a painter, she studied with Léger and others in Paris, and with Moholy in Dessau, where she started to take photographs. Back in Paris she discovered the possibilities of achieving certain photographic effects with mirrors. In the years that followed she took photographic still–lives which followed the Cubist painting tradition. Only in the

1960s, after she had returned to painting, were small exhibitions of her photographic work mounted. Florence Henri died in 1982, in France.

Herbert Bayer, born in 1900 in Upper Austria, trained in typography before beginning his studies at the Bauhaus in 1921. In 1925 he turned to photography, and after completing his apprenticeship under Kandinsky, was made director of the print and advertising workshop in Dessau. Following an initial series of close-ups (some extremely close, in the case of portraits), he took further photographs in which the structures of things are more clearly worked out analytically, and with unusual perspectives. Adopting Moholy's ideas, Bayer placed increased significance on the colour gradations between black and white and frequently explored the possibilities of photo-montage. He applied his gift for graphic design to Bauhaus advertising, and in 1928 began work for a Berlin advertising agency. His series of surrealistic photographs, which Bayer himself described as 'photo plastics', brought a fresh stimulus to photography generally. The photograph itself now formed part of

96 Florence Henri, Fruits, *1929.*

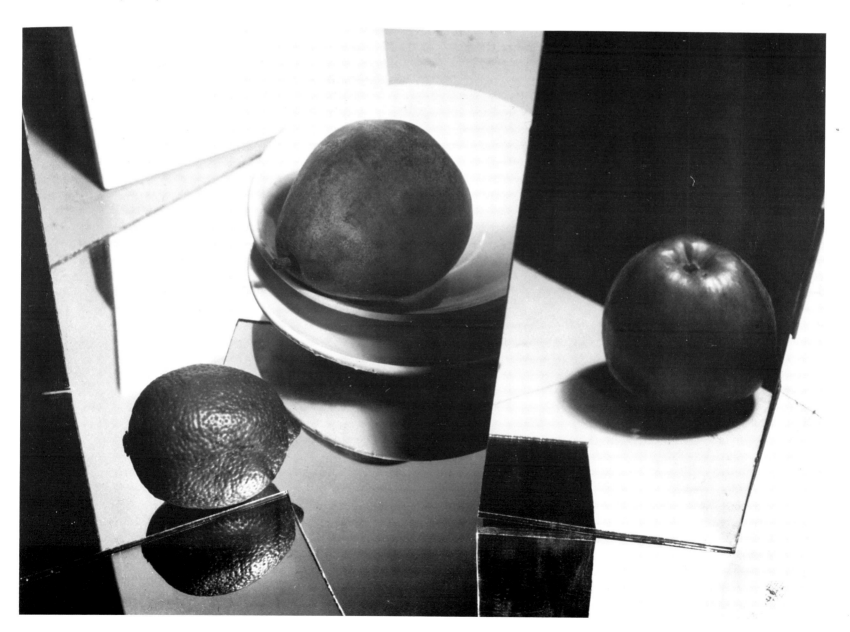

97 *Laszlo Moholy-Nagy,* portrait of Ellen Frank, *1929.*

the construction and composition of the picture, in a process which demonstrated strict objectivity and great skill and craftsmanship. The creation of series, as on an industrial conveyor belt, fascinated him and inspired him to see everyday things in new ways. Bayer's contact with the Surrealists, including Salvador Dali, with whom he spent his winter holidays, had a pronounced influence on this genius of photography and form. After moving to the USA in 1938, he was much involved in extensive design projects, at the Aspen cultural centre for example, and as an artistic advisor to the Atlantic Richfield Company.

The Bauhaus Stage

On 4 March 1929, a theatre critic wrote in the *Berlin Boersen-Courier,* ' . . . the stage at the Bauhaus has recognized its own special mission. It is the art of movement in relation to the pure expression of space and the pure expression of material; the integration of human rhythm into the rhythm of absolute structure. Today it is what we might in the broadest sense call "dance". It is a path between Wigman and Granowski. If prominent figures from the dance world show themselves on it, then it may be called art. In Dessau, it remains more idea, will, or doctrine. But it does stimulate.' (*Experiment Bauhaus*, p. 256f.) These lines can scarcely have caused Oskar Schlemmer himself any distress. He was aware of how advanced his theatrical method was, and expected his pieces to encounter resistance. Yet it would be misleading to describe the performances as pieces. If the traditional aim of theatre was to convey messages and to communicate in the form of drama or comedy, and if the sets and actors

were intended to create an illusion of reality, then Schlemmer's work marked a break with tradition. Before portraying anything, theatre was to be reduced to its original elements, namely light, figural arrangement and sound in an artificial space. 'The human being in space . . . as the original theatrical situation, is the starting-point for his considerations. Schlemmer presupposes the cubic abstract space of the stage as a creation of proportion and numbers, consisting of point, line, surface, flat forms and bodily forms. If these formal elements are joined by light, colour and movement, the result is what Schlemmer calls the "stage for an optical event", which includes man only to steer its mechanism.' (Dirk Scheper, *Experiment Bauhaus*, p. 251.) Schlemmer distinguishes between mechanical movement motivated by the understanding and organic movement motivated by feeling. Both, ideally, should be combined in the dancer. These views were also evident in his earlier ballet products in Stuttgart. After Schreyer's departure from Weimar following a dispute, Schlemmer succeeded him as stage director in 1932 and continued to experiment. Particularly impressive were the costumes he made in the workshop, which he developed as four types. First, if the space is cubically determined, the costume responds by being cubical also. He calls this 'changing architecture'. Second, if the laws according to which the human body functions in space (i.e. its physiology) are the determining factor, a so-called puppet costume is designed, which reacts in its own way to the performing space. Third, if the 'laws governing the movement of the human body in space' are expressed on their own in a costume, the result is the 'technical organism':

The fourth basic type of stage costume is intended as the visible expression of what Schlemmer calls the 'metaphysical anatomy' of the human being. It illustrates the concept 'dematerialization', by stressing,

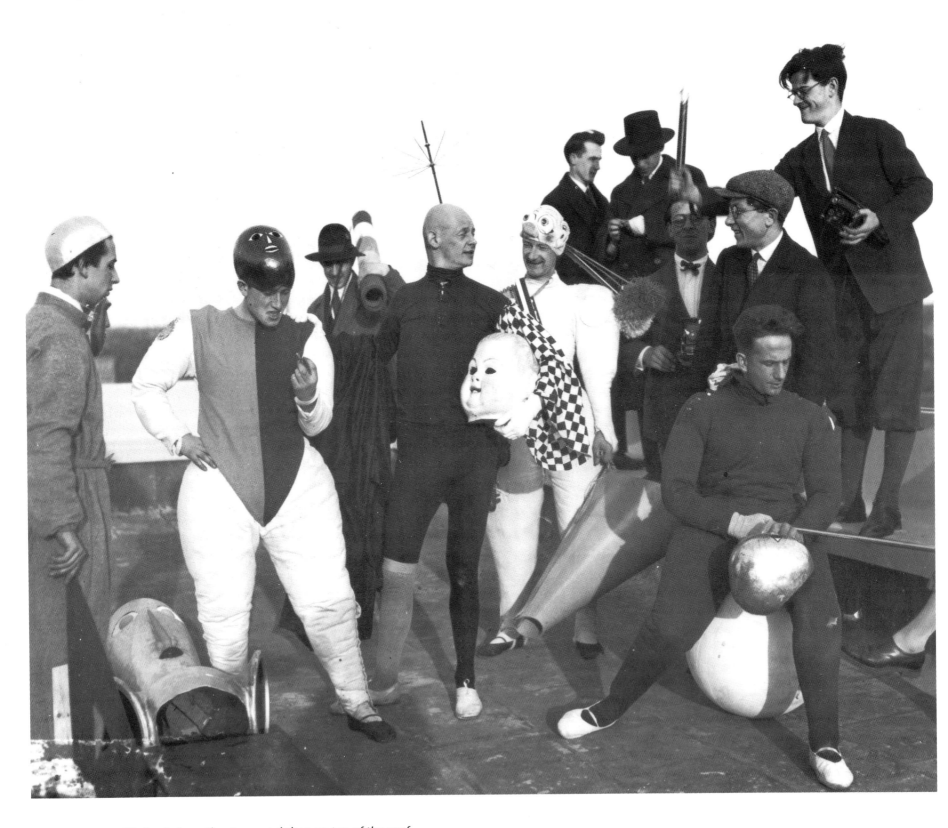

98 *Pupils from the stage workshop on top of the roof
in Dessau, 1927. Oskar Schlemmer in the middle of the picture.
Photo by Irene Bayer.*

for example, 'the star shape of the open hand, the infinity sign of crossed arms, and the cross formed by backbone and shoulder', but also shows the division and dissolution of forms, as well as the deforming of the human body by costume . . . Schlemmer wants his costume suggestions, developed out of the elementary functions of costume and space, to be understood as basic types for contemporary stage costumes, from which a new individualization, 'appropriate to the actor's function and the meaning of the production', can emerge. (Ibid, p. 251f.)

Among the works performed with the co-operation of the students were: *The Figural Cabinet*, 1923; *Meta, or The Pantomime of Places*, 1924, on which the group around Kurt Schmidt worked, and *The Adventures of the Little Hunchback*, a puppet play of 1923/4 from an idea by Kurt Schmidt.

99 Oskar Schlemmer, Figurine Plan for the Triadic Ballet I, *pen, ink, watercolour, posterpaint and bronze on paper, 1924–26.*

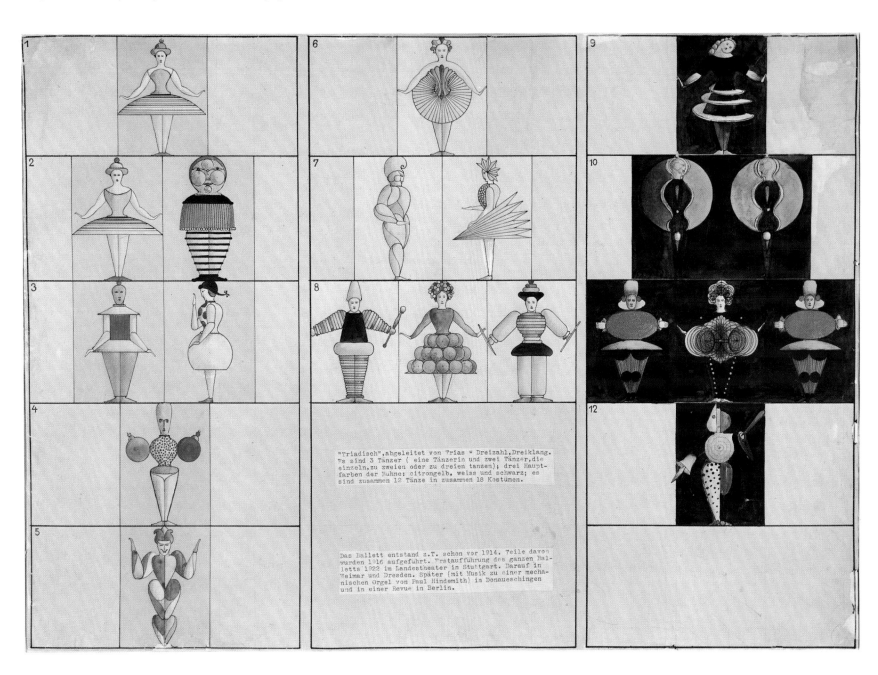

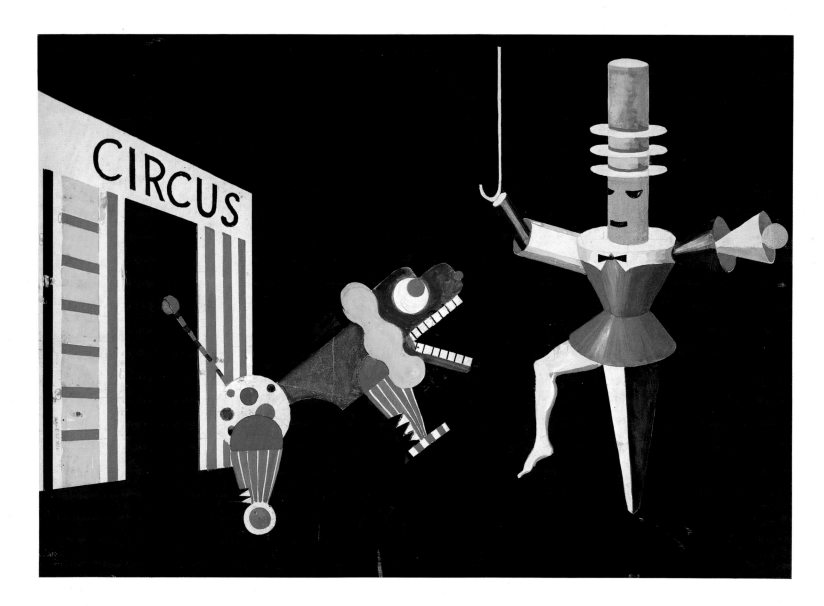

100 Xanti Schawinsky, Circus, *tempera, ink and silver bronze
on paper, c. 1924.*

In 1926, the newly constructed theatre in Dessau was named 'an experimental stage for dancers, actors and directors', reflecting its purpose more clearly. There were many experiments with new seating arrangements for the spectators, which provided a different viewpoint for the audience from the usual one facing the stage. There was also, until 1927/28, a series of experimental workshops and performances. The Darmstadt ballet teacher, Manda von Kreibig, helped to gain a more prominent role for dance, which was becoming more professional. Moods and themes almost reminiscent of the Commedia del Arte were expressed through dance, also by other dancers such as Palucca, during the 'wild' Twenties in Berlin. Schlemmer worked together with von Kreibig in 1928–29 on a tour programme which included the following elements: dance of slats, dance with hoops, dance in space, dance of forms, dance of gestures, dance of the stage wings, game with building blocks, dance in metal, glass dance, women's dance, and the masked chorus. All the pieces were performed to piano accompaniment, and various percussion instruments were added, such as sirens or alarm clocks. There were guest performances in Frankfurt, Basel, Stuttgart, Breslau and Berlin, although

101 Kurt Schmidt, The Man at the Keyboard, *tempera, ink and silver bronze on paper, c. 1924.*

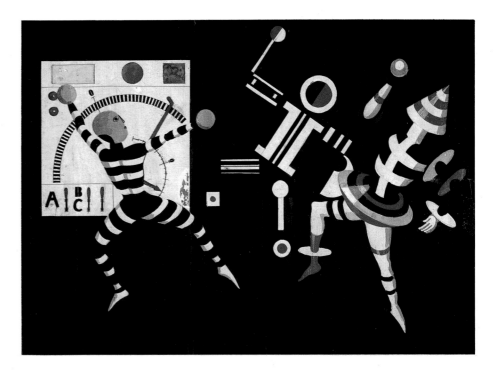

Schlemmer was modest enough to describe them as purely experimental. When Hannes Meyer took over from Gropius as director and the emphasis shifted to more technological considerations, Schlemmer's work became the subject of dispute and was accorded less recognition. As life in general at the Bauhaus became increasingly politicized, he was criticized for his 'unpolitical' approach in the theatre. After Schlemmer's departure in 1929, the Bauhaus theatre ceased to function.

102 Heinz Loew, mechanical stage, model, 1927.

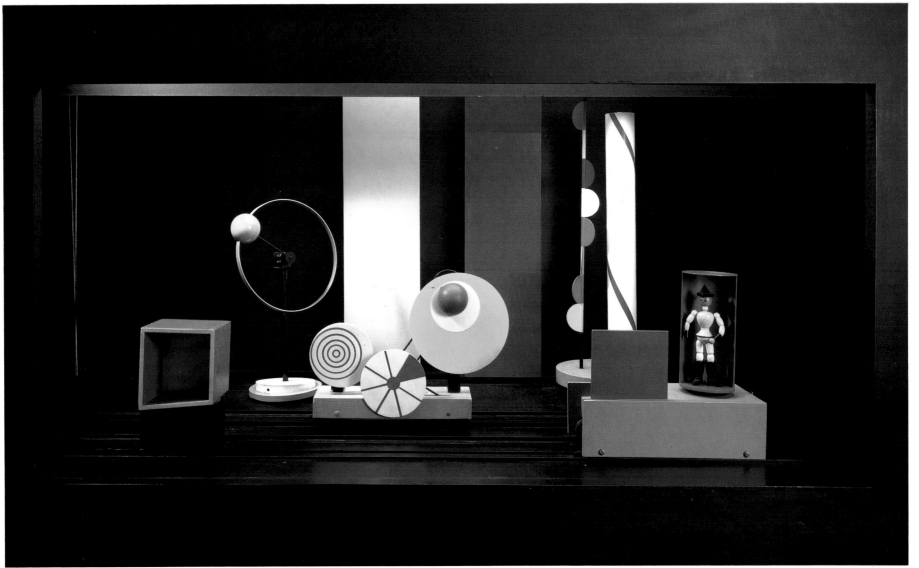

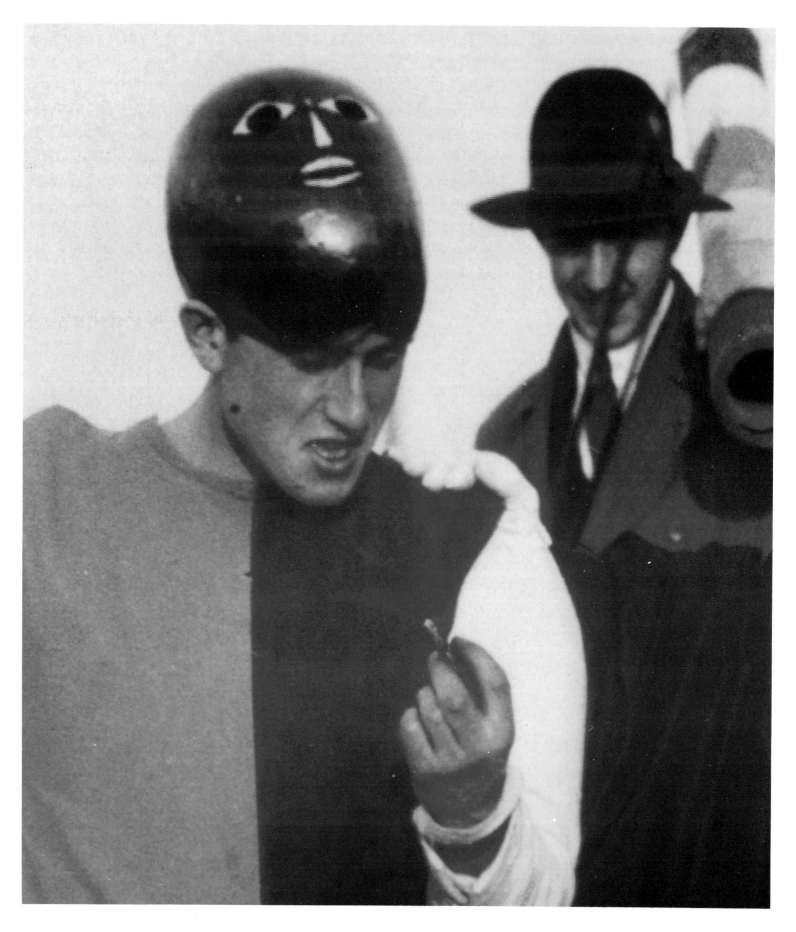

Details from 98 **103** *(above)* **two students.** **104** *(opposite)* ***Oskar Schlemmer and student.***

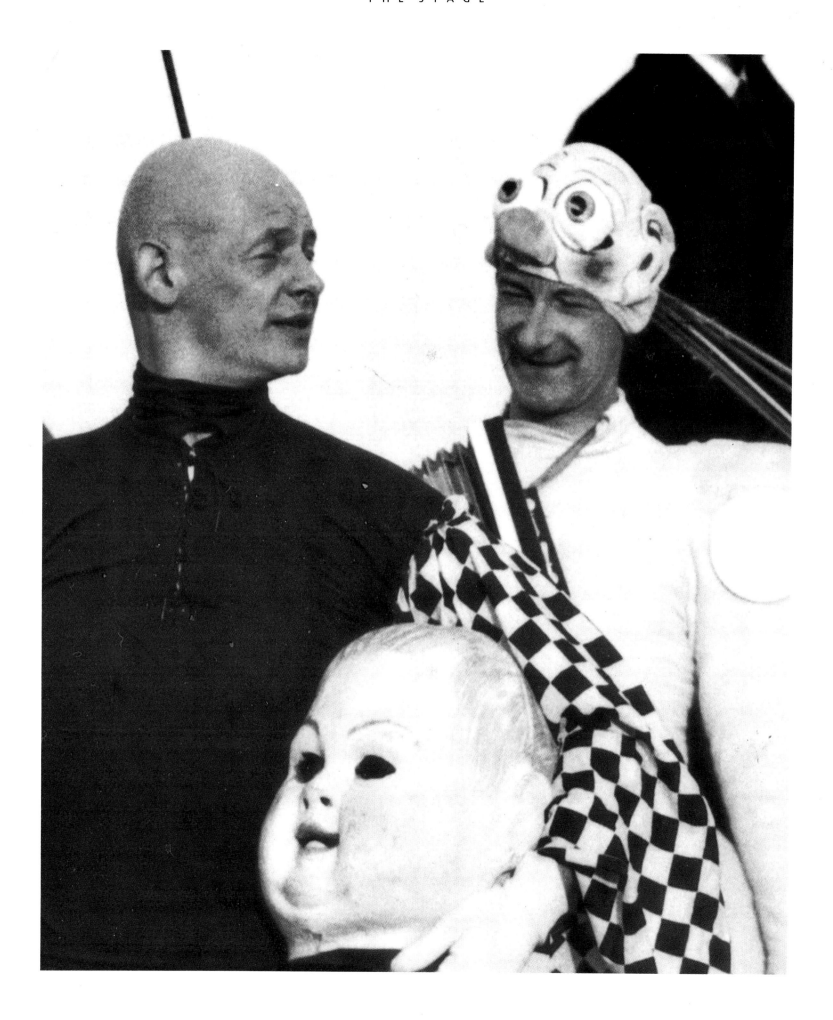

The Wall-Painting Workshop

Johannes Itten, who directed the wall-painting workshop (established in 1919), earned as little applause for his proposals for the Bauhaus walls at Weimar as the students did with their spontaneous decorating. Although Itten had a preference for darker shades, in 1920 the newspapers were continually raging at the motley mixture of colours being gleefully applied to the Bauhaus corridor walls by the students. Typically for the Bauhaus, there was intense discussion over the question of what the wall paintings should look like, and various serious suggestions were made, even for painting the canteen. Lou Scheper remembers:

In its early period the workshop was like everywhere else in the Bauhaus: here, too, the functional approach to work was combined with play. So when the canteen was being painted, the walls and the ceiling constructions, the last corners of which could only be reached by throwing up sponges soaked in paint, became a rough and tumble of swirling small-scale decorations in vibrant colours. Unleashed by Peter Roehl, we gaily painted and squirted away together with a bad conscience, for we were aware that what we were doing was completely unfunctional and inappropriate in a room intended for eating and relaxation. And all this at a time when people were already starting to talk about the psychological effect of colour, then being methodically taught at the Bauhaus! Itten, who made the rules, demanded that we cover our expressive excesses with a friendly, contemplative greyish green, as the background for an oriental maxim to edify us during meals. (Christian Wolfsdorff, *Experiment Bauhaus*, p. 283.)

Walter Gropius himself had no particularly clear idea of the workshop's purpose. He made suggestions, for

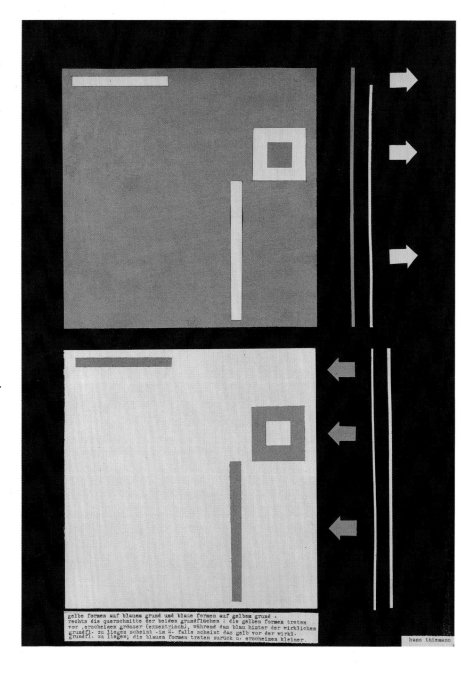

105 Hans Thiemann, Yellow shapes on blue background – blue shapes on yellow background, 1930.

instance, that the Weimar town hall be painted by Bauhaus students, but the citizens reacted less than enthusiastically and his request was turned down. The new colour theories of the Bauhaus were not universally appreciated when in 1922 he painted an eighteenth-century Weimar house cornflower blue. Kandinsky, the workshop's first director, was particularly interested in

106 Oskar Schlemmer, Bauhaus Stairway, *oil on canvas, 1932.*

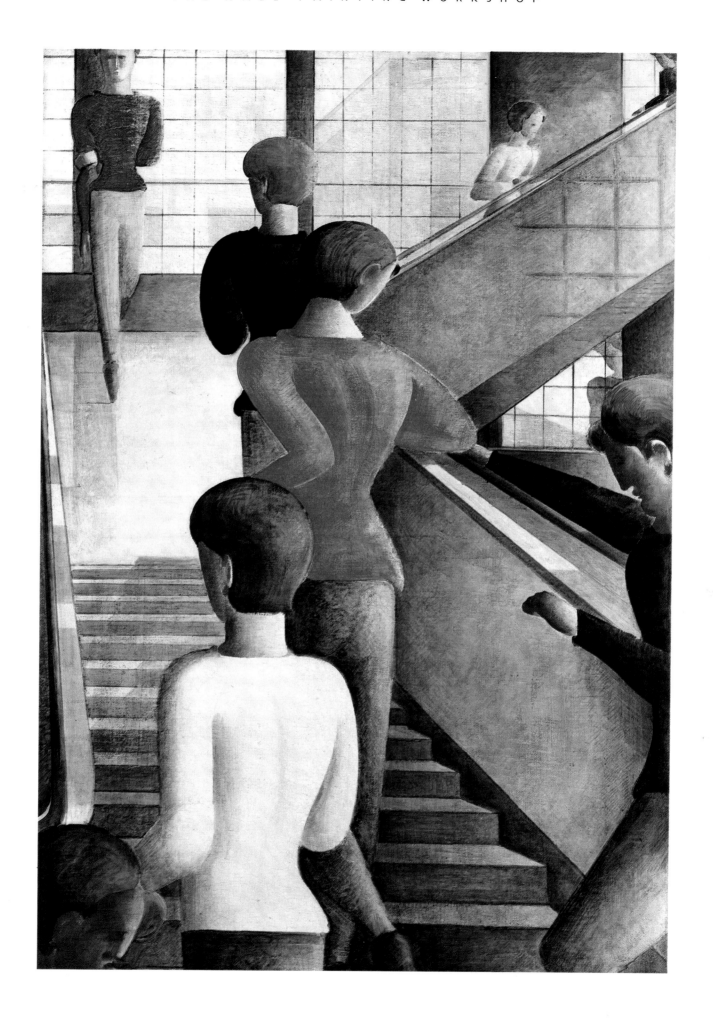

107 *Herbert Bayer, kiosk design, tempera and collage on paper, 1924.*

wall-painting as a larger-scale extension of his own painting. Oskar Schlemmer, who took it in turns with Itten to run the course until 1922, produced a few murals, but these were similarly oriented towards his other work. Only after 1923 was there a teaching plan which included a variety of techniques and exercises in wall-painting. This introduced the possibility of creating spatial effects with colour, and distinguished between two basic variations:

1. *Concurrence of the colour with the given form, so that the effect of the latter is enhanced, giving rise to a new form:*
2. *the conflict of the colour with the given form, so that its form is transmuted.*

One of these two forces must necessarily be employed whenever colour is applied to form.

The resulting power of colour to shape the given room in this way or that is one of the most important concerns facing the Bauhaus. (Ibid, p. 284.)

Kandinsky, as well as Gropius, associated colour in space with the possibility of creating tension by pairing opposite colours. The psychological effect of colours was also taken into account and utilized by Hinnerk Scheper, director of the workshop from 1925, who concentrated mainly on the painting of exterior walls. After three years as an independent architectural planner, Scheper's experience was varied, and he worked on colour schemes for clinics as well as historical museums such as the Folkwang Museum in Essen. Stressing the use of pastel shades, he avoided primary colours. Stronger tones were used only to emphasize the parts of buildings that were architectonically significant. In 1926 he also developed his own course for the students in Dessau, dealing with

108 *Florence Henri, Non-Objective Composition, oil on board, 1926.*

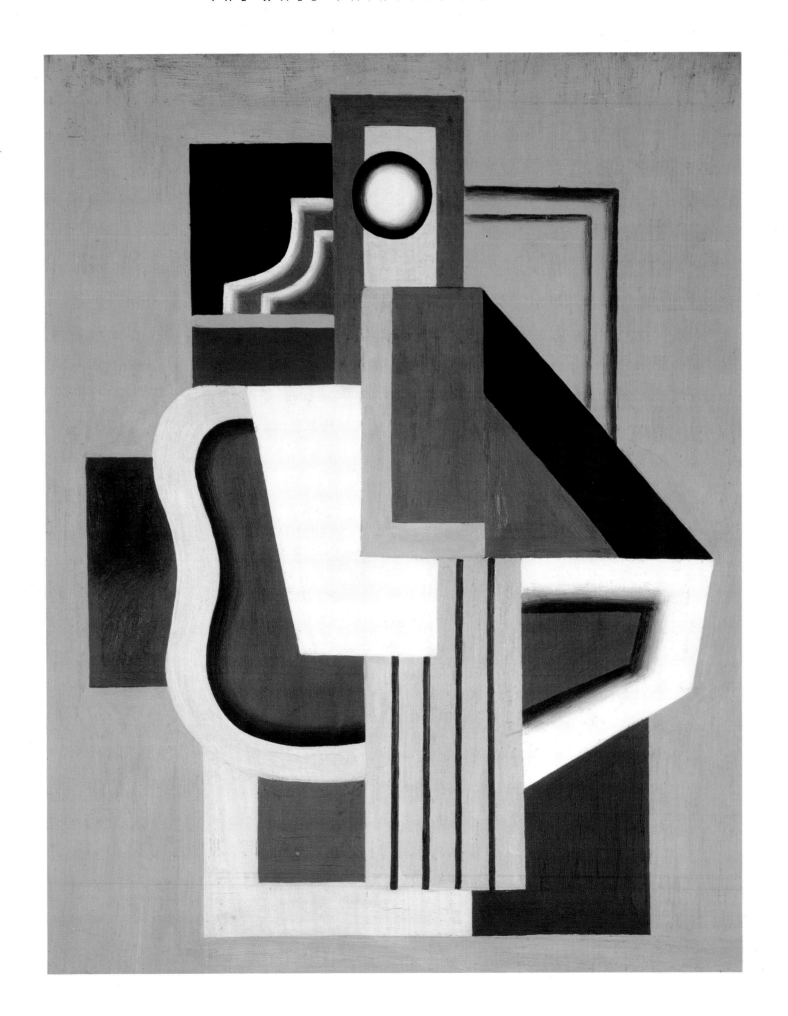

questions of colour. Since neither Scheper nor the other workshop teachers have left behind any written notes on a particular teaching method for wall-painting, the history and extent of the workshop's influence remain somewhat obscure. Although Scheper, Kandinsky and Gropius were certainly familiar with the great murals in Mexico, it is not known whether these had any influence on the Bauhaus. Hinnerk Scheper accepted an invitation to Moscow in 1929, where he received numerous commissions to carry out exterior design work on housing estates.

A small but highly lucrative sideline for Scheper and the workshop was the development of wallpapers. As early as 1929 the small collection of Bauhaus wallpapers, produced by a firm near Osnabrück, was distributed to a number of wallpaper dealers. (Hannes Meyer was ultimately responsible for the workshop also being able to operate as a business.) In the years that followed, wallpaper designs at the Bauhaus concentrated on small patterns, profiting from investigations into a variety of materials.

The Ceramics Workshop

If any one workshop illustrated the Bauhaus manifesto's almost medieval tendency towards craftsmanship, then that workshop was the Bauhaus pottery. One reason for this may have been that, due to a lack of space in the Bauhaus at Weimar, the pottery moved to a traditional handicrafts centre which already existed in Dornburg, 40 kilometres away. Another reason, however, was clearly the nature of the work itself. The production of vessels, pots and bowls is one of the oldest craft forms in human history, as archaeological excavations all over the world continue to show. Clay is a natural substance, and pottery calls for skill, an understanding of form, a

knowledge of the object's function, and artistic ability.

It is no coincidence, then, that the ceramics workshop was located at the centre of the Thüringen potteries, which are still in operation to this day. The seven groups of students who attended therefore received a form of training entirely in accord with traditional pottery craftsmanship. Gerhard Marcks, who had previously worked with the sculptor Richard Scheibe, was artistic director of the workshop. Master potter Max Krehan was employed as a handicrafts teacher in September 1920. The students (who included Marguerite Friedlaender, Johannes Driesch, Otto Lindig and Theodor Bogler) found in him an instructor who taught pottery the old, traditional way. Marcks also devoted himself particularly to experimental work in clay and ceramics. In due course, numerous new forms were produced which attracted attention at the first Bauhaus exhibition in 1923. Some of the pieces were then sold to industry, where they were used as production models. In a letter to Marcks in 1923, Gropius combined words of praise with some advice concerning this work: 'Yesterday I looked at the many new vessels you have made. They are almost all unique, and it would be wrong not to seek ways of making the fine work you have achieved in them available to more people . . . We must find ways of reproducing some of the pieces by machine.' (Klaus Weber, *Experiment Bauhaus*, p. 58.)

Marcks, in an oversensitive reaction to Gropius's proposal, warned him against turning too quickly to industry, since that would mean the workshop developing into one of many production centres. For Marcks, the craftsman's training was of paramount importance. Like Itten before him he inevitably quarrelled with Gropius. At the beginning of 1924, Otto Lindig took over as technical director, and Bogler as business director. Marcks left the Bauhaus at the beginning of 1925. Negotiations with the state manufacturers of porcelain in Berlin led to sales of the

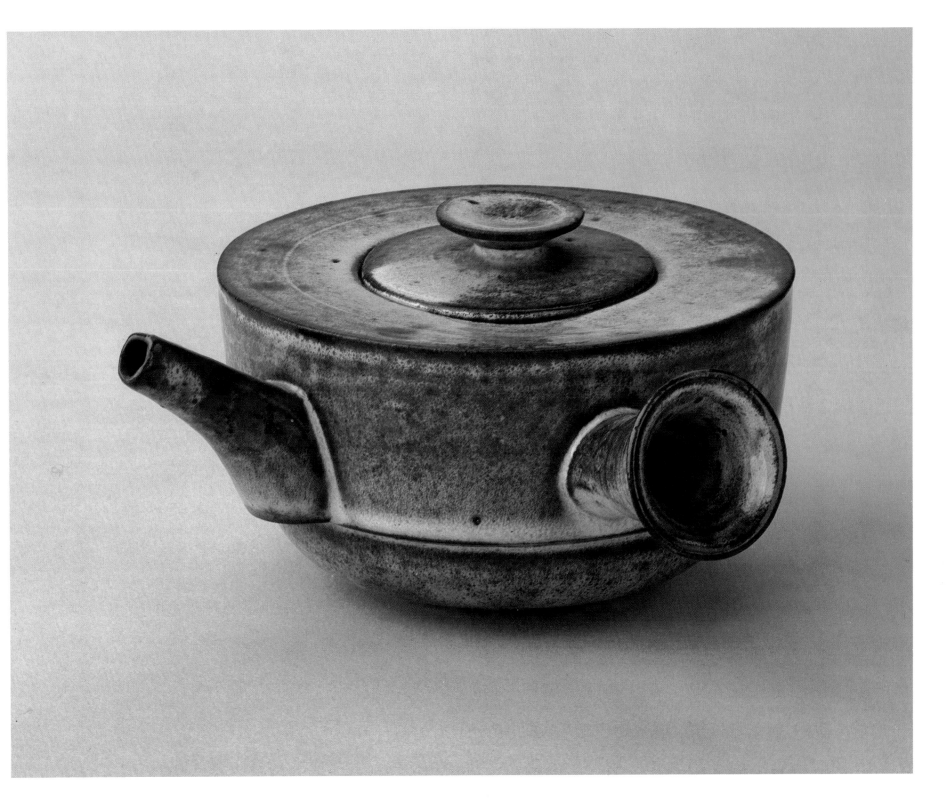

109 *Theodor Bogler, little teapot, 1923.*

plaster moulds developed, particularly by Bogler, for articles of tableware. Yet industry was still reluctant to place large orders, despite the positive response enjoyed by the workshop when it took part in fairs at Leipzig and Frankfurt. Although Bogler withdrew, Otto Lindig continued the Dornburg pottery as part of the Bauhaus, before assuming full responsibility for it himself in 1930.

127

110 Margarete Wildenhain-Friedlaender, jug, 1932.

111 Max Krehan (shape), Gerhard Marcks (decoration), bottle with handle. A work showing the clear influence of Marcks.

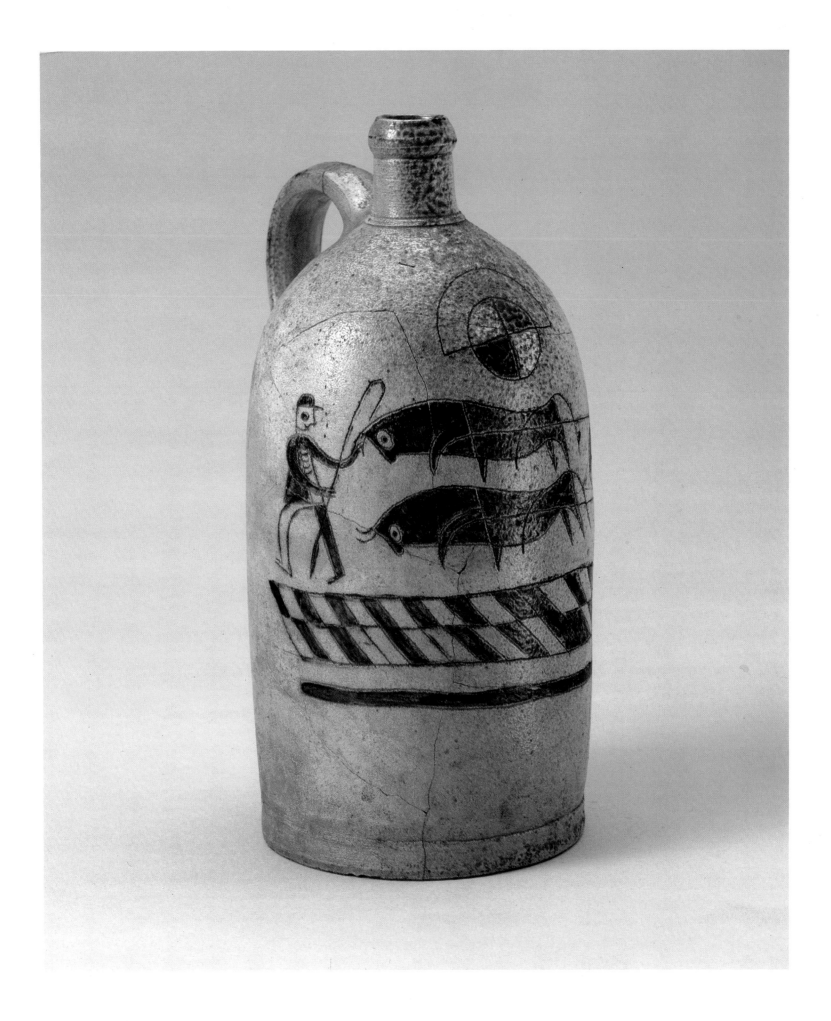

Although the history of this workshop produced less spectacular results than the other workshops, during its short period of operation it provided important stimuli for ceramic forms.

The Weaving Workshop

Because it was able to take over the looms of van de Velde's old school in Weimar, the weaving workshop was one of the first to start work at the Bauhaus. Initially the syllabus included many aspects of textile production, including crochet, knitting and sewing:

113 Gunta Stölzl, tapestry, 1926/27.

yet within a short time the workshop was specializing in designs for industry. From 1921 Georg Muche was artistic director and he lost no time in promoting the production of textiles with forms influenced by Itten. Due to the lack of well-qualified teachers in the subject, many women students began to experiment with weaving, using basic colours and forms from the preliminary course. Even so, breaking the ties with traditional woven motifs for carpets and wall-hangings, for example, was no easy matter. Only under the growing influence of Kandinsky and Moholy did work

112 Weaving workshop in Weimar, 1923.

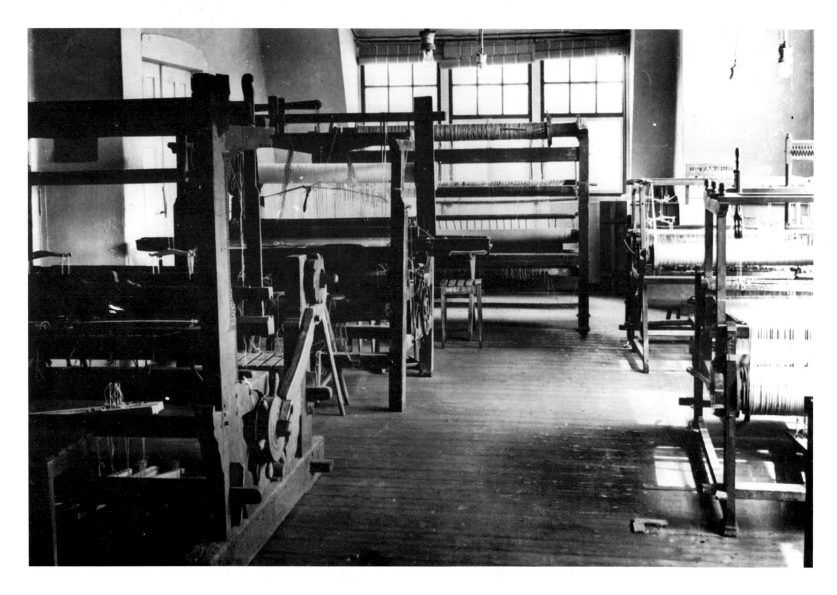

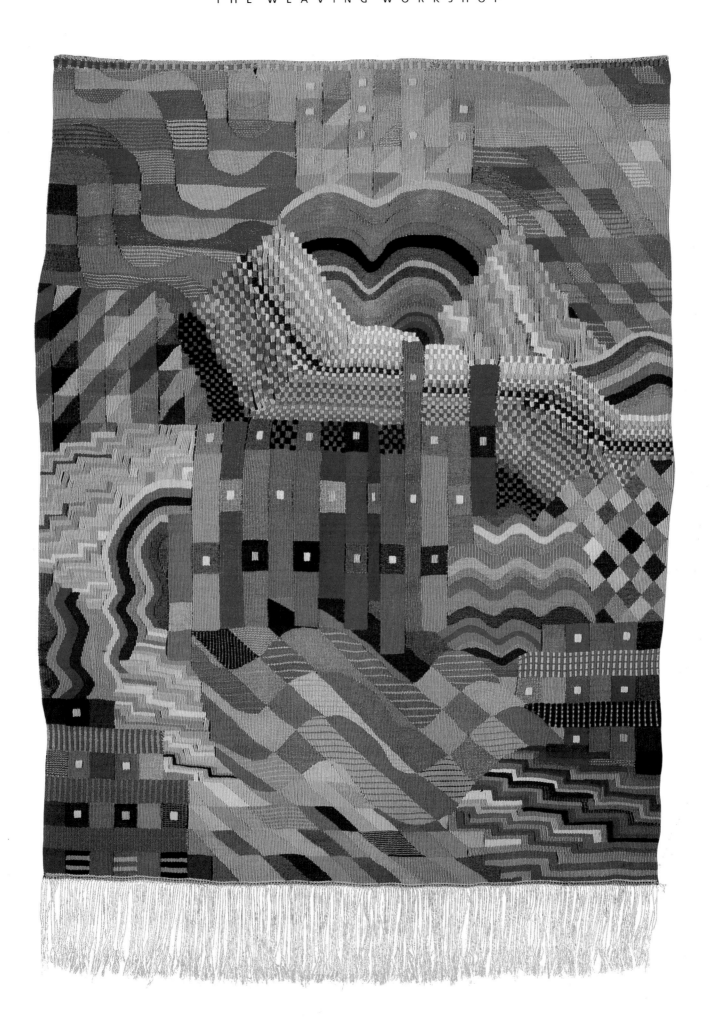

here achieve a clarity of expression that was in line with what the other workshops were creating. The weaving workshop produced numerous carpets, curtains and wall-hangings for the Weimar Bauhaus exhibition in 1923, and because of its close involvement with the

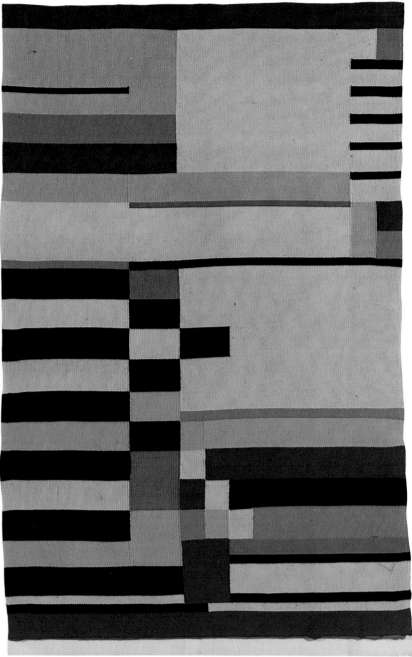

114 Gunta Stölzl, outline for a carpet, gouache on paper, c. 1926.

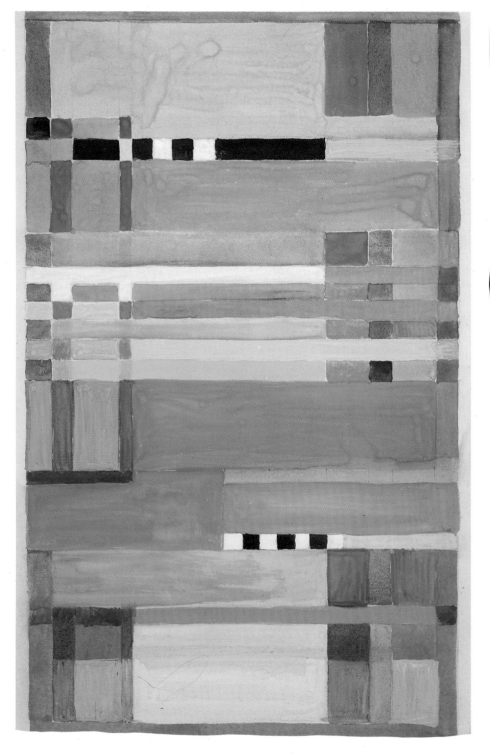

115 Ruth Hollos-Consemüller, tapestry, c. 1926.

other workshops it received a variety of commissions that kept it in touch with developments elsewhere in the institution. By 1925, it had produced quilts, carpets, children's clothes and ribbons, as well as chair covers.

Gunta Stölzl, a pupil of Itten, proved to be the most talented of the 130 or so students. After the move to

116 Anni Albers, tapestry, 1926.

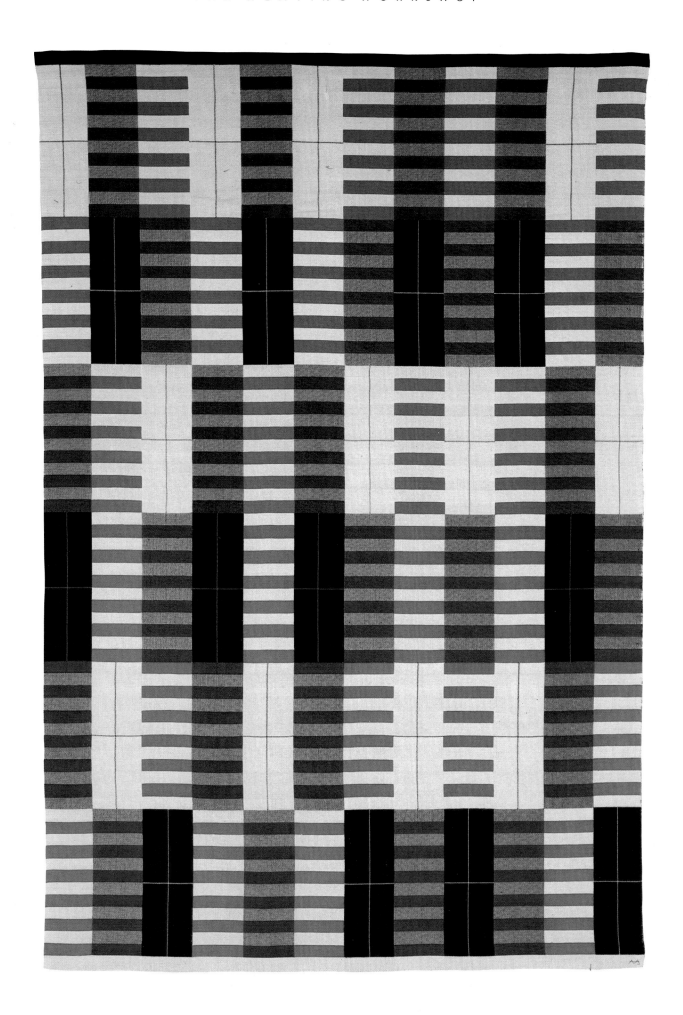

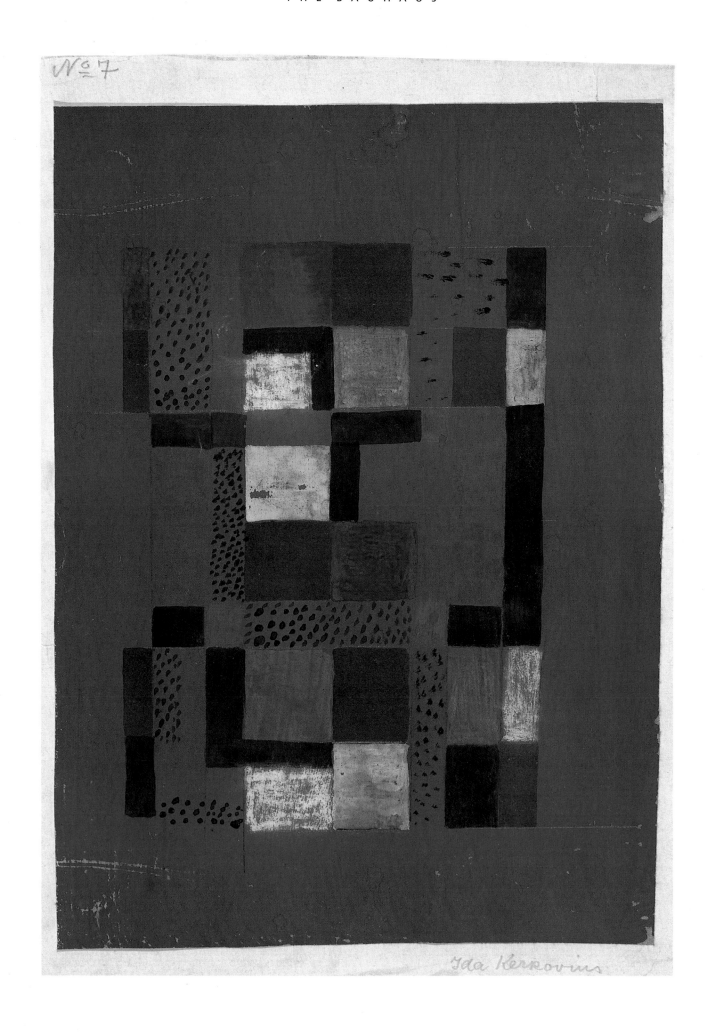

Dessau, she was entrusted by Gropius with establishing the new workshop. In 1927, after Muche had left the Bauhaus, she became director of the weaving workshop, and, with the benefit of her previous experience, was able to renew contacts with industry. Designs were sold to firms in Munich and Stuttgart, which were then produced there under licence. Clearly, though, the workshop's capacities were not being fully exploited, possibly because its achievements were underestimated by Gropius. Indeed, there was a general prejudice against the weaving workshop, and some, like Moholy, talked very disapragingly of the women there. Gropius himself, distinguishing, albeit euphemistically, between 'the beautiful and the strong sex', contributed little to the reputation of the workshop (though he was quick to claim its products for his office). The main cause of the weaving workshop's difficulties, however, was the fact that the possibilities inherent in textile design were not being properly recognized. In that respect, little has changed to this day. Of course the financial crisis which affected the whole school during the Weimar period was also responsible for work potential not being exploited. The emphasis on craft skills was very slow to loosen its grip on the workshop, despite the staunch efforts of Gunta Stölzl. She tried, with courses on dyeing and the mechanized manufacture of materials in factories, to introduce a more professional approach to work, but her days at the Bauhaus were numbered. Political quarrels and intrigues led to her resignation in 1931.

Stölzl was replaced by Lilly Reich, who was invited to the Bauhaus by Mies van der Rohe. As the pre-eminence of architecture now became increasingly pronounced, the weaving workshop lagged further and further behind as one of the institution's attractions.

Its influence was principally in two areas. Firstly, the

theories on colour and form developed by the various Bauhaus teachers were absorbed into industrial manufacture: new designs were produced which found their way into people's homes. Secondly, it was realized, only many years later, that weaving was a field of artistic expression in its own right, on a par with painting and sculpture. Many examples may still be seen today of the influence of Bauhaus textiles in design work – at tapestry exhibitions, for example in Italy, or at the Documenta in Kassel. Gunta Stölzl left for Switzerland in 1931, and until her death in 1983 worked mainly on carpets, and as a designer of textiles.

How a Whole is Produced from Many Parts: Architecture at the Bauhaus

There is a much repeated phrase, which tends to be uttered on such public occasions as the formal opening of an important building or the laying of a foundation stone, or at exhibitions, or indeed any event where the champagne is flowing and art is in the air: 'Typical Bauhaus!' If a house shows a clear, practical use of line, and a well-planned structure, the names of Gropius or Mies van der Rohe inevitably crop up in conversation. Such supposedly profound knowledge of 'Bauhaus style' is calculated to inspire awe in those listening with rapt attention. Yet at the same time the name 'Bauhaus' is simply not used today in connection with supermarkets, with Italian designer chairs or with fasion. In other words, there is an inability to grasp the complex and partly contradictory nature of the period when the Bauhaus was a developing influence.

Looking for a 'Bauhaus style' of design is an altogether futile pursuit – there was no such thing. Similarly, in architecture there was no 'Bauhaus house'.

117 Ida Kerkovius, outline for a wall carpet, tempera and pencil, 1921.

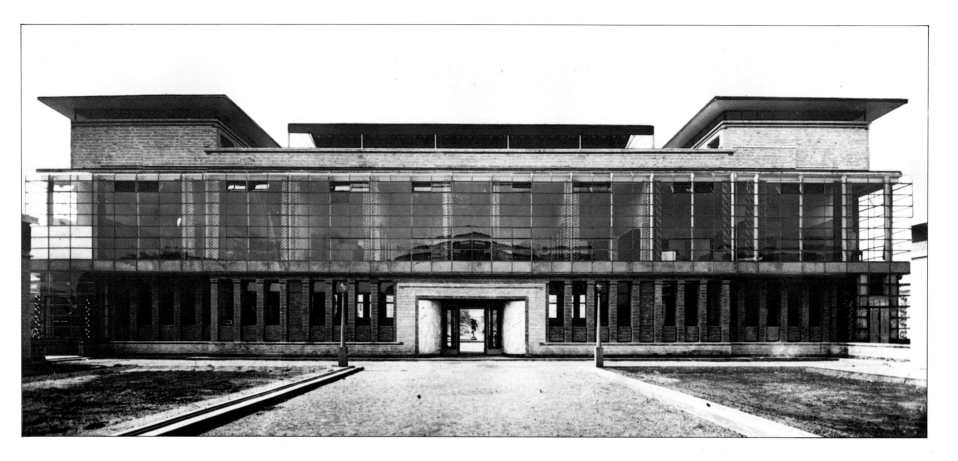

119 *Walter Gropius, design for the Deutscher Werkbund.*

Yet why is there such a desire to simplify and stylize, particularly when Bauhaus architecture is being discussed? The answer is to be found solely in our present-day attitudes towards architecture. Buildings have become another form of prestige symbol. There is nothing wrong with symbols – as long as there is something for them to symbolize, they will exist. Nor is there any point in reopening the discussion as to whether high-rise buildings should exist or not. Instead it is our concept of achitecture as a whole that can provide the key to an understanding of the Bauhaus.

There can be no doubt that the spirit behind the founding of the Bauhaus in 1919 supplied the basis for its subsequent development. The overturning or rejection of traditional, outmoded values led to new ideas which culminated in this unique institution. The

118 *Rudolf Lutz, preliminary course, probably with Itten.*

result was not a uniform entity but a cross-section of the various currents of the time. For this reason, any attempt to standardize the activities of the Bauhaus, however well-intentioned, betray a misunderstanding of the subject.

Even Bauhaus enthusiasts may be surprised to discover that, despite the promise expressed in the 1919 Manifesto, it was not until 1927 that the teaching of architecture was finally organized into a structured programme at Dessau. Before that architects received their training in the office of Walter Gropius and his colleague Adolf Meyer. At the time, in fact, the professional label 'architect' guaranteed nothing. Often people who called themselves architects had trained in building or technical drawing and attended a building trade school. 'The training involved co-operating on projects which Gropius and Meyer happened to be engaged in. Gropius also made constant efforts to

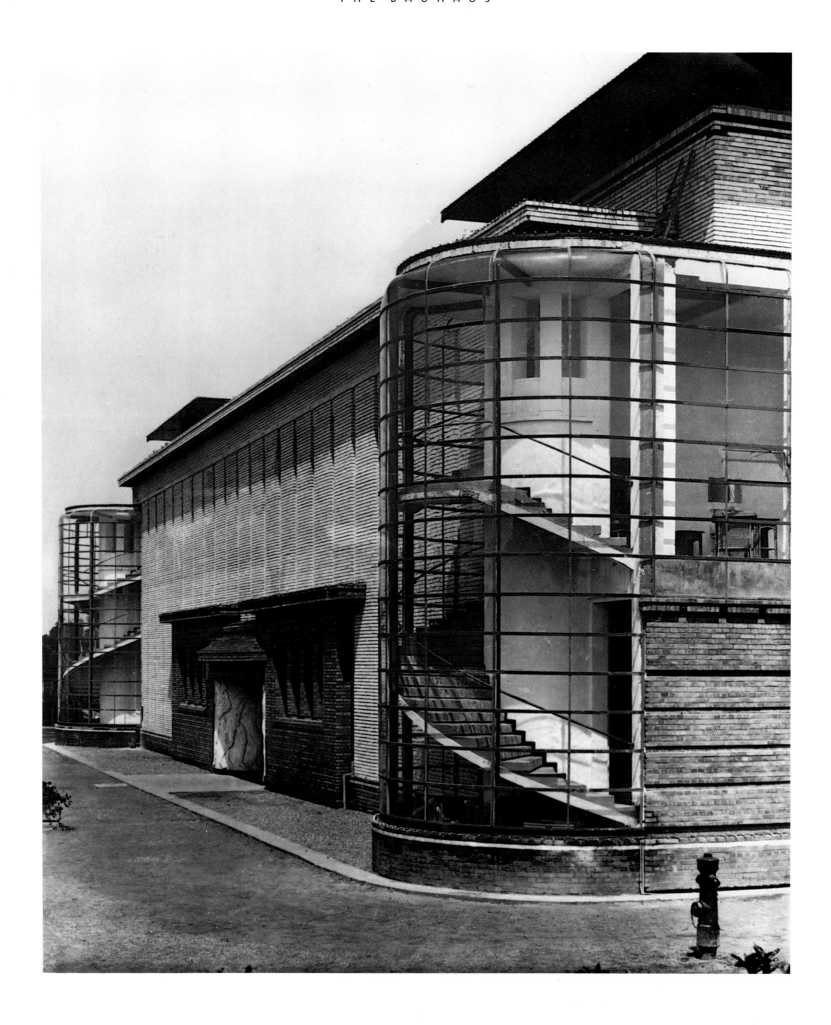

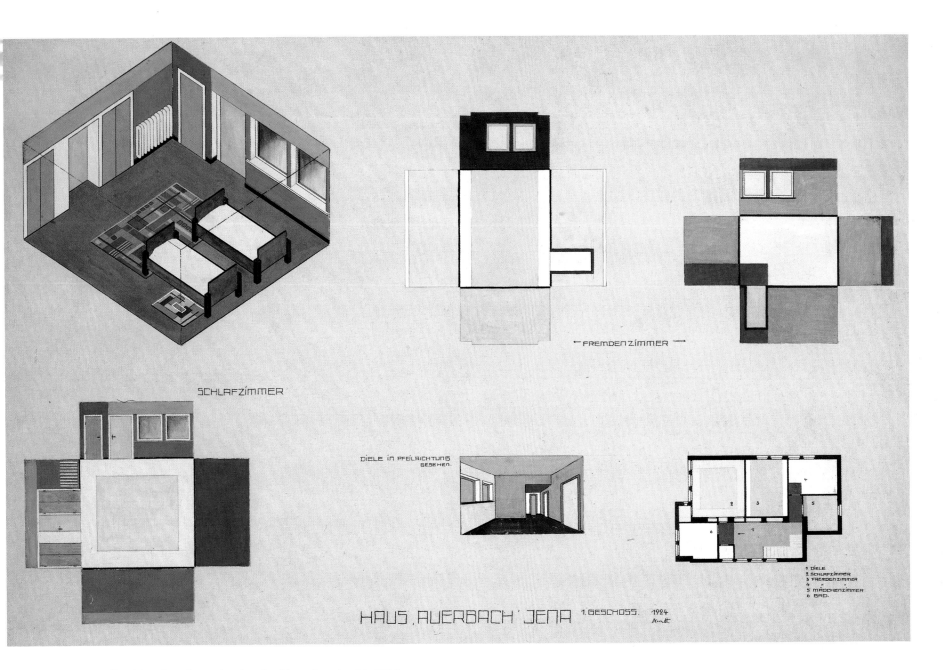

SCHLAFZIMMER

FREMDEN ZIMMER

DIELE IN PFEILRICHTUNG GESEHEN.

HAUS AUERBACH JENA 1. GESCHOSS. 1924 Arndt

1 DIELE
2 SCHLAFZIMMER
3 FREMDEN ZIMMER
4 "
5 MÄDCHENZIMMER
6 BAD.

121 Alfred Arndt, colour plan for the 'Haus Auerbach', 1924.

involve the Bauhaus workshops in carrying out commissions, though they never participated in projects at the formation stage . . . The most extensive and lengthy commission was the Bauhaus settlement, on which Fred Forbat at first worked alone. Later, further individual suggestions were permitted and the whole project was rounded off with the building of the "Haus

120 Walter Gropius and Adolf Meyer, office building in Cologne, visible staircase, 1914.

am Horn" in 1923.' (Christian Wolfsdorff, *Experiment Bauhaus*, p. 310.)

As director, Gropius clearly played an important part in selecting projects, and the workshops were integral to their further development, though not merely as centres supplying the various parts necessary to the whole. The 'Haus am Horn' provided a very clear example of how interdependent the individual areas were. Workshop autonomy went hand in hand with collective collaboration. The aim was to create a

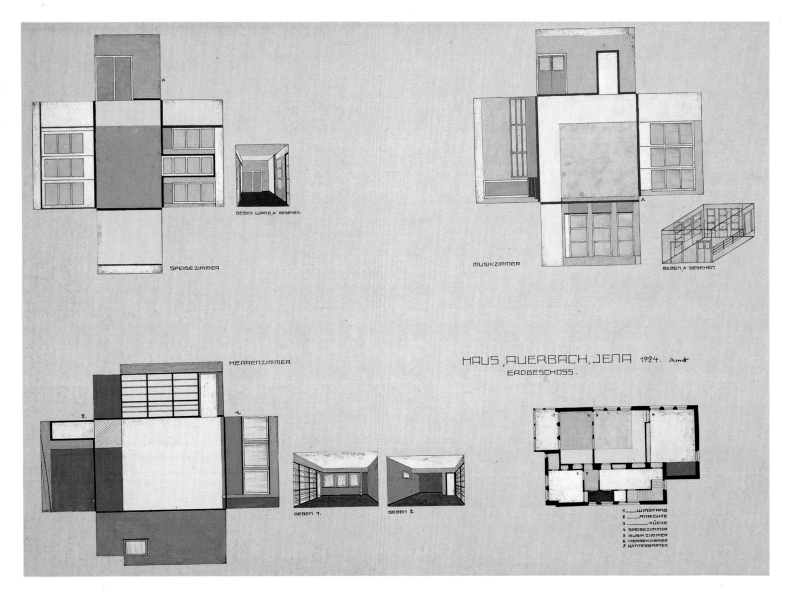

SPEISE ZIMMER

MUSIKZIMMER

HERRENZIMMER

HAUS, AUERBACH, JENA 1924. Arndt
ERDGESCHOSS.

122 Alfred Arndt, colour plan for the 'Haus Auerbach', 1924.

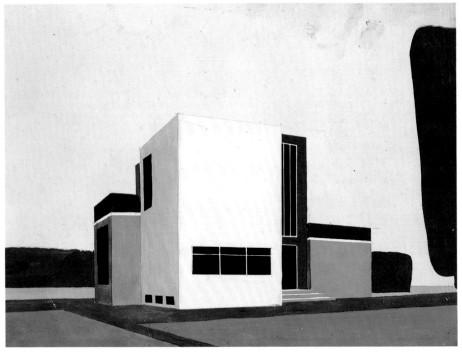

building in which the various arts and handicrafts would unite to produce a *Gesamtkunstwerk* (total work of art) for the benefit of the potential occupants. This was precisely what Gropius had referred to in his manifesto, and offers the only real key to understanding the creative impetus behind the Bauhaus. The future was being built – the architects left no-one in any doubt of that. Critics who are troubled because they find the designs too fantastic, should always bear this in mind. For whoever attempts to turn his back on tradition and

123 Farkas Molnar, outline for a one-family house, 1922.

outmoded structures – in whatever area – should be conceded the right to indulge his fantasy.

The 'Haus am Horn', finally realized in Georg Muche's designs, holds the distinction of having been the first building to be produced entirely under the direction of the Bauhaus. Together with Marcel Breuer and Farkas Molnar (the only trained architect), Muche further explored its theoretical aspects before publishing their findings in a memorandum in 1924. They proposed the organization of a 'working group for architecture', firstly to structure the training of young architecture students, and secondly to suggest concrete projects for its planning. All were convinced that the potential occupants of these houses would adapt to their aesthetic criteria: a new architecture for new people. Architectonically this was expressed particularly in the layout of the rooms. The tone was set by a large central area, around which were grouped the smaller, functional units such as kitchen and bathroom. The central room was to be a point of communication, to maintain and even to create social values. This idea was a revolutionary break with the tendency of contemporary house-building to create separate rooms, and yet it remained traditional in the sense that it sought to revive the ancient idea of the communal area. However, since the building materials were to be glass, concrete and steel, the new design was by no means a return to the cave. Futurist and Expressionist influences were both in evidence, the latter promoted by the Gropius Bauhaus Manifesto and its motto of art and craftsmanship in unity (though this idea, too, had some basis in tradition).

The designs of the group led by Breuer were ahead of their time. The idealistic notion that the new inhabitants were to share the aesthetic tastes of the architects should not prejudice our assessment of these works too much, as it reflected a general trend amongst intellectual circles of the left.

More representative of the Dessau Bauhaus were the five summerhouses on the estate at Törten, designed by Gropius in collaboration with Hannes Meyer in 1926:

Their special quality was their technical solidity and economical ground-plan. Each building comprised 18 flats, containing three rooms and ancillary rooms over just 48 square metres in surface area – without seeming cramped. The rooms were oriented to the garden side (South) and the staircases accommodated in a covered stairwell on the North side, from which the flats could be reached via open balcony-like access galleries (pergolas). This solution was a response to . . . social-hygienic and psychological considerations. Planning was preceded by systematic investigations into the effects of the environment, prospective neighbourly relations and other factors. (Hans Wingler, Bauhaus-Archiv Berlin (1989), p. 110.)

Following the introduction of these fundamental ideas about economizing in living space, still stronger reference was made to the industrial estate in the architecture course organized at the Bauhaus by Hannes Meyer in 1927, after he had taken over as director. He set out his ideas, which contrasted sharply with those of Gropius, in the Bauhaus publication *Bauen* (*Building*):

Building means the considered organization of life processes.
– The technical operation of building is therefore only part of the process.
– The functional diagram and economic program are the decisive guidelines of the building plan.
– Building no longer panders to the ambition of the individual architect.
– Building is a co-operative effort involving workers and inventors. Only he who himself masters the living process through working together with others . . . is a

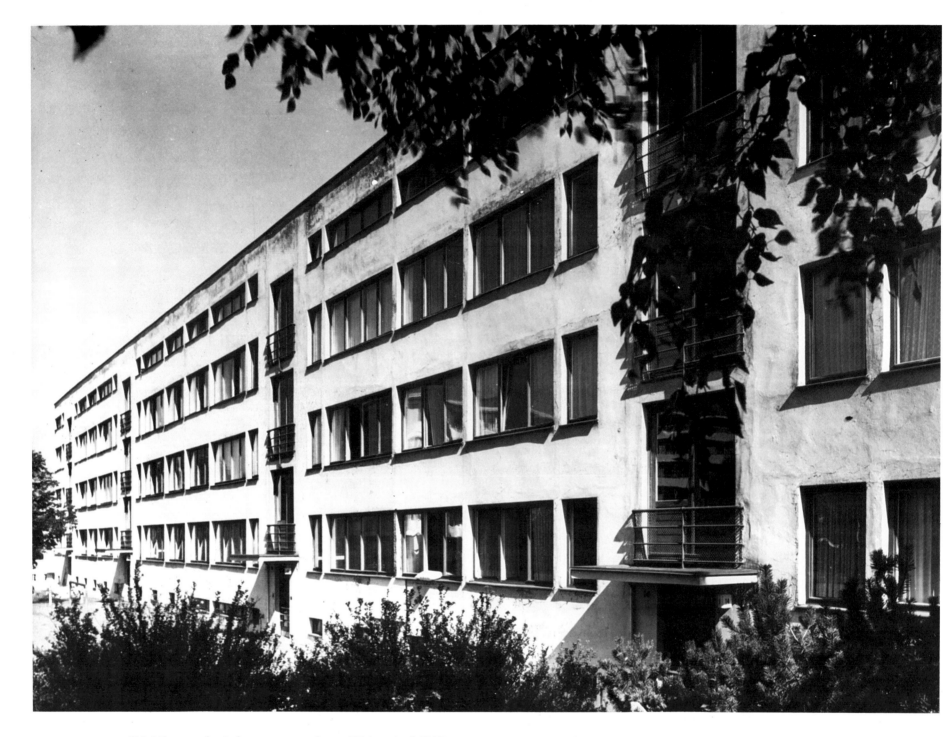

124 Mies van der Rohe, apartment house Weissenhof, 1927.
Street-side view. The houses were unpopular with the inhabitants.

master builder.
— Building thus changes from being the private concern
of individuals (furthered by unemployment and
homelessness), into the collective concern of comrades
of the people.
— Building is only organization: social, technical,

economic, psychological organization.

Hannes Meyer, who presumably had the Communist

125 and 126 Hannes Meyer and Hans Wittwer, Bundesschule
ADGB in Bernau, 1928–30. Designed in Dessau.

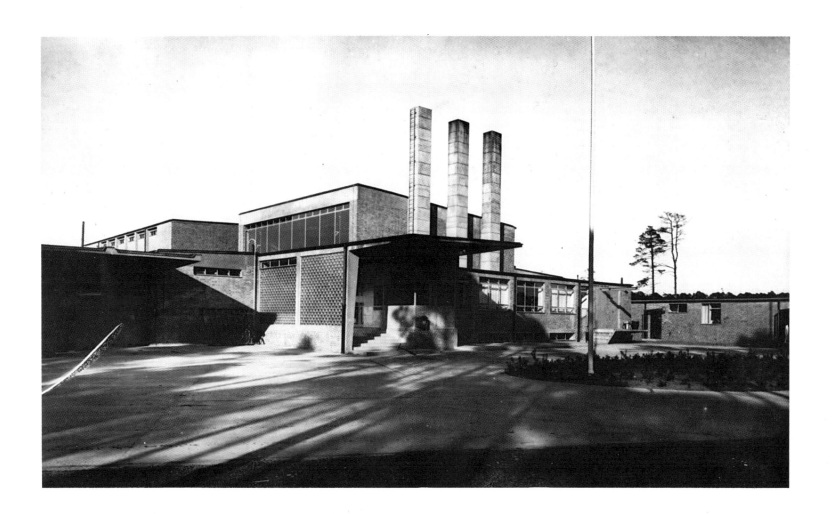

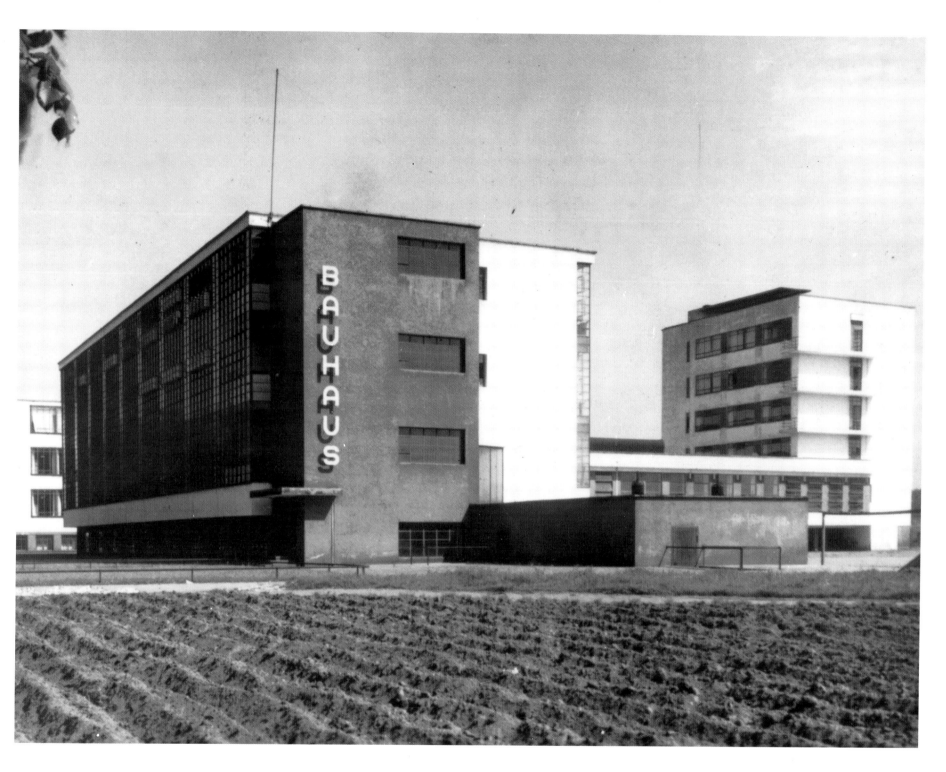

*128 Walter Gropius, Bauhaus Dessau, 1925/26.
Photo by Walter Funkat.*

Party programme close to hand when writing these lines, introduced for the students' benefit a broad sweep of subjects culminating in the scientific study

127 Photo collage with Hannes Meyer, 1928.

of building design, a topic which until then had never before been taught at the Bauhaus. Their principles of design were based on a diagram representing the living space and habits of the future occupants of the houses, which paid particular attention to the light conditions

and the relationship with landscape. Meyer's practically determined rejection of any architectural aesthetic of the kind still being practised to a certain extent before his time, was shared by the architect Ludwig Hilbersheimer, whom he invited to the Bauhaus in 1929. Two years previously, Hilbersheimer had

130 Mies van der Rohe, 1933. Portrait photo by Werner Rohde.

designed a house for the Stuttgart Weissenhof Settlement. All in all it can be said that considerable advances were made during the short period of Meyer's directorship in pointing the Bauhaus towards the real

129 Hannes Meyer and Hans Wittwer, Bundesschule ADGB in Bernau, 1928–30. Connecting hall.

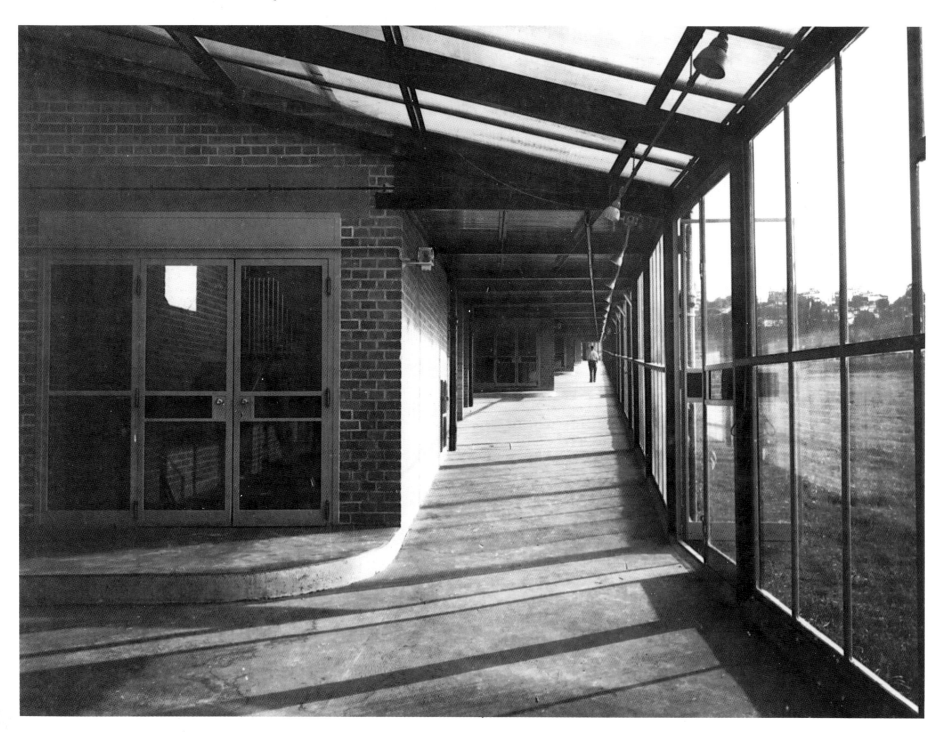

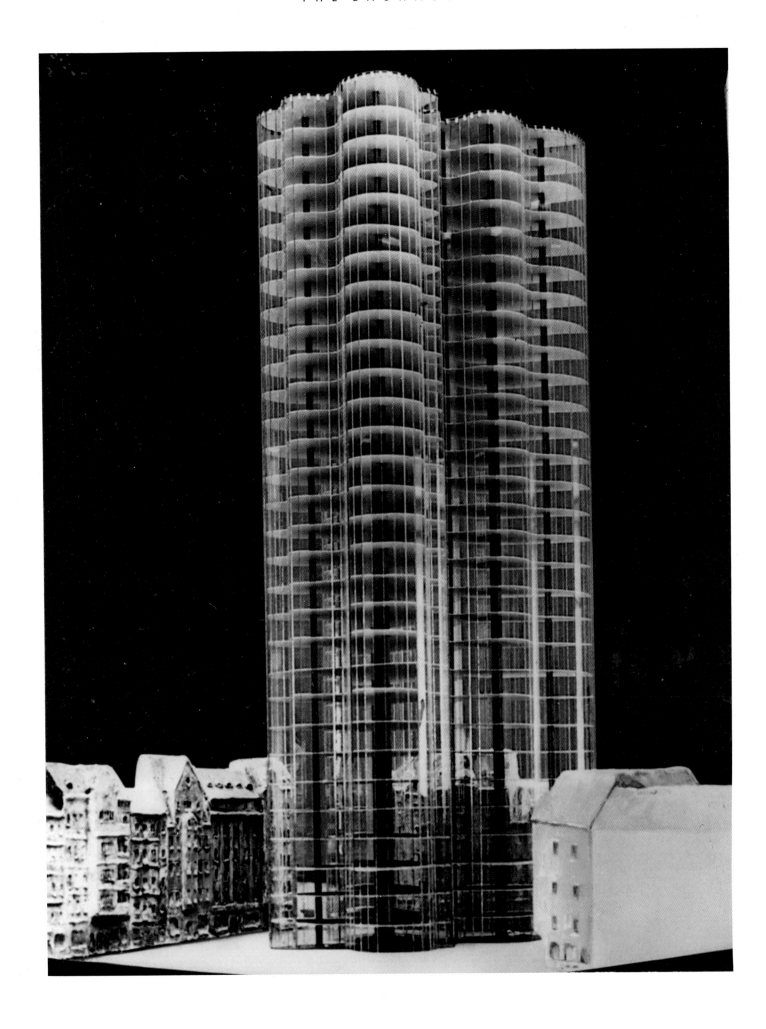

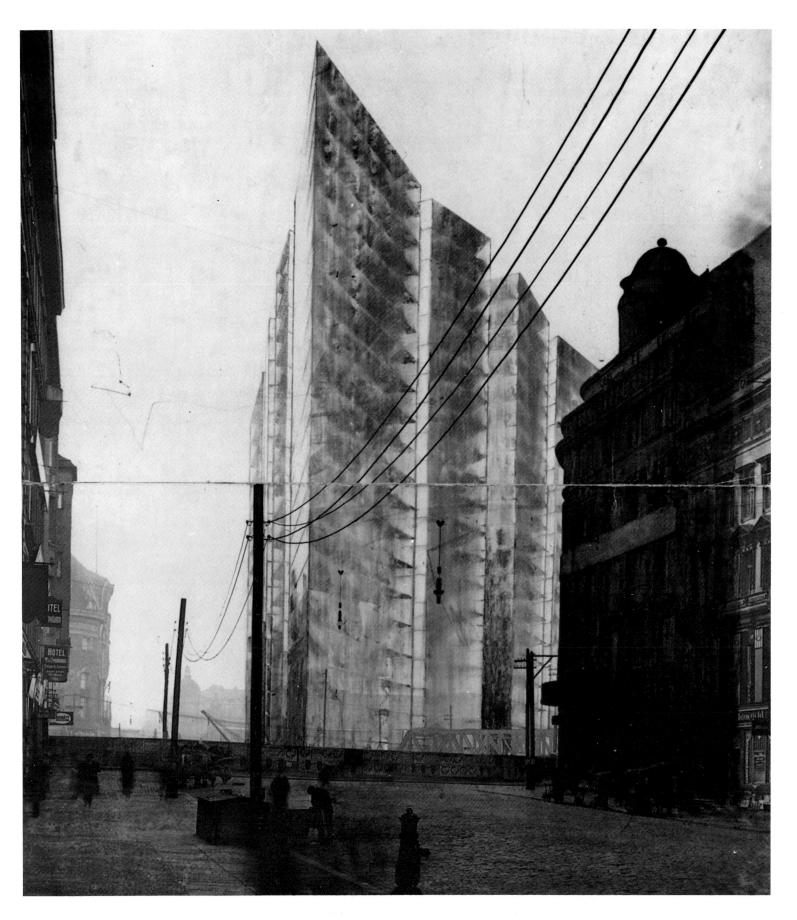

131 Mies van der Rohe, model for skyscraper project, 1921.

132 Mies van der Rohe, competition entry for
Friedrichstrasse, Berlin.

133 Hinnerk Scheper, colour plan for an interior design, c. 1930.

world. Nor was artistic work neglected, though this accusation is repeatedly levelled against him. It is a comment that would seem to have more to do with his politics than with his qualifications as an architect.

When Mies van der Rohe became director, the teaching structure was retained, but the study-time was reduced to six semesters and scientific architectural training became more intensive. The extent to which this period represented a clean break from the Weimar school is evident in Mies's rather off-hand remark: 'I don't want a marmalade of workshop and school, I want school.' This statement was directed against the free form of teaching that had long prevailed in the preliminary courses and workshops, which Mies opposed. His approach soon had an impact on the new students, almost all of whom had undergone some prior training in architecture and were using the

Bauhaus to pursue their studies. In this way Mies contributed further to the existing predominance of architecture at the Bauhaus, which moved to Berlin in 1932, following the closure of the Dessau institution.

At the opening of the new Bauhaus in Berlin, Mies outlined his ideas in an interview:

Our aim is to train architects to have a command of the whole area of architecture, from the smallest building to the city building – not just the building itself, but also the whole development down to the textiles used. In our architecture we are striving for nothing less than a form of 'Gesamtkunstwerk' . . . Out of all the classes we hold, it is strictly speaking only the photography

134 Hannes Meyer and Hans Wittwer,
Bundesschule ADGB, 1928–30.

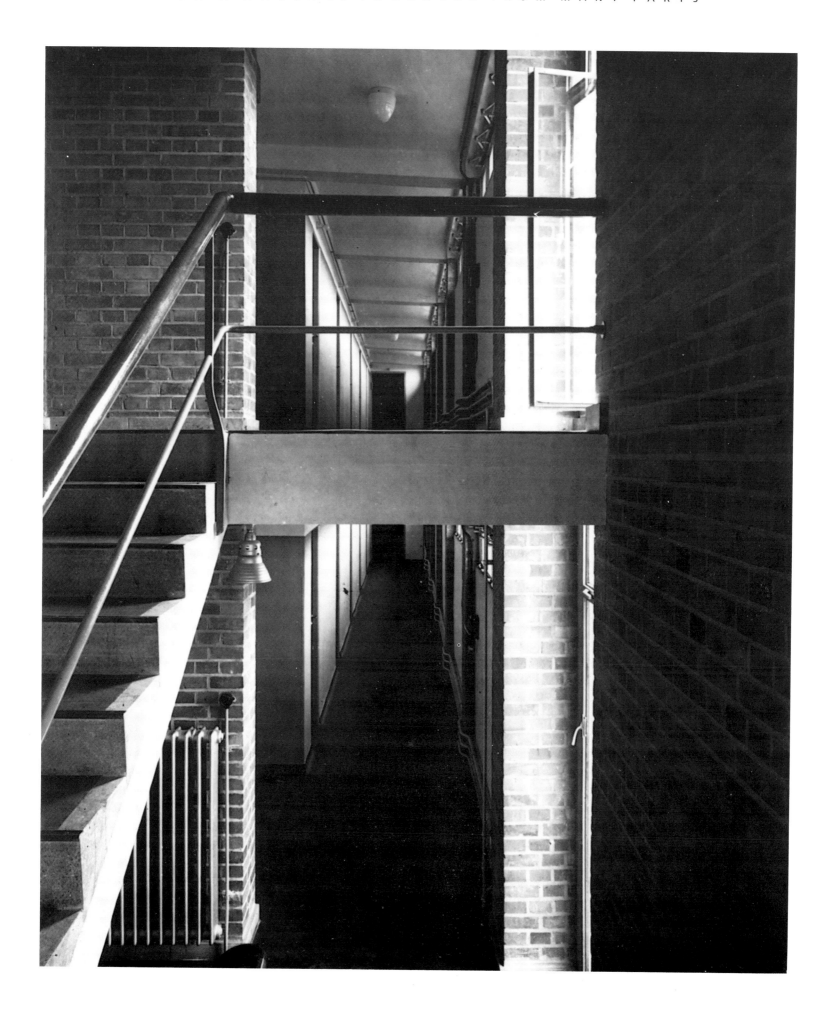

class, and, in a certain sense, the painting class, that transcend these limits. If the means were available, we would bring in still more painters and a sculptor, too, as it seems to me absolutely right that all young architects should learn lessons from the visual artists. Large workshops . . . make it possible for teaching to have a foundation in craftsmanship. Also models are produced for industry in the workshops. There has been no basic change in the aims of the Bauhaus since it was founded. (Experiment Bauhaus, p. 312.)

This is not the place to decide whether any 'basic' change had occurred or not – the arguments involved are too complex, and would go well beyond the bounds of our discussion here. What clearly emerges, however, is that Mies had again taken up the original idea of the *Gesamtkunstwerk* as a building, and once more harnessed the energies of the Bauhaus to that goal, albeit under different circumstances. It was only to be for a short time, however, since the ban on the institution was already imminent.

Before the move to Berlin, there had been a period

135 Walter Gropius, outline for Wannsee buildings, 1930.

136 Fred Forbat, Siemensstadt Berlin, functional stereometric
architecture, 1930/31.

of trouble in Dessau. In 1932 the building was temporarily closed. The students' displeasure at the dismissal of Hannes Meyer had led to gatherings in the great hall, where Mies was challenged to make a statement. He responded by having the police clear the canteen, a uniquely scandalous event for the institution.

The mayor of Dessau then closed the Bauhaus for a few weeks, in the hope that the waves would subside. However, Mies was still widely criticized for what had happened. The students in any case found him unapproachable: he was surrounded by the self-made aura of the architect as a being who inhabits higher

spheres. His personal reputation was enhanced by his creation of the latest architectonic type of building, which he had introduced at the international exhibition in Barcelona. Then there was his radical use of glass, steel and concrete for powerful, visionary high-rise

buildings. His entry for the competition to design a high-rise building at the Friedrichstrasse Railway Station in Berlin in 1921 shows the model high-rise structure surrounded by buildings of traditional architecture. The abandon with which he was prepared to impose such a

137 Fred Forbat, Siemensstadt Berlin, east view of Buildings 1, 2 and 3, 1929–30.

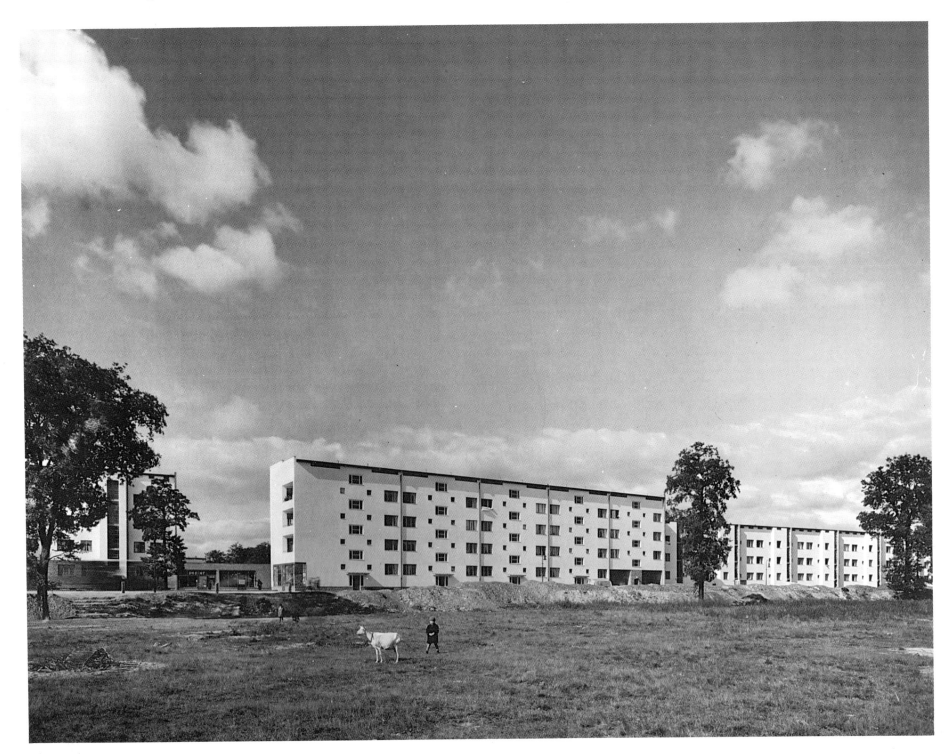

sensational concept, even though the project was not pursued, is a clear indication of how ready he was to break with tradition.

Rohe's personality was described by many students as complex and difficult. He presented a marked contrast to Hannes Meyer's almost anti-authoritarian behaviour and teaching style, and also to other teachers such as Ludwig Hilbersheimer, who continued to work on at the Bauhaus, serving as an important mediator between Mies and the students. Hilbersheimer's architecture had greater credibility than the paper plans of Mies.

The principles advocated by Hilbersheimer . . . were not generally recognized, however. If one compares them with what was happening in building in Germany at the time, only a few points of agreement can be established. Neither his low building estates nor the 'mixed' building estates he propagated were generally discussed. The commonest form of building at the time, the three- or four-storey block of flats is only of secondary importance to him . . . His theoretical concepts of low and mixed building estates . . . their anticipatory character and the way in which they are geared to meet the needs of the lower classes have not helped them to gain general acceptance. For the students they were of great importance: not only did they counterbalance the teaching of Mies, which was strongly oriented to aesthetics, with practically directed considerations, their ideological tendency made Hilbersheimer, in contrast to Mies, also seem acceptable to left-wing students, even though it was not bound to any party and hence did not exclude those of other persuasions. (Christian Wolfsdorff, Experiment Bauhaus, p. 313.)

The directors were forced by the Nazis to dismiss Hilbersheimer in July 1933, in order that teaching might continue. He emigrated to the USA in 1938, as Mies had done in 1937.

On 20 July 1933, a meeting of the teaching staff decided to wind up the Bauhaus, which since October 1932 had been run in Berlin as a private institute under the direction of Mies.

Under its three directors, Gropius, Meyer and Mies, the tasks addressed by the Bauhaus had changed, and so, too, had people's perception of it. Each of these personalities left his own individual stamp on architecture. Whereas Gropius stressed *Wahrhaftigkeit* (truthfulness) and the functional purpose of the building, Meyer insisted that the architect's duty was to relate it to the needs of society. Mies was committed to his own aesthetic vision, which had little more than a theoretical link with reality. He too was moving, albeit along a different path, towards the idea of the *Gesamtkunstwerk*. In view of the political disturbances at the time and the violent upheavals caused by Hitler's dictatorship, there was a certain irony in this. And yet perhaps it is precisely at such times that fantastic visionaries will emerge, in order to ward off harsh reality.

4. The Idea Lives on

Although it has been common practice, in numerous publications, to connect the spread and impact of the Bauhaus idea in all its variations with the ban on the Bauhaus and its destruction as an institution in 1933, this rests on a false assumption. For it would be quite wrong to date the international influence of the Bauhaus on design and architecture in general from Hitler's coming to power and the emigration of many Bauhaus members.

If we return to the roots of the ideals expressed in the *Bauhaus Manifesto*, with its Expressionist and Futurist influences, the picture that emerges is one of a European culture – of artists who predominantly viewed themselves as cosmopolitan, who intellectually rejected all types of national chauvinism and who defined themselves as artistically free and united with artists of whatever nationality. For this was the spirit that inspired the ideas, the works and the many different contacts which distinguished the Bauhaus right from the time of its foundation and won it early fame.

During the 1920s, for example, Kandinsky was represented by his pictures at six New York exhibitions, and after 1925 his work was shown with that of Feininger, Klee and Jawlensky. From as early as 1930, Hannes Meyer built numerous forward-looking housing projects in the Soviet Union, and a small Bauhaus exhibition took place in New York in 1931. The art crtitic H.R. Hitchcock and the architect Philip Johnson visited the Dessau Bauhaus whilst preparing a book and an exhibition on 'The International Style'. Along with many students from all over Europe, as well as Japan, the American Howard Dearstyne came to study at Dessau in 1928. In the 1930s he contributed to the spread of Bauhaus ideas in American architecture and was later, from 1957, Professor at the Illinois Institute of Technology in Chicago. Many other instances of the

international role played by the Bauhaus might be cited: all show that, long before Hitler's expulsion of the artists, the idea of a new form of design and building as practised in Weimar, Dessau and Berlin was gaining world-wide recognition. It seems necessary to stress this since the emigration of the artists and the spread of their influence abroad, particularly in the USA has repeatedly been represented as a positive consequence of the Nazi regime.

If the Bauhaus met with a warmer welcome in America this was partly because radical design proposals, oriented to modern technological media such as reinforced concrete and glass for building purposes, were more readily accepted there than in a Europe on the verge of war. People were far more open to new ideas in design. Leading figures from the Bauhaus, including Gropius, Mies, Albers and Moholy-Nagy, found their way to America in the 1930s, often via England.

Through Gropius, Cambridge in Massachusetts became . . . a Bauhaus centre . . . As Professor and Director of the Architecture Department of the Harvard Graduate School of Design, he had pupils from all over the world, over 250 of whom later filled teaching posts at universities, technical colleges and schools of design. Gropius passed on his social-ethical maxims, teaching his conviction that in education the stress should not be on the 'personal', that imitation should be neither a means nor an end, but that 'objective' facts had to be conveyed as they are given to us by nature and psychology. From 1946, strengthened by his emeritus status in 1952, he was busily engaged in building activities with 'The Architects Collaborative' (TAC), which attracted all the more public discussion as it involved some unusually large commissions, (Wingler, Bauhaus in Amerika, *p. 6f.)*

138 *Xanti Schawinsky*, Floating Architecture, *oil on canvas, 1927.*

In America Gropius again became, as he had been in

139 *Paul Klee*, Bastard, *glue, tempera and oil on jute, 1939.*

140 *Paul Klee*, Flowers in Stone, *oil on cardboard, 1939.*

Weimar, the central figure around whom many former Bauhäusler gathered. At his suggestion, Moholy-Nagy, who was living in England, was invited in 1937 to Chicago, where at the initiative of the 'Association of Arts and Industries' he founded and directed the 'New Bauhaus', before finally closing it again after barely one year. Apart from financial difficulties, there were problems about the content of the training and the role of authority. Richard Koppe, a former student of the New Bauhaus, criticized Moholy-Nagy's teaching system for being 'alien to American society. The special system of apprentice, journeyman and master . . . did not in practice exist in the United States.' (Neumann, *Bauhaus und die Bauhäusler*, p. 364.) So the transference of training practice became an obstacle to integration, as did the reputations of the Bauhaus teachers, which elevated them to the rarified sphere of the inaccessible artist. Whether Gropius, Mies van der Rohe and Moholy-Nagy liked it or not, conflicts which they could no longer resolve through their teaching were coming to a head in the United States.

The 1938 Bauhaus Exhibition in the Museum of Modern Art played an essential part in making the works of the Bauhaus and its ideas better known. So, too, did the work of Josef Albers, who from 1933 taught at Black Mountain College in North Carolina. As Professor at Yale University in New Haven, 1950 to 1959, he became an impressive and well-known figure in the art world. Working from the basis of the investigations and colour analyses of the German Bauhaus he became a precursor of 1960s' Op-Art. Robert Rauschenberg was a product of his school. In 1939 the indefatigable Moholy-Nagy founded the 'School of Design', which numbered Johannes Molzahn, Marli Ehrmann and Frank Levistik amongst the teaching staff. After it had been recognized as a college and changed its name to the 'Institute of Design' in 1944, it attracted increasing numbers of students, for the teaching plan too had been modified and adapted to American conditions. Three years later the Institute of Design was incorporated into the Illinois Institute of Technology, where Mies and Ludwig Hilbersheimer were already teaching architecture and town-planning. Walter Peterhans was running the preliminary course for the architecture students, and Howard Dearstyne, a former student of the Dessau Bauhaus, was also on the teaching staff. Other former Bauhäusler such as Andreas Feininger, Marcel Breuer, Herbert Bayer and Xanti Schawinsky, to name but a few, achieved considerable success as employees or free-lance workers in design and commercial art in New York, where they exerted a fundamental artistic influence. But it was not so much product design that caused a stir in the 1950s and 1960s as the architecture of Gropius, Mies and their faithful followers in America, such as Philip Johnson and Louis Kahn. The author Tom Wolfe lampooned them in 1981 as 'white gods' who were able to preserve their status only through professional connections and the fact that architectural criticism in any normal sense had gone by the board. Like the criticism previously expressed in Europe after the war, his brilliant jibes are aimed at the soulless, puristic, formalistic funtionalism of architecture, and its subservience to the right-angle. Examples he gives are the Seagram Building by Mies ('he was a big, fleshy, though still good-looking individual, who smoked expensive cigars') and the glass-, concrete- and iron-bearing boxes of ('Silver Prince') Gropius.

This criticism is justified to the extent that after Dessau the Bauhaus showed a tendency to believe in technology and the apparently unlimited possibility of developing formal solutions. On the other hand, the Bauhaus cannot be held responsible for every cubic building form, every uncomfortable tubular steel chair

141 Laszlo Moholy-Nagy, title page from The New Bauhaus, *photograph, 1937.*

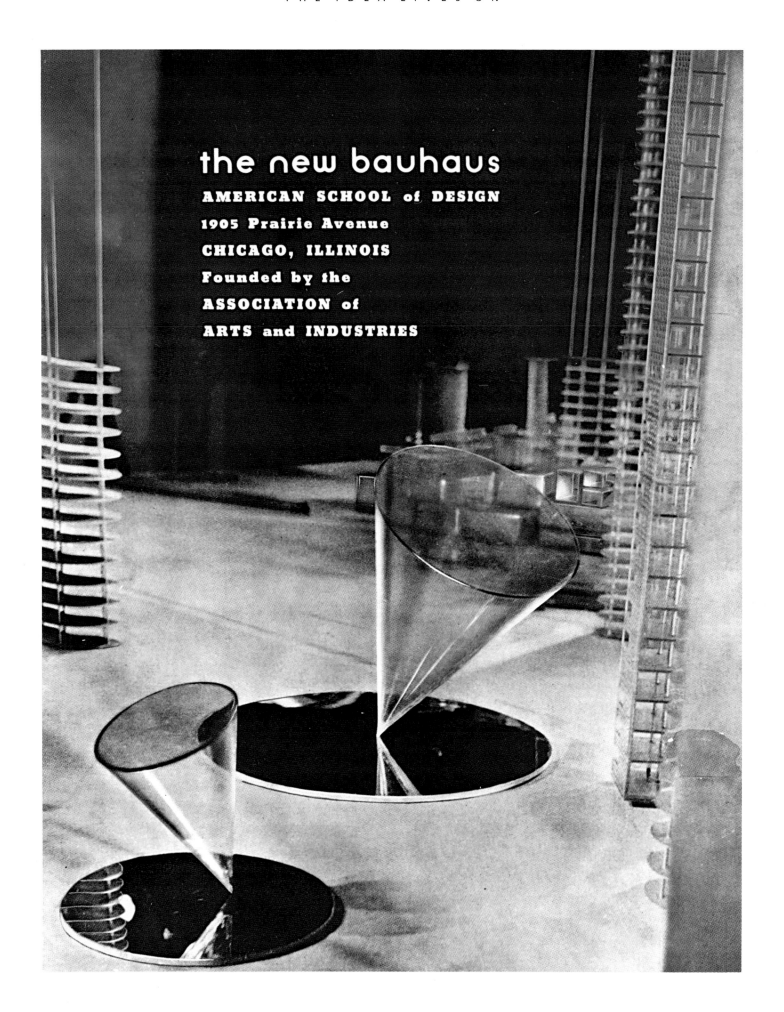

the new bauhaus
AMERICAN SCHOOL of DESIGN
1905 Prairie Avenue
CHICAGO, ILLINOIS
Founded by the
ASSOCIATION of
ARTS and INDUSTRIES

or unsuccessful blue-yellow-red combination. If today the parameters of architecture and design have shifted — if, for reasons of conservation, for example, the scarcity of resources has led designers and architects to copy Bauhaus ideas uncritically, then that is in no way a reflection on the original concepts from Weimar, Dessau and Berlin. Similarly, it would be a mistake to blame the graphics and advertisements developed and used by the Bauhaus for those instances where they were misused in Nazi publications.

On the contrary the ideas of the Bauhaus continued to reject authoritarian state structures, rousing renewed opposition in Germany even after the war. Hence the failure of the initiative, in which the former Bauhaus student Hubert Hoffmann took part, to re-establish the Bauhaus in Dessau after 1945. 'We were surrounded by Stalin's ideas on graphic and pictorial art, which were surprisingly similar to those of the Third Reich.' (Neumann, *Bauhaus und die Bauhäusler*, p. 374.) It was not until the late 1970s that the East Germans decided no longer to categorize the work of the Bauhaus as 'bourgeois art', but this decision came far too late and to no avail.

An attempt by former Bauhaus student Inge Scholl to build up a School of Design in Ulm, West Germany, encountered massive resistance in the 1960s and 1970s from the Baden-Würtemberg regional government, under the leadership of the former Nazi judge Filbinger. Once again, liberal teaching principles and innovative ideas fell victim to financial restraints.

These developments should be borne in mind by anyone who seeks to censure the Bauhaus. 'Any criticism should be directed not against the Bauhaus but against our modern world, which has taken away the ground from under the Bauhaus and destroyed it . . . without even being aware of it.' (J. Mohlzahn, in Neumann, *Bauhaus und die Bauhäusler*, p. 75.)

Certainly, the Bauhaus should be approached with an open mind. To be receptive to the stimuli of ideas from Weimar, Dessau and Berlin, as well as from institutions and individuals all over the world with affinities to the Bauhaus, to reflect them and to develop their use, are activities which bring their own rewards.

142 *Xanti Schawinsky,* Enigma Collage: A Thousand Hearty Greetings and Thanks, *photo and ink, 1928.*

Chronology

1907 Hermann Muthesius founds the *Deutsche Werkbund* in order to foster co-operation between artists and industry.

1912 Walter Gropius joins the *Werkbund*.

1919 April: Gropius is appointed director of the State Bauhaus at Weimar, an amalgamation of the former Weimar Academy of Fine Art and the Weimar Arts and Crafts School. He issues the *Bauhaus Manifesto*, proclaiming a new unity of arts and crafts. In the first year Johannes Itten, Gerhard Marcks and Lyonel Feininger are appointed Masters of Form. Students are to follow a basic course and then to be taught in craft workshops.
Autumn: Itten establishes the preliminary course.

1920 Pottery workshop moves to Dornburg.

1921 Sommerfeld House in Berlin, designed by Gropius and Adolf Meyer with collaboration of Bauhaus workshops, is completed. Paul Klee and Oskar Schlemmer join the teaching staff as Masters of Form.
Van Doesburg begins publishing *De Stijl* magazine in Weimar.

1922 Wassily Kandinsky joins the teaching staff as Masters of Form.

1923 Itten resigns and Laszlo Moholoy-Nagy is appointed to run the preliminary course. Emphasis of school changes slightly to unity of art and technology.
August-September: first full-scale Bauhaus Exhibition includes the experimental house 'Am Horn', equipped entirely by Bauhaus workshops.

1924 Nationalists with majority in local parliament and cut funds to school by half. Gropius announces Bauhaus will close the following year.

1925 The school moves to a purpose-built building in Dessau. Former Weimar students, Josef Albers (preliminary course), Herbert Bayer (printing), Marcel Breuer (furniture), Hinnerk Scheper (wall-painting), Joost Schmidt (sculpture) and Gunta Stölzl (weaving), join the teaching staff as Young Masters.

1927 Gropius sets up an architecture department under Hannes Meyer.

1928 Gropius resigns. Meyer becomes director and brings a new emphasis on designing for cheap mass production.

1929 Bauhaus exhibits works at the Industrial Museum in Basel and takes part in the International Exhibition in Barcelona.

1930 Meyer is forced to resign for political reasons (he is too left-wing) and Mies van der Rohe is appointed director. The furniture, metal and wall-painting workshops are combined to form the interior design workshop.

1931 Nazis take control of Dessau city government.

1932 Nazis close Dessau Bauhaus. Mies rents disused factory near Berlin where teaching can be continued.

1933 After police and stormtroopers close the new building, Mies announces that the faculty has decided to dissolve the Bauhaus. Many staff flee Germany.

1937 Moholy-Nagy founds the 'New Bauhaus' in Chicago. It closes after only one year.

List of Illustrations

1 Lyonel Feininger, cover illustration (Cathedral) for the Bauhaus Manifesto, woodcut, 1919.

2 Iwao Yamawaki, Attack on the Bauhaus (Der Schlag gegen das Bauhaus), photo collage, 1933.

3, 4 View of the Bauhaus building in Dessau, 1926, Photo by Lucia Moholy.

5 August Macke, With a Yellow Jacket, watercolour 1913.

6 Wassily Kandinsky, Composition Study, 1910.

7 Paul Klee, Precious Container for Stars, watercolour, ink and pen, 1922.

8 Lyonel Feininger, Halle, Am Trodel, oil on canvas, 1929.

9 Pablo Picasso, Restaurant, Still Life, oil on canvas, 1914.

10 Theo van Doesburg, Composición en blanco y negro.

11 Carlo Carrà, The Enchanted Room, acrylic, 1917.

12 Kasimir Malevich, Scissors Grinder, oil on canvas, 1912.

13 Carlo Carrà, Funeral of the Anarchist Galli, oil on canvas, 1911.

14 Gino Severini, Suburban Train, oil on canvas, 1915.

15 Kasimir Malevich, Suprematist Composition, White on White, oil on canvas, 1918.

16 Lothar Schreyer, woodcut, Bauhaus Weimar, 1923.

17 Johannes Itten, Coloured Composition, paper collage, 1920.

18 Members of the Bauhaus at Dessau on top of the roof, 1927. Photo by Lucia Moholy.

19 Piet Mondrian, Composition with Yellow and Blue, oil on canvas, 1929.

20 Walter Gropius, Fagus building near Hannover, 1911.

21 Werner Graeff, Rhythm-Study, black on yellow paper, 1920.

22 Fernand Léger, The City, oil on canvas, 1919.

23 Walter Gropius, Kandinsky and Oud in Weimar, 1923.

24 Theo van Doesburg, contra-compositie, oil on canvas, 1925.

25 Walter Gropius in Weimar, 1923.

26 Wassily Kandinsky in Weimar, 1923.

27 Oud in Weimar, 1923.

28 Johannes Itten, Horizontal-Vertical, oil on canvas, 1917.

29 Paul Klee in his Dessau atelier, c. 1927.

30 Johannes Itten, Workshop Meister Francke, Weimar, 1921.

31a, b, c Vincent Weber, Three Material Studies, wood and wire, 1920–21.

32 Oskar Schlemmer, Concentric Group, oil on canvas, 1925.

33 Johannes Itten, Tower of Fire, wood and coloured glass, 1922.

34 Lyonel Feininger with his wife in the Dessau atelier.

35 Oskar Schlemmer, Group with Seated Woman, oil on canvas, 1928.

36 Portrait of Laszlo Moholy-Nagy preliminary course, wood and glass, 1923. Artist unknown.

37 Study from the Moholy-Nagy preliminary course, wood and glass, 1923. Artist unknown.

38 Laszlo Moholy-Nagy, The girls Boarding School, photo collage, 1925.

39 Petra Kessinger – Petitipierre, study from the Albers preliminary course, pen and ink, 1929–30.

40 Gunta Stölzl and weaving workshop students on the staircase. of the Dessau building, 1927.

41 Lothar Lang, Colour Scheme, tempera, 1926–27.

42 Fritz Tschaschnig, study from the Kandinsky colour seminar, tempera, 1931.

43 Bauhaus balconies in Dessau.

44 Karl Hermann Haupt, The Red Man, gouache and watercolour on paper, 1925.

45 Lena Meyer-Bergner, Radiating Displaced Centre, watercolour, 1927.

46 Oskar Schlemmer, Nature, Art, Man, ink on paper, c. 1928.

47, 48 Oskar Schlemmer, Simple Head Construction, pencil on paper, c. 1928.

49 Oskar Schlemmer, copper, brass and nickel figure in nickel-plated zinc, 1930–31.

50 Sculpture workshop with works by Schlemmer, Weimar, 1923.

51 Oskar Schlemmer, Solitary Figure on Grey Background, oil on tempera on linen, c. 1928.

52 Oskar Schlemmer, abstract figure, plaster and metal, 1921–23.

53 Karl Hermann Haupt, Composition, watercolour, 1925.

54 Albert Henning, Bauhaus students before an excursion, 1932.

55 Laszlo Moholy-Nagy, letterhead and cover for Bauhaus Verlag, printed on paper, 1923.

56 Marcel Breuer, lattice chair, wood and black fabric, 1922.

57 Marcel Breuer, chair, tubular steel and black fabric, 1928–29.

58 Marcel Breuer, chair, tubular steel and black fabric, 1925–26.

59 Mies van der Rohe, Weissenhof chair, tubular steel and cane, 1927.

60 Portrait collage of Josef Albers, c. 1928. Photographer unknown.

61 Heinrich Bormann, interior architecture, 1932.

62 Walter Gropius's office, Weimar, 1923.

63 Metal workshop in Dessau, Marianne Brandt and Hin Bredendieck.

64 Christian Dell, wine jug, plain silver and ebony, c. 1925.

65 Wilhelm Wagenfeld, gravy boat, silver and ebony, 1924.

66 Marianne Brandt, teapot, brass and ebony, 1924.

67 Metal workshop in Weimar, 1922, including Hans Przyrembel, standing left, Marianne Brandt, centre, and Otto Rittweger, seated left.

68 Josef Albers, teacup, porcelain, glass and steel, 1926.

69 Marianne Brandt, bedside Kandem lamp, metal, c. 1928.

70 Wilhelm Wagenfeld, desklamp, metal and glass, 1923–24.

71 Christian Dell, wine jug, plain silver with ebony handle and finial, 1924.

72 Laszlo Moholy-Nagy, Untitled, oil on canvas, 1925.

73 Joost Schmidt, printed poster for the Bauhaus exhibition, 1923.

74 Eugen Batz, typographic study from Albers's preliminary course, collage with newspaper and posterpaint, 1929–30.

75 Herbert Bayer, printed poster, 1930.

76 Erich Mrozek, printed poster for matches, 1932.

77, 78 Joost Schmidt, wallpaper for the Bauhaus catalogue, 1930–31.

79 Herbert Bayer, Xanti Schawinsky and Walter Gropius in Ascona, 1933.

80 Laszlo Moholy-Nagy, photogram with the Eiffel Tower, c. 1929.

81 Herbert Bayer, Nude on the Beach, 1929–30.

82 Peterhans course, c. 1929. Photographer unknown.

83 Laszlo Moholy-Nagy, Double Torso, 1927.

84 Herbert Bayer, Eye, 1929.

85 Double portrait of Holde Rantzsch and Miriam Manuckiam, c. 1927. Photographer unknown.

86 Ilse Fehling and Nicol Wassilieff, 1926. Photograph by Otto Umbehr (Umbo).

87 Laszlo Moholy-Nagy, Tactile Exercises, photo montage, 1938.

88 Irene Hoffmann, detail from an ashtray, c. 1928.

89 Paul Citroen, Self-Portrait, 1932.

90 Werner Zimmerman, photo of Marianne Brandt on her balcony at the Bauhaus atelier, Dessau, c. 1928.

91 T. Lux Feininger, Collage of Weaving Workshop, 1928.

92 Lou Scheper, Collage, 1928.

93 From the Peterhans course, 1929. Photographer unknown.

94 Herbert Bayer, Portrait of Ilse Gropius, 1928.

95 Herbert Bayer, Still Life, 1936.

96 Florence Henri, Fruits, 1929.

97 Laszlo Moholy-Nagy, Portrait of Ellen Frank, 1929.

98 Pupils from the stage workshop on top of the roof, Dessau, 1927. Photograph by Irene Bayer.

99 Oskar Schlemmer, plan for the Triadic Ballet I, pen, ink, watercolour, posterpaint and bronze on paper, 1924–26.

100 Xanti Schawinsky, Circus, tempera, ink and silver bronze on paper, c. 1924.

101 Kurt Schmidt, The Man at the Keyboard, tempera, ink and silver bronze on paper, c. 1924.

102 Heinz Loew, mechanical stage, model, 1927.

103 Two students from the stage workshop on top of the roof, Dessau, 1927. Photograph by Irene Bayer, (detail).

104 Oskar Schlemmer and student from the stage workshop on top of the roof, Dessau, 1927. Photograph by Irene Bayer, (detail).

105 Hans Thiemann, Yellow Shapes on Blue Background – Blue Shapes on Yellow Background, 1930.

106 Oskar Schlemmer, Bauhaus Stairway, oil on canvas, 1932.

107 Herbert Bayer, Kiosk Design, tempera and collage on paper, 1924.

108 Florence Henri, Non-Objective Composition, oil on board, 1926.

109 Theodor Bogler, little teapot, 1923.

110 Margarete Wildenhain-Friedlaender, jug, 1932.

111 Max Kehan (shape) and Gerhard Marcks (decoration), bottle with handle.

112 Weaving workshop in Weimar, 1923.

113 Gunta Stölzl, tapestry, 1926–27.

114 Gunta Stölzl, outline for a carpet, gouache on paper, c. 1926.

115 Ruth Holles-Consemuller, tapestry, c. 1926.

116 Anni Albers, tapestry, 1926.

117 Ida Kerkorins, outline for a wall carpet, tempera and pencil, 1921.

118 Rudolf Lutz, preliminary course, probably with Itten.

119 Walter Gropius, design for the Deutscher Werkbund.

120 Walter Gropius and Adolf Meyer, office building in Cologne, visible staircase, 1914.

121, 122 Alfred Arndt, colour plan for the "Haus Auerbach" 1924.

123 Farkas Molnar, outline for a one-family house, 1922.

124 Mies van der Rohe, apartment house, Weissenhof, 1927.

125, 126 Hannes Meyer and Hans Wittwer, Bundesschule ADGB in Bernau, 1928–30.

127 Photo collage with Hannes Meyer, 1928.

128 Walter Gropius, Bauhaus Dessau, 1925–26. Photograph by Walter Funkat.

129 Hannes Meyer and Hans Wittwer, Bundesschule ADGB in Bernau, 1928–30. Connecting hall.

130 Portrait of Mies van der Rohe, 1933. Photograph by Werner Rhode.

131 Mies van der Rohe, model for skyscraper project, 1921.

132 Mies van der Rohe, competititon entry for Friedrichstrasse, Berlin.

133 Hinnerk Scheper, colour plan for an interior design, c. 1930.

134 Hannes Meyer and Hans Wittwer, Bundesschule ADGB, 1928–30.

135 Walter Gropius, outline for Wannsee buildings, 1930.

136 Fred Forbat, Siemensstadt Berlin, functional stereometric architecture, 1930–31.

137 Fred Forbat, Siemensstadt Berlin, east view of Buildings, 1, 2 and 3, 1929–30.

138 Xanti Schawinsky, Floating Architecture, oil on canvas.

139 Paul Klee, Bastard, glue, tempera and oil on jute, 1939.

140 Paul Klee, Flowers in Stone, oil on cardboard, 1939.

141 Laszlo Moholy-Nagy, title page from the New Bauhaus, photograph, 1937.

142 Xanti Schawinsky, Enigma Collage: A Thousand Hearty Greetings and Thanks, photo and ink, 1928.

Picture Credits

Bibliography

Adorno, Theodor, W., *Aesthetische Theorie*, Frankfurt 1970.

Andresen, Troels, *Malevich, Catalogue Raisonnée of the Berlin Exhibition*, Stedeljik Museum, Amsterdam 1970.

Apollonio, Umbro, *Futurist Manifestos*, London 1973.

Bauhaus Idee/Form/Zweck/Zeit, Catalogue, Goeppinger Galerie, Frankfurt/M. 1964.

Bauhaus and Bauhaus People, Personal opinions and recollections of former Bauhaus members and their contemporaries, edited by Eckard Neumann, New York 1970.

Bauhaus, 50 years, Catalogue of the Exhibition in the Royal Academy of Arts, London 1968.

Bauhaus, 50 Jahre new bauhaus, Bauhausnachfolge in Chicago, edited by Peter Hahn, Berlin 1987.

Bauhaus Utopien, Arbeiten auf Papier, edited by Wulf Herzogenrath, catalogue, Köln, Stuttgart 1988.

Bauhaus 1919–1933, Meister und Schülerarbeiten, Weimar, Dessau, Berlin, Zürich 1988.

The Bauhaus, Masters and Students, New York 1988.

Bauhaus – a teaching idea, Exhibition Catalogue, Carpenter Centre for the Visual Arts, Harvard University, Cambridge, Mass. 1967.

Berndt, Heide/Lorenz, Alfred/Horn, Klaus, *Architektur als Ideologie*, Frankfurt 1968.

Bloch, Ernst, *Erbschaft dieser Zeit*, Zürich 1935.

Bloch, Ernst, *Vom Hasard in die Katastrophe, Politische Aufsaetze aus den Jahren 1934–1939*, Frankfurt 1972.

Collins, Peter, *Changing Ideals in Modern Architecture 1750–1950*, London 1971.

Dube, Wolf-Dieter, *The Expressionists*, London 1985.

Experiment Bauhaus, Bauhaus Archiv, Berlin, 1988.

Franciscono, Marcel, *Walter Gropius and the Creation of the Bauhaus in Weimar*, University of Illinois 1971.

Gay, Peter, *Weimar Culture, The Outsider as Insider*, London 1969.

Glaeser, Ludwig, *Ludwig Mies van de Rohe, Drawings in the Collection of the Museum of Modern Art*, New York 1969.

Giedion, Siegfried, *Space, Time and Architecture, The Growth of a New Tradition*, Cambrdige, Mass. 1947.

Gropius, Walter, *Bauhausbauten Dessau*, München 1930.

Gropius, Walter, *Internationale Architektur*, München 1925.

Grote, Ludwig, *Exhibition Catalogue, Die Maler am Bauhaus*, München 1950.

Hitchcock, Henry-Russel, *Architecture, Nineteenth and Twentieth Centuries*, London 1963.

Hitchcock, Henry-Russel and Johnson, Philipp, *The International Style, Architecture since 1922*, New York 1966.

Horkheimer, Max, *Gesammelte Schriften Band 5: 'Dialektik der Aufklärung' und Schriften 1940–1950*, Frankfurt 1987.

Hughes, Robert, *The Shock of the New*, London 1980.

Johnson, Phillip, *Mies van de Rohe*, Museum of Modern Art, New York 1947.

Jordy, William, H., *American Buildings and their Architects, Progressive and Academic Ideals at the Turn of the 20th Century*, New York 1972.

Kepes, Gyorgy, *Language of Vision*, Chicago 1944.

Le Corbusier/Jeanneret, Pierre, *Œuvre Compléte*, Les Editions d'Architecture Artemis, 8th edn. Zurich 1967.

Lasch, Hanna, *Architekten-Bibliographie*, Deutschsprachige *Veroeffentlichungen 1920–1960*, Leipzig 1962.

Malewitsch, Kasimir, *Suprematismus, Die gegenstandslose Welt*, Köln 1962.

Mies van de Rohe, Ludwig, *Katalog der Ausstellung der Akademie der Bildenden Künste Berlin*, 1968.

Moholy-Nagy, Laszlo, *Vision in Motion*, Chicago 1947.

Moholy-Nagy, Sybil, *Moholy-Nagy – Experiment in Totality*, New York 1950.

Murray, Peter and Linda, *Art and Artists*, London 1979.

Neumann, Eckard (ed.) *Bauhaus und die Bauhäusler, Erinnerungen und Bekenntnisse*, Köln 1985.

Pevsner, Nikolaus, *Wegbereiter moderner Formgebung, Von Morris bis Gropius*, Hamburg 1957.

Rassegna, quarterly, Year XI, 40/4, December 1989.

Schmidt, Diether, *Bauhaus Weimar 1919–1925, Dessau 1925–1932, Berlin 1928–1933*, Dresden 1966.

Teut, Anna, *Architektur im Dritten Reich 1933–1945*, Berlin, Frankfurt, Wien 1967.

Tisdall, Caroline, *Futurism*, London 1985.

Wesepohl, Edgar, *Die Weissenhofsiedlung der Werkbundausstellung 'Die Wohnung' in Stuttgart 1927, Wasmuths Monatshefte Für Baukunst XI*, 1927.

Westphal, Uwe, *Werbung im Dritten Reich*, Berlin 1989.

Wick, Rainer, *Bauhaus Paedagogik*, Köln, 1975.

Wingler, Hans-Maria, *The Bauhaus 1919–1933*, Cambridge, Mass. 1968.

Wingler, Hans-Maria, *The Bauhaus Weimar Dessau Berlin Chicago*, Cambridge, Mass. 1969.

Wolfe, Tom, *Mit dem Bauhaus leben = From Bauhaus to our house*, Frankfurt 1986.

Index

Albers, Josef, 45, 50–53, 57, 80, 86, 111, 159, 162
Arndt, Alfred, 90
Arndt, Gertrud, 59
Art Press of the State Bauhaus-Weimar, 90
Auerbach, Ellen, 111

Batz, Eugen, 111
'Bauhaus' Magazine, 53
Bauhaus Manifesto, The, 6, 11, 69, 93, 137, 141, 159
Bauhauskompendium, The, 62
Baumeister, Willi, 66, 92
Bayer, Herbert, 95–96, 97, 108, 113–115, 162
Bayer, Irene, 108
Beckmann, Max, 92
Behrens, Peter, 29, 31, 77, 84
Bernhard, Lucian, 93
Boccioni, Umberto, 92
Bogler, Theodore, 126, 127
Brandt, Marianne, 50, 84–86, 108
Braque, Georges, 18
Breuer, Marcel, 75, 77–80, 83, 141, 162

Campendonk, Heinrich, 69
Carrà, Carlo, 20, 92
Cézanne, Paul, 17
Chagall, Marc, 92
Chirico, Giorgio de, 18–20, 23, 92
Collein, Edmund, 108
Constructivism, 17, 25, 47, 48, 75, 93
Cubism, 17, 18–23, 25, 112

DaDa, 23–25, 96
Dali, Salvador, 115
de Stijl group, The, 18, 26–28, 77
'Der Blaue Reiter', 17
Dearstyne, Howard, 162
Delaunay, Robert, 11, 60
Dell, Christian, 49, 50, 84
Der Sturm, Berlin, 46
Dessau Meisterhaueser, 25
Deutscher Werkbund, The, 32
Doesberg, Theo van, 18, 26–28, 75, 77, 93
Driesch, Johannes, 126
Dürer, Albrecht, 62, 65

Einstein, Albert, 69, 84
Enderlin, Max, 108
Expressionism, 14–18, 59, 93, 141

Feininger, Andreas, 108, 162
Feininger, Lucas Theodore, 111
Feininger, Lyonel, 11, 58, 69, 90, 91, 93, 108, 111, 159
Feist, Werner, 108
Film & Photo Exhibition, The, 108
Forbat, Fred, 139
Friedlaender, Marguerite, 126
Funkat, Walter, 108

Gerson, Lotte, 108
Goethe, Walter von,
 'Theory of Colours', 18, 56
 Golden Section, The, 65
Goncharova, Natalia, 92
Graeff, Werner, 28, 108
Gris, Juan, 18
Gropius, Walter, 6–11, 25–26, 28, 31, 32, 38, 40, 42, 43, 45, 46, 50, 57, 62, 66, 69, 72, 73, 75, 77, 80, 83, 86–88, 90, 91, 93, 96, 102–105, 109, 119, 122, 126, 135, 137–140, 155, 159–162
 Fagus Works, The, 7, 28
 Werkbund Exhibition building, 7
Grosz, Georg, 92

Haus am Horn, The, 139, 141
Heckel, Erich, 92
Heinze, Fritz, 108
Henri, Florence, 108, 112–113
Hilbersheimer, Ludwig, 146, 155, 162
Hitler, Adolf, 11
Hoelzel, Adolf, 42, 60–61
Hoffmann, Hubert, 165

Itten, Johannes, 40–46, 62, 73, 84, 102, 122, 132

Jawlensky, Alexei von, 69, 159
Jucker, Karl Jacob, 84, 88
Jugendstil, Der 18, 31
Jungmittag, Willy, 108
Junker, Karl J., 50

Kandinsky, Nina, 57

Kandinsky, Wassily, 17, 18, 20, 43, 45, 53–57, 62, 73, 86, 90, 92,
 113, 122–124, 126, 130, 159

Kirchner, Ernst, 92

Klee, Paul, 18, 45, 57–60, 62, 69, 86, 90, 95, 159
 Pedagogical Sketchbook, The, 59

Kokoschka, Oskar, 90

Koppe, Richard, 162

Kramer, Ferdinand, 77

Kranz, Kurt, 110, 111

Krehan, Max, 126

Kreibig, Manda von, 118

Kuhnert, Charlotte, 111

Kuhr, Fritz, 108

Lang, Lothar, 55

Larionov, Mikhail, 92

Le Corbusier, Charles-Édouard, 77

Léger, Fernand, 18, 20, 92, 112

Lindig, Otto, 126, 127

Lissitzky, El, 93

Loew, Keinz, 108

Lotz, Wilhelm, 50

Macke, August, 17, 69

Malevich, Kasimir, 20–23, 26

Marc, Franz, 17, 23, 60, 69

Marcks, Gerhard, 25, 66, 92, 126

Marcoussis, Ludwig, 92

Mazdaznan, 42

Meyer, Hannes, 77, 80–81, 88–90, 96, 109, 110, 119, 126, 137,
 141, 142–150, 153, 155, 159

Meyer-Bergner, Lena, 59

Mies van der Rohe, Ludwig, 51, 57, 77, 81–83, 90, 135, 150–155,
 159, 162

Moholy-Nagy, Laszlo, 25, 43, 45, 46–50, 77, 84, 86, 93–95, 102,
 105, 107, 108, 109, 111, 112, 113, 130, 159, 162
 Berliner Stadtleben, 49
 From Material to Architecture, 46
 Marseilles, 49

Moholy-Nagy, Lucia, 105–108

Molnar, Farkas, 141

Mondrian, Piet, 11, 18

Morris, William, 32, 40

Muche, Georg, 25, 42, 43, 45, 66, 84, 92, 100–102, 130, 135

National Socialist Party, the, 11, 57, 66, 155, 159

New Bauhaus, The, 50

New Munich Arts Group, 17

Olbrich, Joseph Maria, 29, 31

Op-Art, 51

Oud, Jacobus, 77

Peterhans, Walter, 100, 108, 109–111, 162

Picasso, Pablo, 18, 60

Reich, Lily, 135

Renger-Patsch, 102, 108

Rietveld, Gerrit, 77

Rohe, Mies van de, 51, 57, 77, 81–83, 90, 135, 150–155, 159,
 162

Rosen, Fritz, 93

Rubenstein, Naf, 108

Ruskin, John, 32, 40

Schawinsky, Xanti, 162

Scheibe, Richard, 126

Scheper, Hinnerk, 108

Scheper, Hinnerk, 124–126

Scheuermann, Herbert, 111

Schlemmer, Oskar, 25, 43, 45, 57, 60–69, 77, 92, 111, 115–117,
 118–119, 124
 Triadic Ballet, The, 60

Schmidt, Joost, 95, 97, 109

Schneck, Adolf, 77

Schoenberg, Albert, 69, 84

Scholl, Inge, 165

Schreyer, Lothar, 14, 25, 62, 92, 115

Schuh, Ursula, 53

Schwitters, Kurt, 92

Severini, Gino, 20, 92

Stam, Mart, 77

Stern, Grete, 111

Stölzl, Gunta, 41, 132–135

Stravinsky, Igor, 69

Taut, Bruno, 31, 77

Umbehr, Otto, 108, 111–112
Umbo, see Umbehr, Otto,

Van Gogh, 14, 17
Velde, Henry van de, 38, 83, 90, 130

Wagenfeld, Wilhelm, 50, 84, 88
Wagner, Otto, 31
Wilde, Anne & Juergen, 112
Wingler, Hans, 69
Wolfe, Tom, 162
Work Council for Art, The, 38

Workshops, The, 71–155
 ceramics, 73, 126–130
 furniture, 72, 73–83
 metal, 72, 83–90
 photography, 73, 97–115
 print and advertising, 72, 90–97
 theatre, 62, 73, 115–122
 wall-painting, 73, 122–126
 weaving, 73, 130–135
Wright, Frank Lloyd, 31

Zaubitzer, Carl, 90–91